The World of
Japanese Ceramics

The World of Japanese Ceramics

by
HERBERT H. SANDERS

with the collaboration of
KENKICHI TOMIMOTO

講談社
PUBLISHED BY
Kodansha International Ltd.
Tokyo, New York & San Francisco

Photographs appearing in this book have been made available through the courtesy of: Yoshiaki Jinguji, Figs. 6, 9d, 10b, 13, 18–20, 25, 28–32, 34, 36, 40, 41, 43, 52, 59, 67, 68, 71, 77, 84, 86, 89, 91, 100, 103, 105, 109, 117, 132, 133, 135, Plates 4, 11–15, 19, 20, 22–24, 26, 30–33; Joseph M. Campbell, Figs. 51, 58, 72, 81, 95, 104, 108, 118, 119, 122, 128, Plates 3, 5, 6, 8–10, 21, 25, 35, 36, 41; Harumi Konishi, Figs. 14–17, 24, 26, 27, 44b, 46, 53–55, 61, 85, 106, 112, 124–127, 129, Plate 18; Sakamoto Photo Research Laboratory, Figs. 5, 47, 73, 75, 78, 94, 96b, 97b, 115, 121, 123, Plates 7, 16, 17, 29, 37; Hiroshi Kaneko, Figs. 22, 23, 33, 50, 66, 80, 110, 111; Tokyo Folk Art Museum, Figs. 6, 19, 109, 117, Plates 11, 20, 22, 31–33; Sōsei Kuzunishi, 11a, 37b, 39c, 69, 113; Bin Takahashi, Figs. 1, 2, Plates 27, 28, 38; Shinchōsha, 48a, 64, 116, 120; Tokushima Shimbun, 12, 39d, 56; Boston Museum of Fine Arts, 7, 8; Yukio Futagawa, 48b, 107; Tsuneo Suzuki, 136, 137; Shōzaburō Hiraoka, 130.

DISTRIBUTORS:

United States
HARPER & ROW, PUBLISHERS, INC.
10 East 53rd Street,
New York, New York 10022

Canada
FITZHENRY & WHITESIDE LIMITED
150 Lesmill Road
Don Mills, Ontario

British Commonwealth (except Canada and the Far East)
GEORGE ALLEN & UNWIN, LTD.
40 Museum Street
London WC 1

The Far East
JAPAN PUBLICATIONS TRADING COMPANY
P.O. Box 5030
Tokyo International, Tokyo

Published by Kodansha International Ltd., 2–12–21 Otowa, Bunkyo-ku, Tokyo 112 and Kodansha International/USA, Ltd., 10 East 53rd Street, New York, New York 10022 and 44 Montgomery Street, San Francisco, California 94104. Copyright in Japan, 1968, by Kodansha International Ltd. All rights reserved. Printed in Japan.

LCC 67-16771
ISBN 0-87011-042-X
JBC 2072-780410-2361

First edition, 1967
Ninth printing, 1974

TABLE OF CONTENTS

LIST OF ILLUSTRATIONS

FIGURES

TO STUDENTS OF POTTERY

I RECALL that Dr. Herbert Sanders was conducting research in Japanese ceramics at the Kyoto Municipal College of Fine Arts, with the cooperation of the late Professor Kenkichi Tomimoto, some years ago. It is indeed a delight to learn that the results of his studies will now be published in a book, written with the collaboration of Mr. Tomimoto.

When I was invited to San Jose State College, California to lecture on ceramics for six weeks in 1963, Dr. Sanders, who was responsible for my seminar, always sat behind the students during my lecture, and would provide me with examples and materials he had taken home from Japan to display to the students. I had known Dr. Sanders as a prominent scholar on ceramic glazes in the United States, especially an authority on copper glazes, and was deeply impressed by his modesty and his kind and thoughtful arrangements in assisting my work.

The rapid increase of students in the United States aspiring to become potters in the last decade or more is amazing. However, to be quite frank, the advances made in the field of pottery techniques in general, to my regret, are not as rapid. One reason for this, I feel, is the recent overly heavy emphasis on design, and the lack of experience and work in basic pottery techniques. Of course, a lack of technique makes the production of radical variations in ceramic form and color easier, but too often this lack results in the creative intention ending in destruction. This fact holds true not only for the United States, but also for other countries. The fact that there are a large number of potters in the United States makes this an important matter.

In Japan, even if the potter is known as an "abstract" artist, he has been trained in and has acquired the basic pottery techniques, in contrast to the United States. Although the Japanese potter may be committed to creating abstract forms, he is bound to the conventional techniques and is not able to veer radically away from them. In Japan, therefore, the potter must take care not to remain submerged in empty repetitions of traditional techniques. In the United States, on the other hand, it seems that effort is needed to acquire straightforward, basic pottery techniques. In this respect, I feel it appropriate and timely for Dr. Sanders, who has profound knowledge and experience in pottery, to introduce the traditional and very much alive ceramic techniques of Japan to modern students of pottery, and to provide them with concrete information about the art. I feel that this new book is of great value and a fine contribution to the field.

SHŌJI HAMADA

Mashiko, 1967

INTRODUCTORY NOTE

This is a very valuable book dealing more thoroughly with the techniques of the Far Eastern potter, more especially Japanese, than any book hitherto published. I have written a certain amount on the same subject in my *A Potter's Book*, but this volume covers a much wider field in a very straightforward manner.

No attempt has been made by the author at purely aesthetic appraisal of the work of the potters, old or new, with which the volume is illustrated. This, in a way, is an advantage insofar as it leaves the reader freer to make his own judgments, although ultimately it is aesthetic valuation which will prevail.

The thoroughness of the report over so wide a field astonished me. Its accuracy is remarkable, estimated, in part, by Dr. Sanders' constant reference to what my old and intimate friend Tomimoto had to say concerning clays, pigments, glazes and fire. Tomimoto and I shared everything which we could find out about pots and pot making between 1912 and 1920 in a free and constant flow of letters, postcards and meetings. We were pathfinders in a new field of artistic expression through clay, and he was my best friend and I was his.

Bernard Leach

Tokyo, 1967

PREFACE

THE knowledge and skill of the Japanese potters is the result of centuries of cumulative thought and effort, each generation building on the foundation established by preceding generations. The story of Japanese pottery is therefore a very complex one, and its presentation here would have been impossible without the excellent cooperation and assistance of the potters themselves.

The information here presented is the result of interviews with over one hundred individual Japanese potters, from Mashiko (in the north) to Kagoshima on the island of Kyushu (in the south). It is unfortunate that not all Japanese potters could be mentioned individually in the text, but to do so would have entailed an expenditure of time close to that involved in compiling an encyclopedia. The absence of names of many potters does not in any way imply that they are not worthy of inclusion, but simply means that, in the limited time available, interviews with them were not possible. And, in the time that has elapsed since this material was compiled, young potters have emerged who have established a reputation and will undoubtedly be the leaders of the Japanese pottery world of the future. Also, in the last decade, Japan has seen the deaths of a number of her leading potters, including Rosanjin Kitaōji, Sohō Yanazawa, Michitada Funaki, Kanjirō Kawai, and the author's collaborator for this book, Kenkichi Tomimoto.

The purpose of this book is first to provide Western potters with information about techniques, processes, and glazes used by the contemporary potters of Japan. Its second purpose, no less important than the first, is

13

to make available to the thousands of people interested in Japan and her culture information about an art form that has had continuous expression in Japan since prehistoric times, and to present for their enjoyment photographic examples of the contemporary potters' skills and products. An effort has been made to include representative examples of as many as possible of the types of pottery made by contemporary Japanese craftsmen. Therefore, primary emphasis is on the methods of production, decorating processes, and glazes of contemporary Japanese pottery.

However, this book has still another purpose: the promotion of goodwill and of more complete understanding between the people of Japan and the people of other nations. As one Japanese potter has stated with a smile: "In international relations we should be represented by potters, since among potters there is universal understanding. Pottery is a universal language."

I first wish to acknowledge my gratitude to the Conference Board of Associated Research Councils Committee on International Exchange of Persons for my selection, under the Fulbright Act, as a research scholar in Japan during 1958–59. This book is a development of the research conducted throughout that year.

The project was successful only because of the untiring assistance and encouragement of Mr. Iwao Nishimura, executive secretary, Mrs. Yukiko Maki, American program officer, as well as the entire secretarial staff of the United States Educational Commission in Japan.

For expert advice and assistance in many ways I am greatly indebted to former President Tamiji Kawamura, Professor Terada, Dean of Students, Professor Yūzō Kondō (now President), and Professor Yoshimichi Fujimoto of the ceramics department of the Kyoto Municipal College of Fine Arts. Mr. Fujimoto is now on the faculty of the Tokyo University of Arts.

Among those who assisted with suggestions and letters of introduction to potters throughout Japan were Dr. Fujio Koyama and Mr. Masao Ishizawa, the late Dr. Sōetsu Yanagi, founder and Director of the Folk Art Museum in Tokyo, Dr. Kiyoshi Horiuchi, President of the Mingei Association in Kyoto, and Mr. Shōji Hamada of Mashiko, now Director of the Tokyo Folk Art Museum.

On my many trips and in interviews with potters, communication

would have been impossible without the excellent assistance of Mr. Yutaka Kondō and Mr. Makoto Tashiro, both of whom assisted me as guides and interpreters. To Mr. Yutaka Kondō, also, I wish to express gratitude for the unselfish sacrifice of his time in helping to obtain much of the photographic material.

I am indebted to Mr. Kihei Koyama of the ceramics department of the Kyoto Municipal College of Fine Arts, to Professor Joseph M. Campbell of San Jose State College, who took many of the photographs, and to the many Japanese potters who provided photographs of their work.

I am particularly indebted to my collaborator in the compilation of this book, the late Mr. Kenkichi Tomimoto. All information secured in interviews, as well as additional information provided by Mr. Tomimoto, was discussed and checked daily over a period of three months. Mr. Tomimoto was most generous and unselfish with his time and was my closest associate in Japan. It was a great pleasure to work with him. Beyond this, he was a fine gentleman, gentle and kindly to everyone. I am proud and pleased to have had him as a friend.

<div align="right">HERBERT H. SANDERS</div>

San Jose, 1967

COLOR PLATE 1. In these flower containers by Tōyō Kaneshige of Bizen, the process of changing the kiln fire has resulted in the effect known as *higawari*—that is, the appearance of several colors on one piece.

COLOR PLATE 2. *Goma*-decorated saké bottles by Kaneshige. During the firing, the soft, lightweight pine ash is picked up by the draft and carried through the kiln to settle on the ware. There it fuses with the clay to produce the falling-ash glaze effect called *goma*.

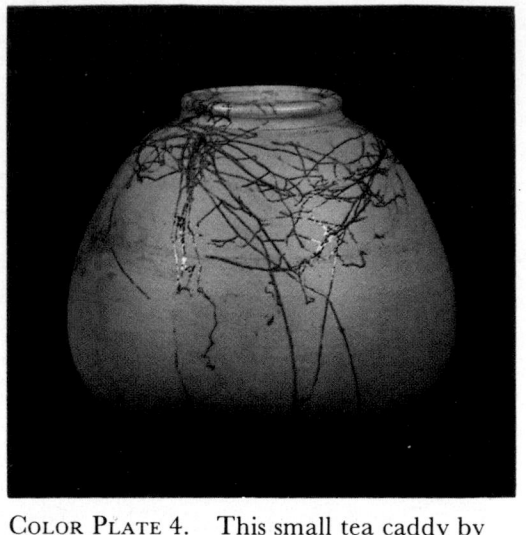

COLOR PLATE 4. This small tea caddy by Rakuzen Asai was wrapped in seaweed when it was placed in the kiln. Ash from the seaweed combined with the clay to form a partial glaze on the pot. The beige-colored ware of Tokoname is known as *hakudei* ("white mud").

COLOR PLATE 3. Saké bottle by Kei Fujiwara. Straw rope soaked in salt water and wrapped around Bizen ware before firing produces *hidasuki*—bright red streaks of glaze on an otherwise unglazed surface.

COLOR PLATE 5. The Tokoname potters burnish their *shudei* (literally, "red mud") pots with steel to produce a shiny surface on the clay, as seen in this teapot by Rakuzen Asai.

18

COLOR PLATE 6. Impressed clay shavings were used to decorate this *shudei* teabowl.

COLOR PLATE 7. Iga water container. The blue-green of a beetle, the red skin (unglazed part), the *koge* ("scorch"), and "stones like stars" are characteristic of Iga ware. This piece shows an unusual excess of ash glaze, and has been given the name "Trifoliate Orange" (*Karatachi*) because it resembles the astringent color and flavor of the fruit of this Oriental citrus.

COLOR PLATE 8. Black Raku
teabowl with reddish-brown
blush. Unless black Raku glaze
is cooled quickly, the black
changes to red-brown.

COLOR PLATE 9. This red Raku teabowl shows
the characteristic shadow pattern of carbon
markings under the glaze.

COLOR PLATE 10. A *bote-bote*
chawan with green lead glaze from
the Fujina area. This type of
chawan ("teabowl") is used by
farmers to serve a teatime gruel
of rice, water and salt.

20

COLOR PLATE 11. The Fujina area of Shimane Prefecture on the western end of the main island of Honshu is one of the two places in Japan that have a tradition of lead glazes, outside of Raku ware. As an indirect result of the research and work of Hamada and Leach, the potters of the area became interested in the yellows found on traditional English slipware, and adapted their lead glazes to produce a ware similar in appearance to the English prototype. This large lead-glazed bowl by Michitada Funaki follows both the shape and colors of the English tradition.

COLOR PLATE 12. Lead-glazed, semi-commercial pieces in the English slipware tradition, from the Marusan and Yumachi kilns of the Fujina area.

21

COLOR PLATE 13. *Temmoku* vase by Hamada. Mashiko clay, when combined with wood ash, produces a good black *temmoku* glaze. The *kaki*-colored ("persimmon-red") areas were produced by Hamada's wiping away the thick *temmoku* glaze with his thumb, leaving a thin residue.

COLOR PLATE 14. *Yuteki temmoku* ("oil-spot" *temmoku*) pieces by Morikazu Kimura. An overload of iron in a *temmoku* glaze will cause "oil spots" to appear on the surface of the glaze.

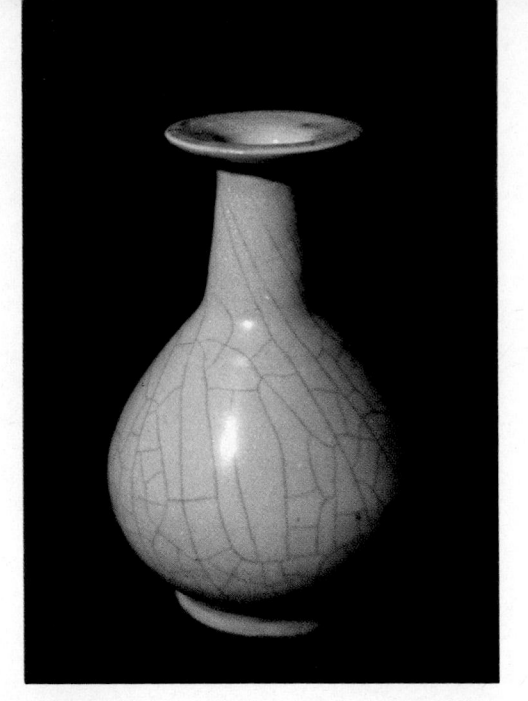

COLOR PLATE 15. Chinese Sung dynasty style vase by Sōtarō Uno. When the ware is made from clay containing a small amount of iron, the fired glaze becomes a light jade green. The crackle on the neck follows the direction of rotation of the potter's wheel.

COLOR PLATE 16. This *e* Shino ("picture" Shino) bowl dates from the Momoyama period (1573—1615). *E* Shino ware must be fired in an oxidizing fire.

COLOR PLATE 17. *Nezumi* Shino
("gray" Shino) bowl, seventeenth
century. To develop the gray
color, Shino ware must be fired
in a middle fire.

COLOR PLATE 18. This Oribe piece shows the characteristic splash of
ao Oribe (green Oribe) glaze and brushwork in iron under a transparent
glaze.

24

COLOR PLATE 19. Salt-glazed rectangular bottle by Hamada. On this piece the thick glaze coating produces the pebbled texture characteristic of salt glazing.

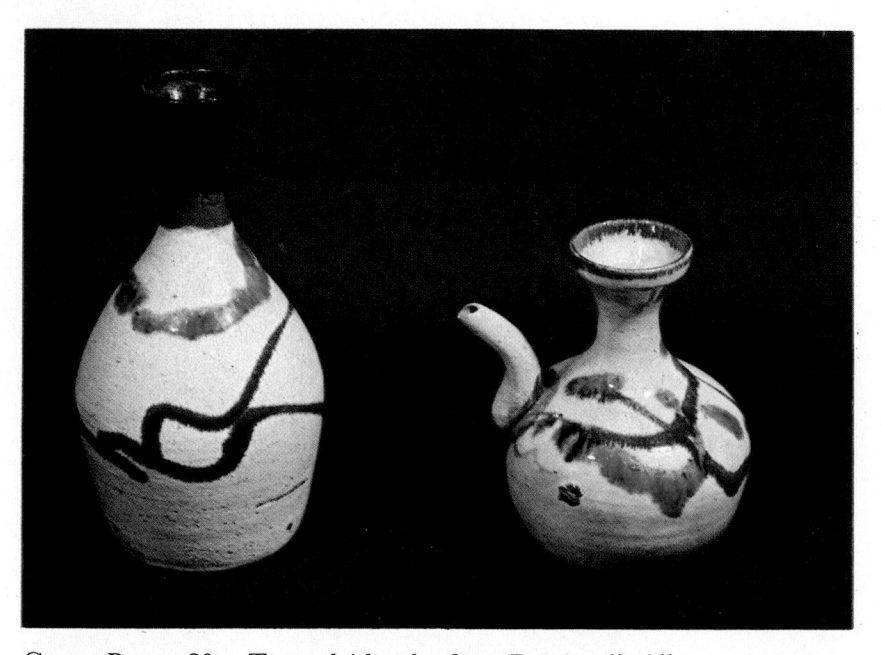

COLOR PLATE 20. Two saké bottles from Ryūmonji. All Ryūmonji glazes are made from regional native materials. The spouted bottle is identical with an Okinawan saké bottle form.

COLOR PLATE 21. Plates from Ushinoto. Either a bamboo tube or a rubber syringe can be used to trail one glaze over another of a different color.

COLOR PLATE 22. This rectangular bottle by Kanjirō Kawai shows superimposed glaze painting of the finest quality.

COLOR PLATE 23. A box by Kanjirō Kawai showing a highly complex, yet free and spontaneous example of wax resist and superimposed glaze.

27

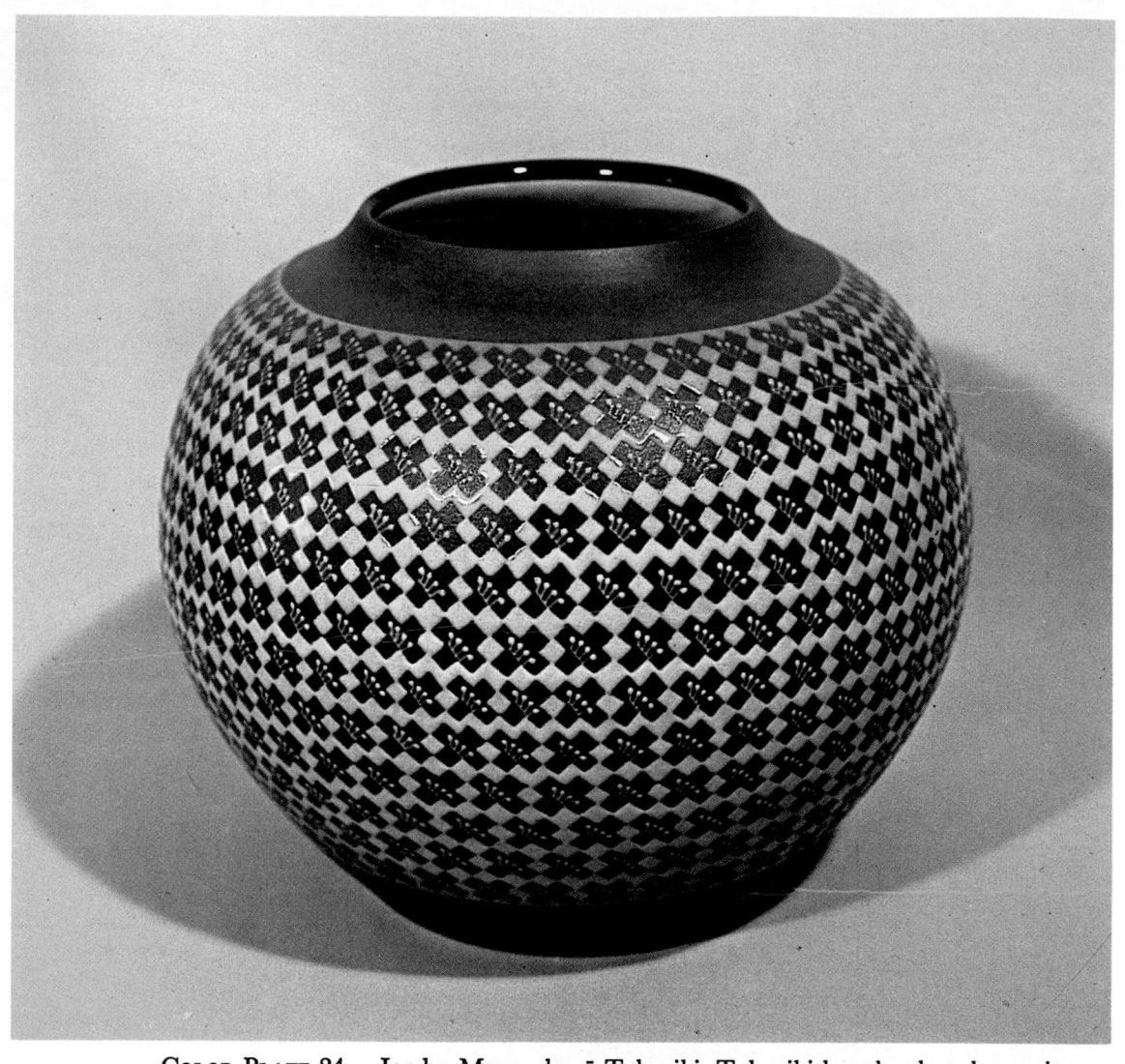

COLOR PLATE 24. Jar by Magosaburō Tokuriki. Tokuriki has developed superimposed glaze painting to an extremely high level.

COLOR PLATE 25. Porcelain bottle with glaze inlay (superimposed) by Suiko Itō. Itō displays great skill in carving porcelain and inlaying it with colored glazes under a transparent glaze.

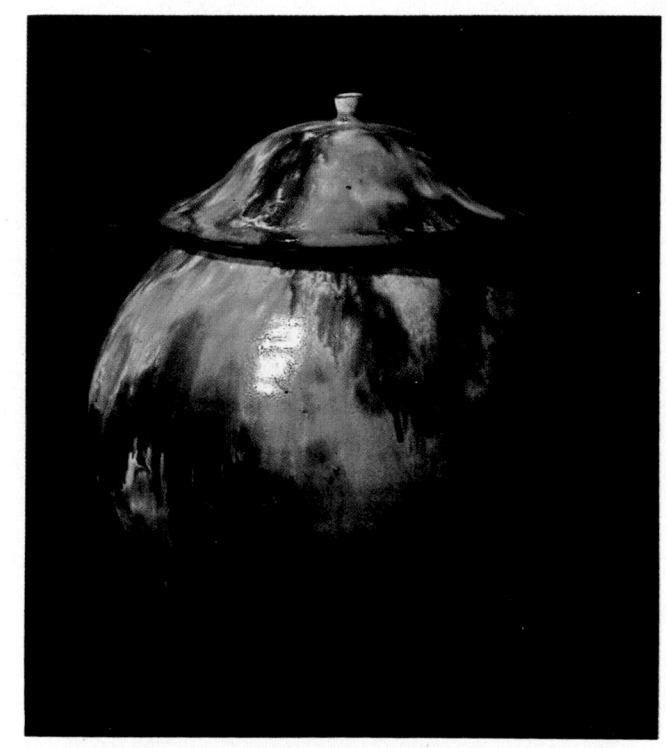

COLOR PLATE 26. A modern adaptation of Kōchiyaki (Chinese Cochin ware) glaze by Sango Uno.

29

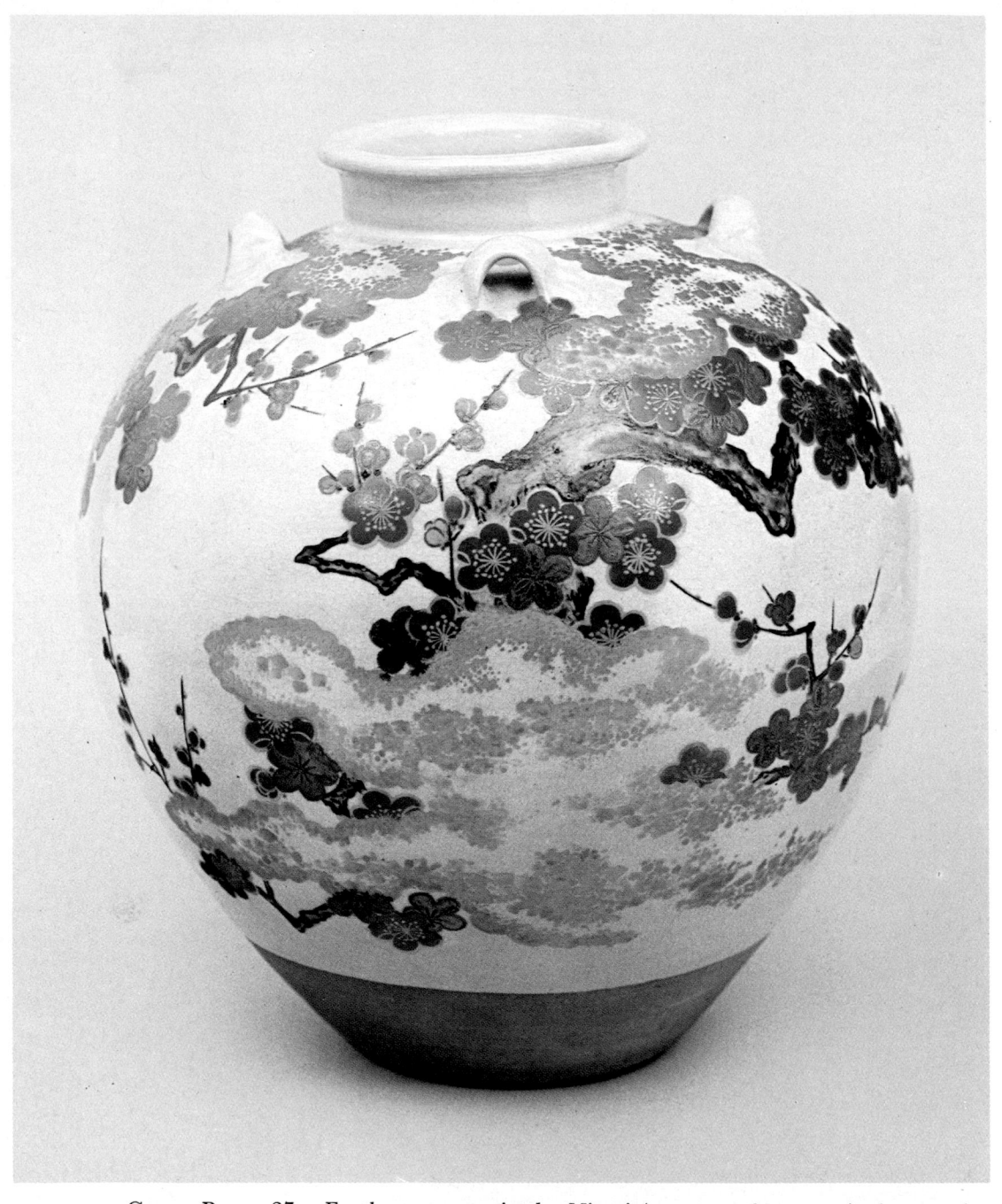

COLOR PLATE 27. Earthenware tea jar by Ninsei (seventeenth century), decorated with overglaze enamel.

COLOR PLATE 28. Overglaze enameled earthenware teabowl by Kenzan I (seventeenth century).

COLOR PLATE 29. White Satsuma enameled earthenware teabowl, late eighteenth or early nineteenth century. The Kagoshima area of Kyushu continues the white Satsuma tradition.

COLOR PLATE 30. This teabowl is the work of Tōzan Itō, the last of the traditional Awata ware potters.

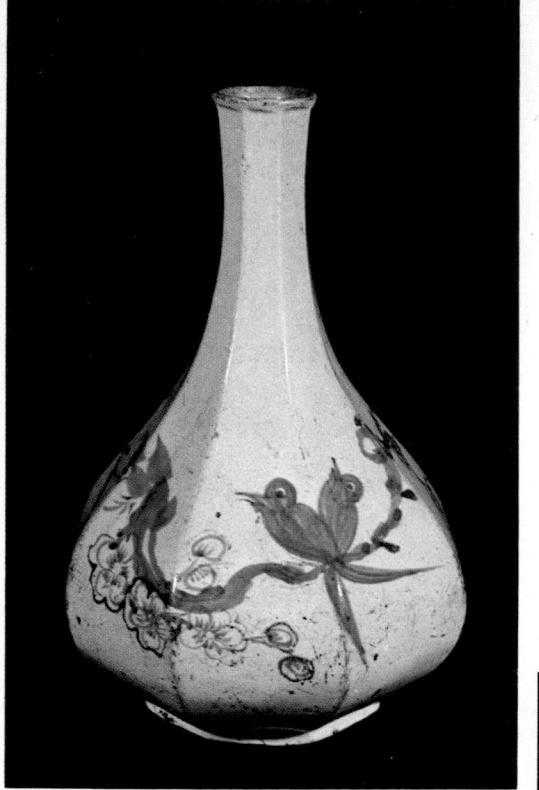

COLOR PLATE 31. A Korean Yi dynasty bottle with cobalt-blue underglaze decoration. Similar shapes and decorations are found in the early porcelain made in the Arita area.

COLOR PLATE 32. A Korean Yi dynasty vase showing copper-red underglaze decoration at its best. This ephemeral color was almost totally lacking in Japanese pottery until the twentieth century, perhaps because the early Japanese potters seemed to favor oxidation firing rather than the reduction firing that makes copper turn red rather than green.

32

COLOR PLATE 33. A Chinese Ming dynasty blue-and-white piece ordered and de-
signed in Japan. The shape of the piece is the shape of an old Japanese dispatch or
letter, which was a long paper accordion-folded into a tall and narrow form that
was again folded and tucked like a knot. Such pieces were imported before porcelain
and cobalt underglaze decoration came to be produced in quantity in Japan.

COLOR PLATE 34. Porcelain plate by Tomimoto, decorated with painted *gosu* (natural cobalt) and red enamel overglaze. Such pieces are rare, since artists who work in blue-and-white are specialists and normally do not use overglaze enamel.

COLOR PLATE 35. Porcelain plate by Yūzō Kondō, decorated with painted cobalt. This plate is similar to one in the Imperial Palace.

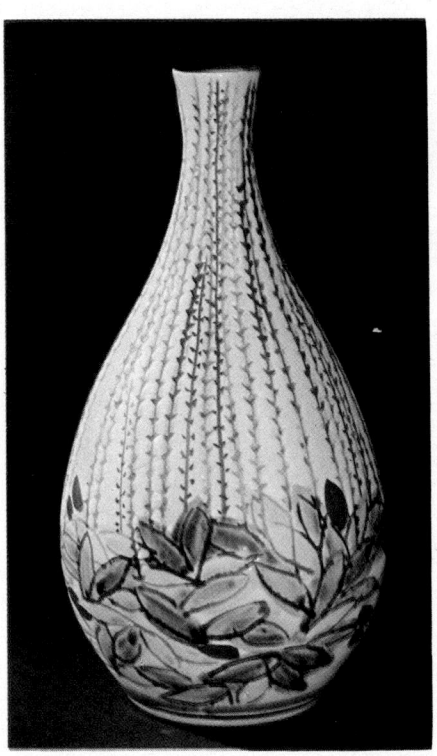

COLOR PLATE 36. Porcelain bottle by Kihei Koyama. The decoration is inlaid cobalt underglaze combined with red enamel overglaze.

35

COLOR PLATE 37. Kakiemon ware derives its name, as well as its fame, from the persimmon-red color of its overglaze enamel.

COLOR PLATE 38. An *ao*-Kutani ("blue" Kutani) saké server (seventeenth century), the shape of which is modeled after similar lacquer-on-wood forms. This piece is a registered Important Cultural Property.

COLOR PLATE 39. Overglaze-enamel plates by Tomimoto. The characters, reading from right to left are *fu* and *ki*, meaning "wealth" and "precious."

COLOR PLATE 40. Covered jar by Tomimoto, decorated with overglaze enamel. To successfully manage several colored enamels on one piece requires complete knowledge of the materials and processes. Note the skill with which Tomimoto has adjusted the pattern to the shape. This piece is now in the Japanese Embassy in London.

COLOR PLATE 41. Wall plaque by Tomimoto, gold on red enamel. This piece shows complete mastery of Japanese brush painting.

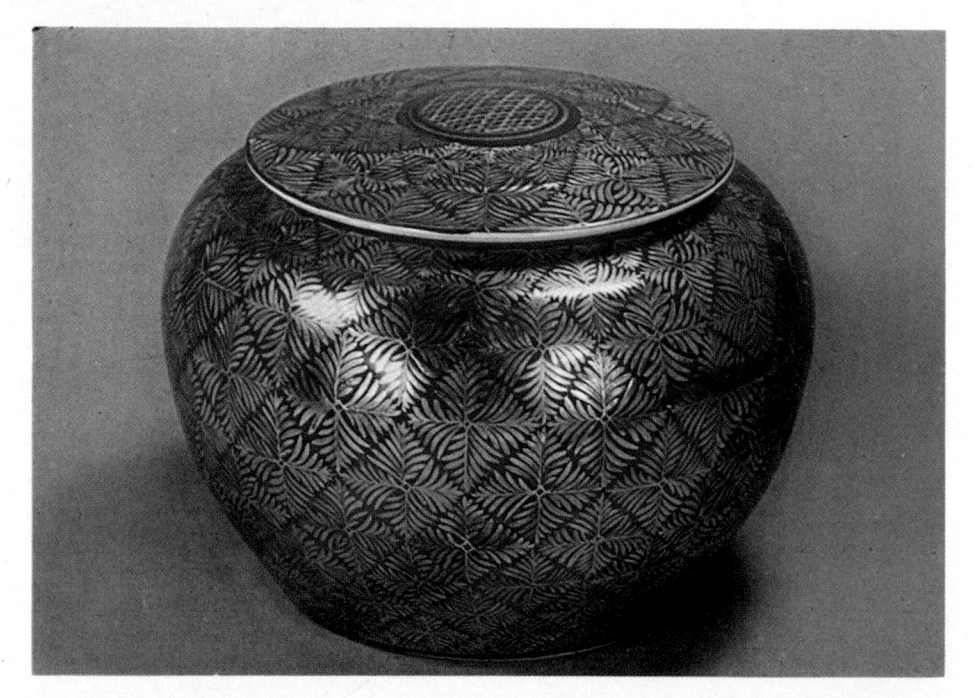

COLOR PLATE 42. Covered porcelain jar by Tomimoto, decorated with gold and silver on red enamel. This piece is in the Japanese Embassy in Washington, D.C.

CHAPTER I

JAPANESE POTTERS

IN A.D. 3, so the *Japanese Chronicle* (*Nihongi*) tells us, the Emperor Suinin repealed the practice of compulsory *junshi* ("following in death"). Up to that time, according to the *Chronicle*, it had been the custom to sacrifice the retainers as well as the horses and other animals of a royal personage when he died. The retainers were buried alive up to the neck around the imperial mausoleum, forming a *hitogaki* or "human hedge." But upon the death of his wife, Suinin took the advice of a retainer, Nomi-no-Sukune, and commissioned one hundred potters from Izumo Province to make clay figures of the servants and horses and ordered these objects interred instead of the Empress's living retainers and animals. Thus originated the famous *haniwa* sculptures (*Fig. 1*).

The ancient account indicates at least two facts about pottery in Japan: that affairs of state and cultural activities have often been closely connected, and that Japan, so far as recorded history can tell us, has always been a potter's country.

With nothing more than a pad of woven matting or a piece of rope, the prehistoric inhabitants of the Japanese islands produced remarkable wares, characterized by relatively massive walls, incised lines, bold modeling and carving. It was the predominance of mat or rope markings on the pottery that caused archaeologists to name this Neolithic culture Jōmon (roughly 4500–250 B.C.) after the mat markings (*Fig. 2, 3*). No one knows whether the Jōmon techniques came to Japan from the mainland of Asia or whether they simply evolved from usage, but as early as 200 B.C. Chinese civilization had spread to the archipelago by way of Korea. The settlers, for the most part occupying northern Kyushu, brought to their

new surroundings a knowledge of farming, the use of bronze and iron, and a new type of earthenware.

This new earthenware, named Yayoi, after the area in Tokyo where it was first discovered in a shell mound in 1884, represents a radical departure from the early pottery. Still a soft vessel, fired in primitive kilns, it was, however, much more graceful, had thinner walls, and was either undecorated or very simply decorated (*Fig. 4*).

Such an innovation in the artifacts of a primitive culture would have been impossible without the potter's wheel, and all evidence indicates that it was during this period that the wheel was first introduced into Japan from the mainland.

But by the fourth century real development is more clearly evident. At that time, news of an improved kiln in use in South Korea was brought back to Japan by an expeditionary force sent there by the "imperial" family, the family that held the reins of power in the Yamato area, then the political and cultural center of Japan. Invented in China, the *ana-gama* (cellar kiln), a single-chamber kiln built on the slope of a hill, enabled the Japanese potter to get sufficient draft to fire his wares to a high temperature, making possible a new type of earthenware, called Sue ware (*Fig. 5*). Though Korean in style, Sue ware was expertly thrown, and when fired became hard, dense, and somewhat rocklike, a vast improvement over the soft, easily broken Yayoi. The increased density, with its greater durability, made available a product for daily use by the great mass of people.

The *ana-gama*, which continued to be used to produce Sue ware for several hundred years, furnished as well the basis from which present-day Bizen (Imbe) ware and Tamba ware evolved (*Fig. 6*).

The younger Japan continued to pattern itself after the more sophisticated Chinese civilization. During the T'ang dynasty (618–922) Chinese scholars and artists were in great favor at the Japanese court in Nara, and in the eighth century, through their influence, a new kind of pottery made its appearance. The new ware (examples of which are to be found today in the Shōsō-in imperial treasure-house at Nara) so closely resembled the T'ang three-color pottery that for many years it was thought to have been imported from China. It is a low-fire, soft earthenware with green, yellow, and white lead-glaze mottling and streaking, identical

to that of the T'ang dynasty. In 794 the capital was moved to Kyoto, replacing Nara as the cultural center of the country, but the lead-glazed earthenware was still made for the court until the twelfth century.

But since this ware was not allowed to be used outside the court and the court's own Buddhist temples, its influence on Japanese pottery was negligible. While royalty hoarded the lead-glazed products, the method of glazing with celadon, also taken from the Chinese, gained wide popular acceptance. That it required high-temperature firing posed no problem, especially to the potters of the Seto area, whose Sue kilns were the most advanced in Japan. With the use of celadon, the Seto potters achieved a supremacy that they maintained for hundreds of years.

Glazing techniques, along with a new-style kiln from North Korea, were imported by the Sue potters in the neighborhood of Karatsu in northern Kyushu in the late fifteenth and early sixteenth centuries. This kiln was called the "split bamboo" because it resembled a bamboo stalk that had been split in two lengthwise and laid with the cut sides down. The kiln was built on the slope of a hillside and consisted of a number of long connected chambers, the partitions dividing the chambers corresponding to the joints on the bamboo. The new kiln had several advantages over the *ana-gama*, which was actually one long chamber. These were, chiefly, a greater control of heat during firing, a saving in fuel consumption, and increased production area. The construction of the split-bamboo kiln soon spread from Karatsu to the surrounding area in Kyushu.

The *nobori-gama* or "climbing kiln," a series of successively connected chambers built on a hillside with each kiln chamber on a flat step above the preceding one, came about largely from the use of the Korean sloped, split-bamboo kiln.

But the event that directly led to the flowering of the ceramic art in Japan occurred between 1592 and 1598, when the Shogun Hideyoshi Toyotomi's daimyos (clan lords) brought back scores of potters as prisoners of war from an invasion of Korea. The potters were settled on the various fiefs, where they lived under the protection of the daimyos and produced wares for their use. This wholesale importation into the Japanese feudal system "nationalized" and made Japanese the more advanced techniques and skills of the mainland.

Though there were still problems to be solved, the stage was set. The

wheel and the sloped, split-bamboo kiln were in universal use. Glazing was a commonplace in the Karatsu and Seto areas. It is true that the Korean Yi dynasty wares were for some time the prototypes for the majority of pottery products made in Japan. There were some kilns that continued to produce wares in the Japanese traditional style, but the potter's aim was to strive to match those ceramic products that represented the greater culture of the Asiatic continent. The production of porcelain was his highest ambition, its use the reigning desire of the upper classes. It was through the imported Korean potters that this final step towards development was taken.

Early in the seventeenth century, Risampei, a potter who had been brought from Korea by the Takeo clan, discovered porcelain clay in the Arita district, not far from Karatsu. Soon after the discovery, a follower of one of the chief vassals of the Nabeshima clan, Sōden, and his wife, Hyakubasen, led a group of mainly Korean potters from the Takeo kiln to nearby Arita (the reason for this move still remains a mystery), and it was with this group that Risampei started porcelain production in Japan with native materials.

The first Japanese porcelain was the blue-and-white of the early Korean Yi dynasty (*Plate 31*), with which the potters were familiar, but it alone was not completely satisfying to the Japanese. They had long envied the enameled porcelain of the Chinese Ming dynasty (1368–1643) potters (*Plate 33*), and now for the first time a translucent white body was available that could provide the base for the brilliant, colorful overglaze decoration that the Japanese taste of the period craved.

By the middle of the seventeenth century, an Arita potter, Kakiemon Sakaida, had perfected the first Japanese overglaze enamel decoration on porcelain. Once started, the overglaze enamel technique was taken up throughout the Arita area. Much of the early Arita enameled porcelain reached the Western world through the port of Imari, and for that reason became known in the West as Imari ware. Other blue-and-white wares and enameled porcelain of this time were Nabeshima (also known as Imari but not made for export) and Hirado, produced at Mikawachi. By the middle of the seventeenth century, the house of Maeda had established kilns at Kutani, on the Japan Sea side of Japan near Kanazawa, where a very bold, vigorous type of enameled porcelain was manufactured

Fig. 1. The *Nihongi,* one of the earliest Japanese written records, states that the *haniwa* figures and sculptures were first ordered made in A.D. 3 by the Emperor Suinin to replace the custom of interring live retainers and animals together with their deceased lord or lady. These ancient products of the potter's art represent the earliest recorded example of the importance the potter has come to increasingly hold in Japan. The *haniwa* piece from Gumma Prefecture pictured here is thought to represent a female figure. Tokyo National Museum.

46 JAPANESE CERAMICS

Fig. 2. Jōmon vessel. The wares of the Jōmon period show a pattern of rope markings that probably originated from the technique of beating the clay with a cord-wrapped paddle during the forming process.

Fig. 3. Jōmon clay figure (*dogū*). This piece is one of the more ornate and intricately modeled female figures of this type found in considerable number in the northeastern area of the main island of Honshu. These figures are hollow and are generally characterized by snow-goggle-like eyes, a crown-like ornament on the head, stump arms and legs, and decoration implying, at the same time, heavy clothing and nudity.

POTTERS 47

Fig. 4. Yayoi vessel. The ware of this period was more refined and graceful than that of the preceding Jōmon period and was probably made on a primitive type of potter's wheel.

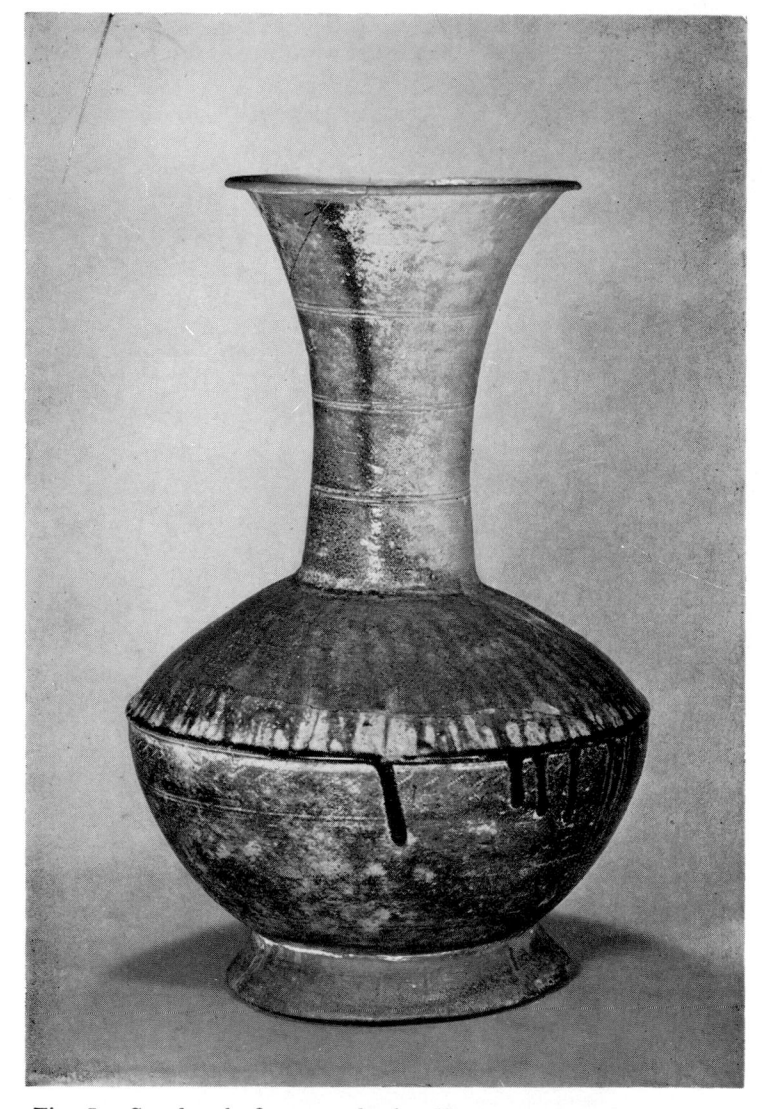

Fig. 5. Sue bottle form, undoubtedly a container for liquids. Sue wares were skilfully thrown and were much more durable than the wares of preceding periods. Occasionally, as seen in this illustration, accidental glaze effects resulted from falling ash in the kiln during the firing process.

Fig. 6. Old Tamba jar for storage of tea leaves. Native Japanese wares of this type were unglazed except for accidental glaze effects resulting from falling ash.

50 JAPANESE CERAMICS

Fig. 7. Seto brown-glazed tea caddies made in imitation of imported Ming wares from southern China. The growing popularity of such pieces as containers for powdered tea used in the tea ceremony prompted widespread imitations by Japanese potters. The caddy in the center dates from the seventeenth century, the others from the fifteenth.

Fig. 8. Saké bottle (eighteenth century) from Bizen, where the Sue tradition has continued for over one thousand years.

(*Plate 38*). Arita and Kutani were the leading porcelain-producing centers in Japan for a hundred years.

Gradually the porcelain techniques were developed elsewhere. Seto, near Nagoya, started overglaze enamel early in the seventeenth century; and at Nagoya, under the direction of the house of Tokugawa, the daimyos of the region, potters gained excellent control of the Arita blue-and-white technique. Primarily through the efforts of Tamikichi Katō, Seto, at the beginning of the nineteenth century, was second only to Arita in porcelain-producing importance.

Seiemon Nonomura, originally a potter at Tamba and exceptionally skilled in the use of the potter's wheel, successfully applied the technique of overglaze enamel to an earthenware pottery body in Kyoto about 1650. When Nonomura, who had studied glazing and the overglaze-enamel technique before coming to Kyoto, set up a kiln near Prince Ninnaji's palace to make ware for his use, Ninnaji conferred on him the name-character *nin*. Nonomura combined the character *nin* with the first character of his given name, Seiemon, thus originating the art-name Ninsei, one of the greatest names in Japanese pottery (*Plate 27*).

Ninsei's style influenced the potters of Kyoto, particularly in the Kiyomizu area, and from there his fame extended to many parts of Japan. Though the potters of one area of Kyoto continued to make the enameled earthenware that has become known as Awata ware, it was through the influence of the Kiyomizu area that the Tateno kiln at Kagoshima developed white Satsuma ware (*Plate 29*), also an overglaze-enameled earthenware.

After Ninsei's death, a former student, Kenzan Ogata, carried on his work. Eventually Kenzan worked out a style of enameled earthenware distinctly his own, rivaling even that of the master, and Kenzan became an art-name handed down to potters of succeeding generations to the present day. By the middle of the nineteenth century, porcelain had become a part of the life of the people of all classes.

Still, some traditional wares continued to be made, differing only in minor ways from those of early times. The Zeze kiln on the shores of Lake Biwa in Saga Prefecture maintained the Seto brown glaze tradition (*Fig. 7*); kilns at Shigaraki and Bizen continued in the Sue tradition of unglazed ware (*Fig. 8*). Tokoname started to produce the Chinese-style,

burnished red-clay ware, and Tamba developed the use of glazes, but in the most unpretentious style of the traditional folkcraft potters. Within the present century the Iga kiln, shut down for generations, has been revived.

The overthrow of the shogunate form of government and the restoration to power of the imperial house in the person of Emperor Meiji in 1868 led to industrialization on a large scale. Up to then the handcraft production of Arita and Seto had operated under the protection and encouragement of feudal lords. But now the potters, free of feudalistic clan government, were at liberty to adopt modern European production techniques and to make use of European glaze compositions and methods of glazing.

An Austrian chemist, Dr. G. Wagener, brought European production methods to Japan. He was invited by the government to come to Arita at the time of the Restoration, and his training of advanced ceramic experts resulted in the establishment of national and prefectural training and research institutes in the ceramic production centers. The dissemination of European techniques promoted Japanese ceramics into an important industry. A burgeoning export trade to Europe, Asia, and the Americas, along with the Westernization of the Japanese, revolutionized the design of ceramic wares. At the start of the twentieth century, traditional Japanese wares and Western coffee sets, tea sets, and dinnerware were to be found side by side in Japanese homes and shops.

This emphasis on industrial development and the adoption of Western culture was not without a destructive influence on many Japanese traditions. Perhaps most of all it caused the sudden demise of the individual potter.

Meanwhile, the "name" potters, preserving the family tradition of many generations, remained as small factories. The family head was the manager or "name" potter (and in some instances a skilled decorator), but the work, an imitation of traditional models, was done by artisans. These pottery families (better known as *noren* families, from their gateway curtain, or *noren*, stating the potter's name and generation) not only survived but also prospered. But the potter without a *noren* could not sell his work.

In the more remote areas the pottery villages that had been main-

tained by the feudal lords sank into oblivion. The potters, after centuries of controlled production, were not prepared to take advantage of the new freedom. Whereas they had formerly sold their products at village fairs and markets of the area in which they lived, porcelain ware was now available from Seto, Kyoto, and Arita. The new transportation system forced many of them to move from their villages and take up other vocations. Those who remained were rapidly absorbed into growing industrial communities. Some, caring little for the strange mushrooming world around them, became farmers.

The plight of the folk potters, all but extinct, had for a long time been of much concern to Sōetsu Yanagi. Encouraged by Shōji Hamada and Kanjirō Kawai, two of modern Japan's leading potters, Yanagi launched the folk-art movement, which culminated in the formation of the *Mingei* ("folk art" or "arts of the people"; a word invented by Dr. Yanagi) Association with the objectives of (1) educating the public to appreciate and enjoy the quiet and unassuming beauty of the folkcraftsmen's products and (2) encouraging the craftsmen to continue their production. Exhibitions, publications, lectures, and sales outlets in the larger cities helped to realize these goals, and even more solid accomplishment came with the establishment of folk-art museums in Tokyo and Kurashiki. Within the past thirty years many of the traditional rural potters have been put back in business. No potter's location was too remote for Yanagi, Hamada, and Kawai. They talked to the potters wherever they were, prodding them back to work, stimulating the continuation of the genius of past ages.

Interestingly enough, Hamada and Kawai were originally trained as engineers at the Tokyo Institute of Technology. They did not become interested in pottery until they went to work in Kyoto at the prefectural ceramic research institute. Of the two, Kawai turned to pottery first, and in 1917 became an individual potter in Kyoto; Hamada, curious since childhood about the teapot he used at school during lunchtime, visited Mashiko in 1920 and there saw potters making teapots of the type that had for so long attracted his interest. That same year he went to England and helped Bernard Leach start his important work at St. Ives. Hamada returned to Japan in 1924 and settled in Mashiko, where he has resided ever since.

But while Hamada, Kawai, Yanagi, and others were absorbed with the decline and near disappearance of the folk potters, Kenkichi Tomimoto, born in 1886 in Yamato Province (Nara Prefecture), near the Hōryūji Temple, and originally trained in architecture, labored to free Japanese pottery from the stranglehold of the *noren* family potters. By so doing, Tomimoto did more than breathe new life into Japanese ceramic art; he also became modern Japan's first individual potter.

It was when Tomimoto returned home in 1911 after studying architecture in England for three years that he met Bernard Leach, who had come to Japan the year before to study the country's people and their arts. Their friendship, whether fated or not, altered the whole course of contemporary Japanese pottery. Tomimoto, acting as interpreter, arranged for Leach to study in the studio of Kenzan VI, a potter skilled in the production of Raku ware. Leaving Leach in Kenzan's hands, Tomimoto left for Yamato and the pursuit of his own career in architecture. But almost daily there was a letter from Leach requesting translation of some terminology. The correspondence inspired Leach to ask Tomimoto to come and study under Kenzan with him, but Tomimoto begged off; he had other plans. Then, sometime over a year later, when Leach was working alone, he persuaded Tomimoto to attempt Raku ware. It was at that time, 1912, that Kenzan VI gave Leach the title and art-name Kenzan VII.

In 1915 Tomimoto built his own small kiln in Yamato, taught himself to make Raku ware, and the two men joined forces. In Leach's own words:

"Later, when Tomimoto did take up pottery we exchanged all the information and experience we gathered separately in complete freedom and harmony right up to the time I left Japan in 1920.

"The following incident will serve to give an idea of our intimacy. Shortly after I had established my kiln and workshop at Abiko on Dr. Yanagi's property, I discovered a method of rolling a pattern on the edge of the large Raku plates I was making, and, thinking that I was the first to find out this technique, I made a drawing on a postcard of the indented roller with a wave pattern on it and sent it off to Tomimoto. The next morning I received a similar postcard from him, crossing mine, also with an engraved wave pattern on it."

Working and studying together, Leach and Tomimoto soon became

aware of the need for a potter to make use of the potter's wheel. They realized they must learn to throw, but when they expressed an interest, they were laughed at. Only workers (artisans) used the wheel! The potter only decorated the ware that the worker made. They persisted, and in time they both became skilful throwers, and consequently Japanese pottery itself turned a corner.

Tomimoto, however, could not subscribe wholeheartedly to the philosophy of the *mingei* and in 1934 he instituted the ceramic section of the Nitten Academy. He resigned after twelve years because of Academy limitations placed on younger artists and, turning his energies elsewhere, started the Shinshō Craft Association, which encourages young potters to design and exhibit their work as early in their careers as possible. After World War II, a group made up of many who found the Academy wanting in principles formed still another organization, the Japanese Craft Association. Almost all of the potters of Japan are members of at least one of these societies.

Today, the Japanese potters are a broad and varied group with many techniques and methods of working. There are the *mingei* potters, many of whom can trace their ancestry back to the Koreans imported by Hideyoshi in 1598. Others have studied at a pottery village or with Shōji Hamada or Kanjirō Kawai. Some have continued the Sue tradition, as has Tōyō Kaneshige, who is the seventy-eighth generation of potters of Bizen ware. There are also those who have started out as artisans in a factory and through determination and industry have educated themselves until they could become individual artist-potters. Others, primarily interested in the modern art movement, make traditional utilitarian wares as a means of livelihood, but do modern sculptural objects as their own creative work. There are also a number who, though educated as painters, have turned to clay as their means of expression.

In 1949 Tomimoto was again called upon to assert his leadership in the Japanese pottery field. This time he was asked by the government to institute the first ceramic art department in any college in Japan. Today many young potters receive their training in this department at the Kyoto Municipal College of Fine Arts.

CHAPTER II

TOOLS AND MATERIALS

THE POTTER'S best tools are his hands. The primitive Japanese demonstrated this truism long ago when, with the exception of a pad of woven matting or a piece of rope, he produced outstanding wares with no supplementary tools. But for centuries, from the time the first throwing wheel made its appearance on the archipelago, Japanese pottery has undergone profound changes.

As the potter's culture progressed and was influenced by the more discriminating society of the Asiatic mainland, more complex kilns and many supplementary small tools came into use in his workshop. For a satisfactory understanding of his contemporary work, these must be considered individually.

The Wheel

So far as we know, the original potter's wheel of the Orient was a circular pad of woven matting that the potter turned by hand—a wheel known in Japan as the *rokuro*. But with the arrival of the *te-rokuro* or "handwheel," the mechanics of throwing developed into a more subtle art. At first the wild-orangewood shaft of the handwheel was set in the earth; its top was cone-shaped and fitted into a conical hole in the center of the underside of the wheel head (*Fig. 9a*). The wheel head was a large, thick, circular piece of wood with shallow holes on the upper surface around the periphery of the disc. The potter kept the wheel in motion by inserting a small wooden handle into one of the holes and revolving the wheel head on its shaft until he got the speed he desired.

Over a period of time the conical bearing would wear irregularly, and the shaft would rot away at the base. Something had to be done to remedy these imperfections, and eventually the conical hole in the underside of the wheel head was replaced by a porcelain bearing with a cone-shaped cup into which the top of the shaft fitted. An iron pipe that had an adjustable orangewood tip set in its top further supplanted the orangewood shaft (*Fig. 9b*). This new design proved helpful, for by adjusting the wooden tip, the wheel head could be raised or lowered to suit the potter's needs. But one disadvantage lingered: when the bearing was lubricated, the oil or grease ran down the shaft. The problem of keeping the wheel running smoothly remained with the potter until it was ultimately solved in the final stage of development.

The present handwheel has a $1\frac{1}{4}$-inch solid iron or steel rod as a shaft. In the top of the shaft there is a cup, in the form of an inverted cone, in which the oil or grease is placed. To the center of the underside of the wheel head is attached a cone-shaped, cast-iron tip that fits into the cup at the top of the shaft (*Fig. 9c*). At some time during its evolution, the handwheel was raised from approximate ground level to its present elevation above the ground (*Fig. 9d*). In order to stabilize it on its longer shaft, now set in stone or concrete, wooden slats were put in the wheel head and attached to an octagonal or round wooden block sixteen inches below the head. The point where the shaft passes through the octagonal or round stabilizing block is called a *habaki* or "close fit."

The handwheel is always turned clockwise, and the weight of the large wheel head induces it, after starting, to rotate for a long period of time. It revolves rapidly. Pieces made on it have a high degree of accuracy and symmetry because there is no movement of the potter's body while throwing, as there is in the case of the kick wheel. In the early days of porcelain making in Japan, the Kyoto, Seto, and Nagoya areas used only the handwheel; elsewhere, in the Kutani area and in Arita, the kick wheel was employed.

Obviously the handwheel is a delicately balanced tool. It is used for small, delicate pieces, such as teacups, rice bowls, and tea-ceremony bowls.

The Japanese-style kick wheel or *ke-rokuro* (from *keru*, meaning "to kick") was probably invented in China during the early Ming dynasty.

The design of the kick wheel (*Fig. 10a*) is similar in many respects to that of the handwheel. The shaft is either the simple wooden shaft of the early handwheel, or has a wooden tip set in the top of an iron pipe, like that of the latter-day wheel. The wheel head, smaller than the one on the handwheel, still has the porcelain bearing set in the center of the underside, and the shaft is anchored in a stone or concrete base. But after this all resemblance ceases (*Fig. 10b*). Where slats are used to attach the wheel head to the stabilizing block of the handwheel, the shaft of the kick wheel is completely boxed in with an octagonal housing. The small stabilizing block is replaced by a much larger and thicker circular wooden block, the upper one-third cut at an angle to provide a kicking surface for the potter. The close fit of the handwheel stabilizing block has been superseded either by a ball bearing or by a porcelain sleeve-bearing that is the full thickness of the kicking block.

The kick wheel is always turned in a counterclockwise direction, and the inevitable motion of the potter's body as he kicks the wheel while throwing gives many Japanese pots that casual lack of symmetry which has much appeal to contemporary Western taste.

There is a Japanese story to the effect that celadon, which the early Japanese potter modeled after the Chinese examples, must be made on the kick wheel. The reason for this is that the crackle in the celadon glaze follows the throwing strains of the clay, and if the pottery were made on the handwheel the crackle would spiral in the wrong direction (*Plate 15*).

Following the Meiji Restoration in 1868, a student of Dr. Wagener went to Germany to learn how to build the downdraft kiln, and saw many wheels operated by belts on pulleys from a single shaft. On his return he set up a similar system in the Seto area, using one man to turn a flywheel that drove the shaft and the pulley system. From this the two-man wheel developed (*Fig. 11*).

Today, the majority of potters in Kyoto use electric wheels, though there are many studios that still have a handwheel and a kick wheel. But it is very difficult now to find craftsmen who can make or repair them.

Ribs and Throwing Sticks

A potter's rib is usually a flat piece of wood, 3/8 to 1/2 inch thick. It may be of any size or shape. Its edges are filed round or beveled, depending upon the purpose for which it is to be used. For small forms, such as teacups, rice bowls, and tea-ceremony bowls, the potter often uses only his hands; for larger and more varied shapes he has his personal assortment of ribs and throwing sticks.

When a rib or throwing stick is used, the cylinder is first pulled up and roughly shaped with the hands alone. The tools are then used to refine and finish the form. Among the ribs used by Japanese potters is the *dango*, a knuckle-shaped piece of wood with which pressure is applied from inside while shaping the pot (*Fig. 14*). It takes the place of the potter's knuckle or fingertips and can be grasped easily in the hand.

In addition to the *dango*, the potter will have at least one profile tool or *kote* for shaping bowls and plates (*Fig. 14*). In order to render a smooth surface, the *kote* must be held solidly and steadily with the beveled edge out, shaping the clay. Tomimoto, the versatile artist-craftsman, used only one *kote* and applied pressure with different portions of a single curve for his various bowls or plate forms. This technique requires moving the *kote* while shaping the form and, unless skilfully used, results in throwing marks or ridges on the surface of the piece. Some potters use a different-shaped *kote* for each form they make. Others use only one *kote* that has a number of different curves.

Most Japanese potters do not employ an outside rib in shaping, but use only their fingers. Among the rural potters of Korean ancestry, however, who coil the ware before throwing, both an inside and outside rib are used. The form of the outside rib is usually square or rectangular, with rounded corners.

The *egote*, or throwing stick, is also a profile tool (*Fig. 15*). It is used in making tall and large shapes. This is particularly true of cylindrical bottle forms in which it would be hard to reach the inside bottom of the ware for final shaping. After the cylinder has been pulled up, and the top constricted to approximately the diameter of the finished neck, the *egote* is inserted and the shaping done. The *egote* must be held very firmly, with

the thumb braced against the top for steadiness. In this manner, the *egote* is drawn up the inside wall of the roughed-out form, with various degrees of pressure as needed to develop the shape.

Swabs and Leathers

American potters, in general, use water as a lubricant for the clay when throwing. The Japanese potter prefers a small bowl of soft clay mud or slip. The application of the slip will vary according to the kind of clay being used, the type of product, and the individual doing the throwing. The *mingei* potter will use his hands or a cloth swab. The potter working in porcelain will use a *hake*, a wide short-bristled brush of a special shape (*Fig. 34*). Once the throwing process is started, it produces its own whipped-cream-like mud as a lubricant for throwing. Tomimoto discovered that when water is used for throwing porcelain, S-shaped cracks develop in the bottom of the pieces. Following the shaping process, most potters take a wet *naze-kawa*, a smooth chamois-skin leather, to smooth the lip or rim of the ware (*Fig. 18*). The *naze-kawa* can also be used to apply the necessary slip for throwing.

Measuring Tools

Very few, if any, of the individual potters of Japan can support themselves and their families solely on what they receive from individually made, one-of-a-kind pieces. The time involved in creating original works, the greater cost of production, and the considerable price the potter is forced to ask conspire to make such production prohibitive. It therefore becomes necessary for the individual potter to design an item or several items that he or an apprentice or a trained artisan can produce in quantity. Often the mass-produced items are the work of an elder son, studying with his father, who will in time succeed his parent. When many pieces of the same size and shape are made, the thrower will check the diameter of bowls with calipers (*Fig. 16*). The diameter and depth of cups and mugs are checked with a *tombo* or "dragonfly," a simple gauge made of bamboo (*Fig. 17*). Sometimes such quantity items may be cast or pressed in a mold.

The Cutting Cord

The *kiri-ito* or "cutting cord" of the Japanese potter may be made in a number of ways. One method, dating back to the Meiji period, when cord was not easily available, makes use of rice straw. Taking only the top half or two-thirds of the stalk, which is first dried and then soaked in salt water until soft and pliable, the potter splits the straw into four equal sections, each to be used for a cutting cord. The straw is bent in the middle, and the loop thus formed is placed around a short wooden handle, firmly held in place by the thumb of the left hand as each end is individually twisted until round. Then the two ends are tightly twisted together. The result is a very strong, flexible straw cord, easily maneuvered, that will also float in the potter's pan of slip while he is throwing.

Rice-straw cords are still popular with many potters for cutting small pieces from the wheel, although now large pieces are usually cut with a twisted copper wire or heavier twisted cotton-fiber cord (*Fig. 18*). The use of the twisted wire or cord is responsible for the famous shell pattern found on the bottom of many Japanese wares (*Fig. 19*).

Molds

Westerners are often astonished to learn that, despite the staggering amount of pottery produced in Japan, the potters make use of relatively few molds, although there are some shapes, of course, that cannot otherwise be efficiently turned out in any volume.

Some potters may still make use of an old Chinese and Korean technique: the biscuit mold that has had a decoration carved into its surface prior to biscuiting (*Fig. 21*). Bowls are thrown whose inside contours are the same size and shape as the biscuited mold. When almost leather-hard, the porcelain forms are inverted over the mold and beaten with a wooden paddle until the carved pattern is firmly impressed into the inside surface. The beating process causes the porcelain to stretch so that the top edge of the form extends beyond the edge of the mold. After trimming, the excess porcelain is removed with a knife; then the foot is trimmed and

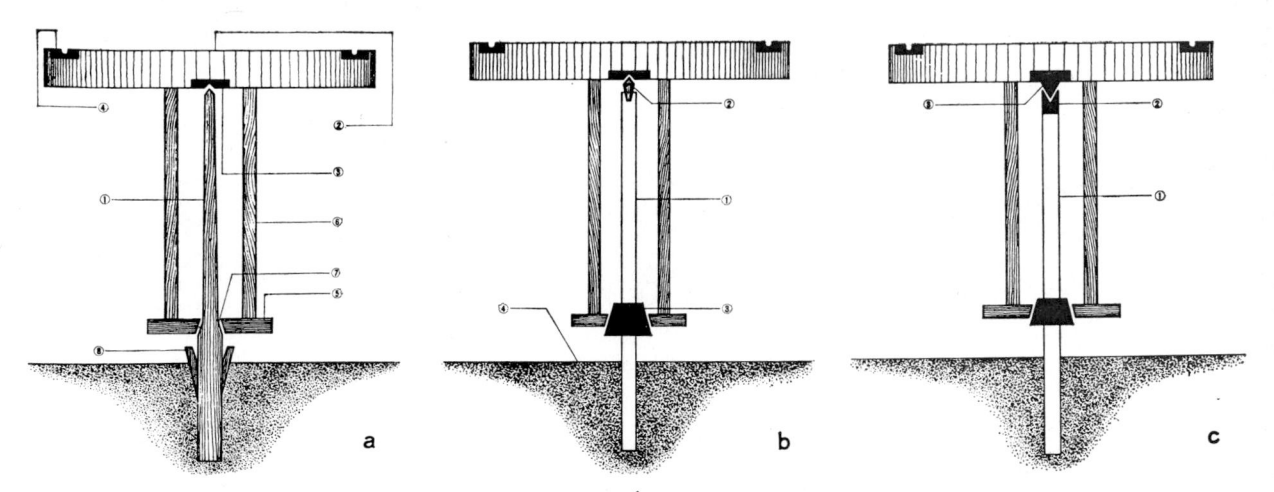

Fig. 9. (a) The early handwheel had a wooden shaft with a conical tip [1]. In the stage shown here, the conical hole in the underside of the wheel head [2] has been replaced by a porcelain bearing with a cone-shaped cup [3] into which the top of the shaft fits. The holes in the surface of the wheel head have been reinforced with porcelain cups [4] to prevent wear. The stabilizing block [5], connected to the wheel head by wooden slats [6], shows a close fit (*habaki*) [7]. The shaft, set in stone or concrete, is held solidly in position by wooden wedges [8].

(b) The wooden shaft is replaced by an iron pipe [1] with a wooden tip [2] set in the top, and the close fit of the stabilizing block around the shaft has been improved by a cylindrical porcelain bearing [3] set on the pipe. The pipe shaft, which is more durable than the old-style wooden shaft, is set in a cast-concrete base [4], thus eliminating the need for wooden wedges.

(c) A solid metal rod [1] with a conical cup [2] at the top has replaced the pipe shaft with a wooden tip. A cone-shaped cast-iron tip [3] has replaced the porcelain bearing on the underside of the wheel head.

(d) Modern handwheel. Such wheels are still found throughout Japan, and some of the older potters take pride in the fact that they have never used an electric wheel.

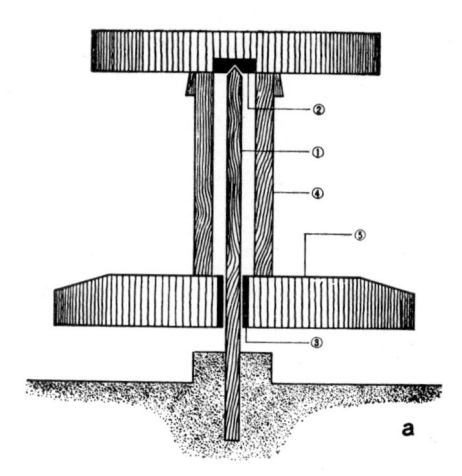

a

Fig. 10. (a) The *ke-rokuro* or "kick wheel" has retained either the orange-wood shaft or the pipe shaft [1] with a wooden tip, as well as the porcelain bearing [2] set in the underside of the wheel head. The kicking block may have either a ball bearing set in its underside or a porcelain sleeve-bearing [3] that is the full thickness of the block. The stabilizing slats of the handwheel have been replaced by an octagonal wooden housing [4] that attaches the kicking block [5] to the wheel head.

 (b) The modern kick wheel.

b

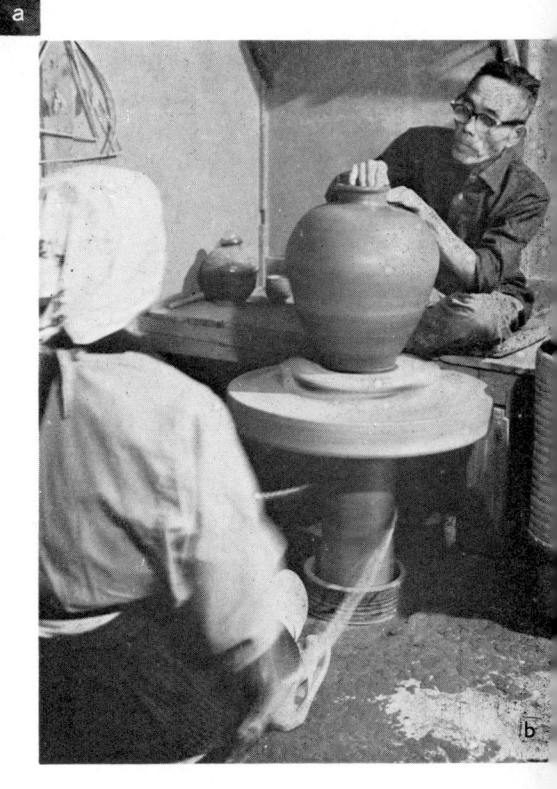

Fig. 11. Two-man wheels, first introduced in the Meiji period, still are used in a few places in Japan for the production of large pieces.

(a) At Takada (near Tajimi, Gifu Prefecture) the assistant turns a wheel patterned after a grain grinder, from which a belt passes to the potter's wheel for the production of large, approximately gallon-sized saké bottles.

(b) This two-man wheel used by Rakusai Takahashi of Shigaraki, Shiga Prefecture, is rotated by a hand-held cord. This system, particularly, demands that the potter and his assistant turning the wheel work in complete harmony.

Fig. 12. Without mechanical power, the potter's wheel in Japan saw an interesting adaption to the production of huge pieces. This unique wheel is still in use on the island of Shikoku.

Fig. 13. The jigger wheel.

Fig. 14. *Dango* (bottom left) are knuckle-shaped ribs used inside while shaping a pot on the wheel. The potter cuts and files these ribs into the shape and the curves that best fit his hand, the ware he makes, and his movement patterns in throwing. *Kote* are profile-shaped ribs used for forming bowls, plates and cups. The four tall *kote* on the left are for tumbler-shaped teacups, while the five *kote* on the right are for bowls and plates.

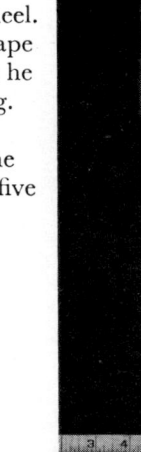

Fig. 16. Calipers may be made of strips of flexible metal or hard wire.

Fig. 15. *Egote* or throwing sticks are used inside to shape tall and narrow-necked forms.

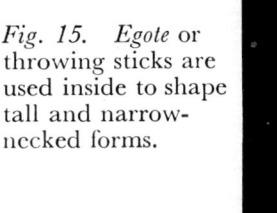

Fig. 17. The *tombo* or "dragonfly" is a bamboo tool used to measure the diameter and depth of duplicate forms. (a–c) *tombo* for tumbler-shaped teacups; (d) *tombo* for a small saké bottle; (e) *tombo* for a plate.

TOOLS AND MATERIALS 69

Fig. 18. *Naze-kawa* (chamois skin) and cutting cords and wires. Rice-straw cords are still popular with many potters for cutting small pieces from the wheel, although now large pieces are usually cut with twisted copper wire or heavier twisted cotton-fiber cord.

Fig. 19. The use of the twisted wire or cord in cutting pieces from the wheel is responsible for the famous shell pattern found on the bottom of many Japanese wares.

Fig. 20. Two thin bamboo strips are used to lift soft pieces from the wheel.

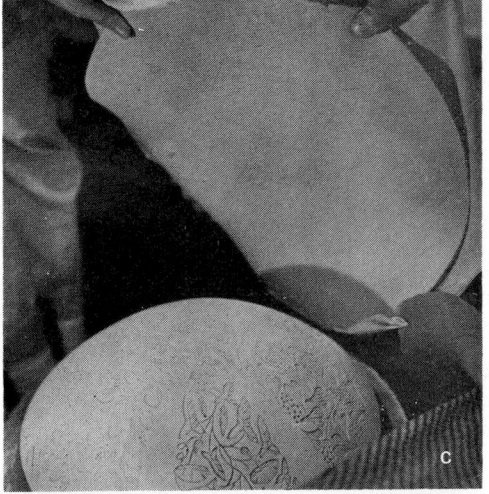

Fig. 21. In this series of photos Hajime Katō demonstrates his modern adaptation of the use of the carved biscuit mold. The mold that will form the inside contour of the bowl is first carved from a solid mass of clay or is cast and then carved from potter's plaster. After the mold has been formed, the decoration is incised into its surface. If made of clay, the mold is biscuit fired at a low temperature and is then ready for use.

(a) Powdered grog (pulverized fireclay) of the same composition as that of the body to be used in making the bowl is dusted through a cloth bag onto the surface of the biscuit mold.

(b) Prepared clay from which the bowl will be made has been cut into slices of uniform thickness.

(c) A piece of cloth has been pressed onto the surface of the slice to protect it from cracking or tearing when it is placed over the carved mold.

(d) After the slice has been draped over the mold, the cloth is removed.

(e) The mold is attached firmly to the center of the potter's wheel. Starting at the center of the clay slice, the potter uses a chamois skin soaked in slip to press the slice firmly against the surface of the mold.

(f) The clay slice stretches and becomes thinner as pressure from the potter's hands causes it to extend beyond the edge of the mold.

(g) A bamboo knife is used to cut the excess clay from the form at the edge of the mold.

(h) A coil of clay is firmly attached to the scored bottom of the piece.

(i) The coil is thrown and smoothed to form a foot rim for the bowl.

(j) When leather-hard, the bowl is removed from the mold.

(k) The bowl is inverted, centered on a chuck, and trimmed to insure removal of any irregularities and to insure uniform wall thickness.

Fig. 22. Clay slabs are pressed into these molds, which break diagonally across the square form to eliminate corners in the mold, and are then joined together. The bottom is formed by a third clay slab pressed and luted with thick slip onto the square bottle form. Sometimes these molds have decoration carved into their surface.

Fig. 23. Drape molds are often used to make small plate forms and ashtrays. Plaster drape molds (pictured here) or ones of biscuited clay are generally used, though the Oribe ware potters use a wooden mold.

Fig. 24. The most widely found tools in the potter's workshop are the *kezuri no dōgu,* the "trimming tools," of which the *kanna* are perhaps the most important.

Fig. 25. These pieces of Sodeshi ware were first thrown on the potter's wheel, after which the surfaces were planed by slicing with a knife.

Fig. 26. Knives are some of the few store-bought tools the Japanese potter uses, but these, too, are mostly reworked to a desired shape (a, b).

Special trimming and carving tools are usually made of simple materials: a piece of strap iron (c), a chisel point (d), and a nail (e) have been attached to handles and filed to shape · (f) is an ordinary sewing needle inserted in a common throwaway chopstick, and (g) is a filed umbrella stay.

Fig. 27. Bamboo knives (*hera*) for trimming, carving or shaping.

Fig. 28. Wooden combs (*kushi*) have been used in the Orient for centuries to produce *kushime* or "comb-grain" decoration on pottery. Steel combs, sections of a steel hacksaw blade, and flexible steel-toothed scrapers are also used to produce decorative effects.

Fig. 29. Early examples of stamping.

(a) The *ame* (amber) glazed sherd from Seto shows the use of individual design-unit stamps combined in a number of variations.

(b) This Korean Koryo dynasty sherd shows both stamping and inlay. The fine, engraved lines and the stamped, stylized chrysanthemums have been filled with white slip.

76 JAPANESE CERAMICS

Fig. 30. These roller stamps used for impressed decoration are made of either carved wood or biscuited clay.

Fig. 31. Wooden paddles can be carved and decorated on both sides. The simple lined and cross-hatched paddles were order-made in Okinawa years ago by Shōji Hamada of Mashiko. The more complex paddles are from the workshop of Hamada's neighbor and former pupil, Tatsuzō Shimaoka.

Fig. 32. The cord-wound bamboo sticks and cords of various braids used for cord-impressed decoration by Shimaoka. This potter's father was a noted and skilled maker of the cords used to fasten the *haori* coat worn over the Japanese kimono.

Fig. 33. The *fude* is the standard Japanese brush for writing, painting and considerable pottery decoration.

a b c d e f g h i

Fig. 34. These *dami-fude* (a–g) were made by Totarō Sakuma of Mashiko for his own use in dripping, trailing, throwing and heavy applications of glaze. The flat *hake* (h, i) pictured represent but two of the many shapes taken by such brushes in Japan.

Fig. 35. This type of large *dami-fude* is used at Ryūmonji as a dripping brush for slip, but at Arita it is used to paint decoration on porcelain. The brush can be slipped out of the bamboo tube, washed, and hung up to dry by the cord seen projecting from the stopper at the top of the tube.

Fig. 36. These special broom-like *hakeme* brushes are used to make the rough *hakeme* ("brush-grain") decoration enjoyed in Japan: usually a swirl of white slip on a dark ground. The four *hakeme* brushes on the left are made of straw, while the four on the right are of pounded palm fiber.

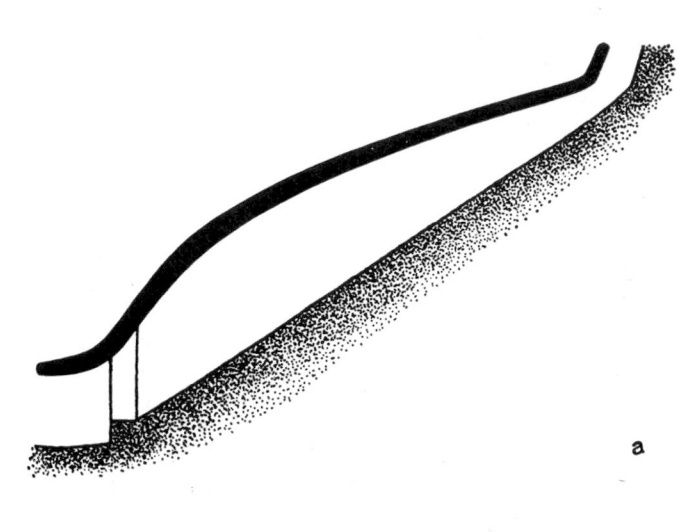

a

Fig. 37. (a) Old Seto *ana-gama*.
(b) Toyozō Arakawa of Tajimi, Gifu Prefecture, uses a semi-aboveground-type *ana-gama,* the only kiln of its kind in use in Japan today.

b

a

b

c

Fig. 38. (a) Karatsu split-bamboo kiln.
 (b) The "beehive" or "rifle" split-bamboo-type kiln at Tamba has fire ports in the roof through which wood is dropped during firing.
 (c) Smoke outlet of the Tamba "beehive" or "rifle" kiln. The smoke outlet is the top end of the kiln and is of honeycomb construction.

80 JAPANESE CERAMICS

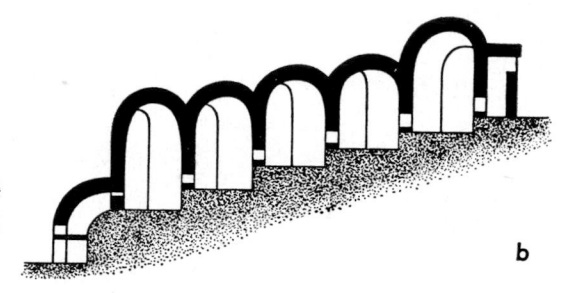

Fig. 39. (a) Arita "round" *nobori-gama*.

(b) Kyoto *nobori-gama*.

(c) *Nobori-gama* ("climbing kiln") at Takada. The *nobori-gama* is constructed on a series of steps carved into a hillside. Each step provides the foundation for an individual chamber, of which there may be as few as three or as many as twenty. All chambers are connected by openings through the connecting walls. On each side of a kiln chamber there is a door, which is closed with brick during firing. In each door there is a fire port through which wood is thrown and a vent hole that may be used as an observation port.

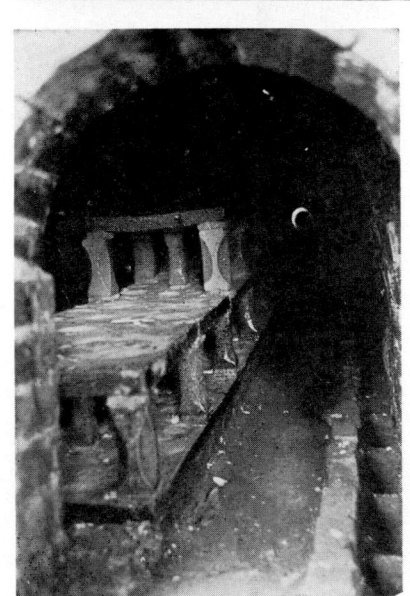

(d) A large *nobori-gama* and pottery yard on the island of Shikoku.

Fig. 40. The interior of Shōji Hamada's three-chambered salt-glaze kiln.

Fig. 41. Hamada uses small clamshells, filled with clay and leveled on a soft clay slab, as kiln stilts, exhibiting a simple but clever use of common materials. The shells decompose during firing.

Fig. 42. (a) Chinese "saké bottle" level kiln of the type used at Ching-te-chen.
(b) In the downdraft kiln, the flames that come up inside the wall below ground level are deflected towards the arched roof by a bag wall or baffle just inside the kiln chamber. The flames strike the roof arch, which sends them downward to circulate among the wares stacked in protective saggers. The fire passes through the floor, of a honeycomb brick construction, then enters an arched tunnel that leads to a smokestack close by.

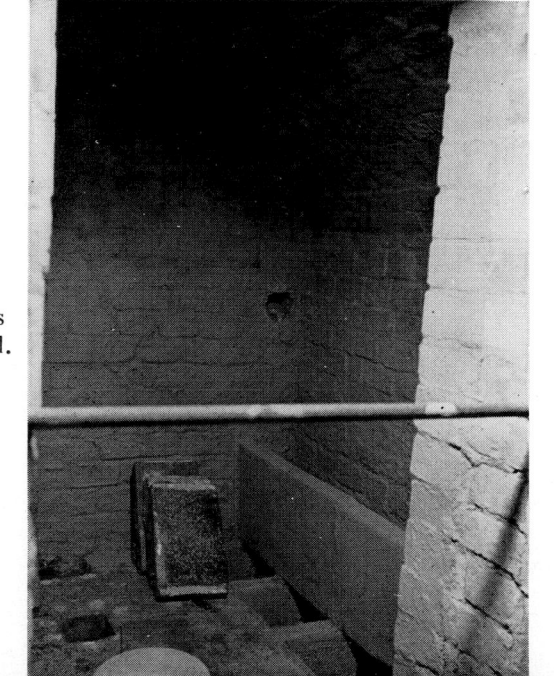

Fig. 43. The small downdraft kiln used by Sōtarō Uno has no bag wall to deflect flames toward the arched roof. For each firing, the kiln is stacked in such a manner that saggers of ware provide a temporary bag wall.

Fig. 44. (a) Raku kiln.
(b) The Raku kiln is a cylinder, three feet in height, of loosely laid-up brick or tile. The firebox, overlaid with fireclay mud, is a brick tunnel that extends out two or three feet at ground level from an opening in the wall of the cylinder. A cylindrical fireclay sagger with about a two-inch clearance between it and the wall of the kiln is placed inside and serves as a muffle.

Fig. 45. The small biscuit kiln is similar in many ways to the Raku kiln, although it does not have a complete muffle.

Fig. 46. (a) The top view of the black Raku kiln at the Kawasaki factory in Kyoto.

(b) Old and new black Raku kiln muffles made in the form of large, lidded saggers. The rice-hull impressions on the new muffle indicate the use of rice chaff as an additive to the fireclay from which the muffle is made. The chaff assists in making the body more porous, thus aiding in resistance to cracking during drying and firing. Two teabowls will just fit into a new muffle, but the shrinkage has been calculated to provide the correct size to hold one bowl.

Fig. 47. (a) Electric kiln for firing enamel. The lid of the kiln has an observation port through which the ware can be watched during firing. Test pieces are suspended on nichrome wire hooks around the observation port.

(b) A top view into Tomimoto's electric kiln.

TOOLS AND MATERIALS 85

Fig. 48. (a) Crushing clay by waterpower at Onda and Koishibara. Water is diverted from the stream at a higher level to operate the crusher (at Koishibara).

(b) As the water from the stream fills the bowl hollowed from the large end of the tree trunk, the trunk tips, raising the hammer end. The bowl then empties, the hammer falls and crushes the clay (at Onda).

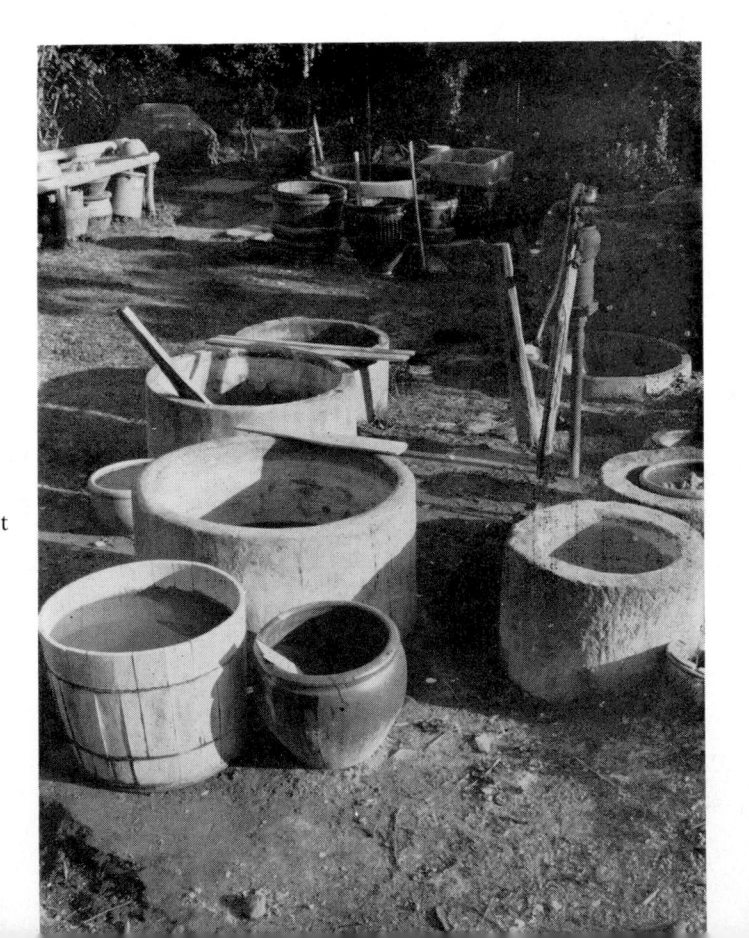

Fig. 49. The clay-settling tanks at Ryūmonji are probably the most typical of the old system.

Fig. 50. Small clay-settling basins at Mashiko.

Fig. 51. The *aramomi* or "press-wedge" process.

Fig. 52. The *nejimomi* ("screw-wedge") process follows the *aramomi* process.

the bowl permitted to dry. Today, plaster drape molds are also utilized, but these molds are usually not carved.

Prior to the Meiji period a primitive type of casting in biscuit molds had been used for the mass production of dolls. But with the industrialization of ceramics, due largely to Wagener's influence, casting and jiggering processes spread throughout Japan.

The use of the drain mold for the casting process is known as *ikomi*, which literally means "into an iron mold." This is probably a reference to the process of pouring liquid iron into molds, a procedure that had been used by the Japanese for centuries before it was adapted for industrial production of clay wares. Casting and jiggering are still mostly restricted to factories where the mass production of dinnerware in identical shapes makes their use necessary. There are, however, a few individual potters who avail themselves of the casting process. This is true for rectangular and square boxes, ashtrays, and bottles made of porcelain. Such cast-porcelain forms are later individually decorated (*Fig. 61*).

Hamada, Shimaoka, and Kawai use molds to hand-press earthenware and stoneware slabs into bottle forms (*Fig. 22*). A good many potters use very simple drape and press molds for shallow plate and tray forms (*Fig. 23*).

Trimming Tools

Of all the tools in the potter's world, the ones most commonly found are those used for trimming—that is, removing excess clay—an operation executed simultaneously with the perfecting of the pottery form itself. In Japanese, these tools are known as *kezuri no dōgu*.

The early potter worked with only one trimming tool, a bamboo knife (whose origin, incidentally, is so dim as to be hopelessly swallowed up in antiquity). After the Meiji Restoration, the increase in commerce and the importation of commodities made available quantities of the thin, soft, strap iron used for binding wooden boxes. The thrifty Japanese potters waste nothing. They soon found a ready purpose for these iron strips, which made first-rate trimming devices, and utilized them in the manufacture of *kanna* (literally, "planes"). *Kanna* are usually six to eight inches long, with an inch or less of one or both ends of the strap

bent at a right angle. The longer section serves as the handle; the shorter is filed to the desired shape and cutting edge (*Fig. 24*).

Some wares exhibit flat planed surfaces wrought by slicing the form with a knife (*Fig. 25*). The knife may be a store-bought knife filed to the desired shape, may be made of a flat section of strap iron filed into a knife blade, or may be a bamboo or wooden knife or even a wooden modeling tool. Hamada states that he has found the best iron knives are ones made in Okinawa, where they still hand-forge iron. This might have to do with the feel, thickness and quality of the hand-forged knife blade rather than with any specific cutting ability. Bamboo knives (*hera*) are usually made of strips, taken from the trunk of a large bamboo, carved flat, with two or three inches of the end filed on the diagonal to a knife-edge (*Figs. 26, 27*). Bamboo must be worked while it is still green because it becomes very hard and brittle when dry. Wooden knives are made from thin strips of wood filed in a manner similar to that used to make bamboo knives.

Carving Tools

The Japanese potter does not do elaborately carved decoration on his pottery, and when the need for a carving tool arises, he improvises from whatever is at hand. For most carved surfaces the bamboo or strap-iron knife or a bamboo tool made for the specific work is sufficient. Tomimoto used a *kugi-bori* ("nail carving tool") made by driving a nail into a piece of bamboo, then filing the nail to a sharp point (*Fig. 27*). Another useful incising tool is contrived from a piece of metal sharpened to a chisel point. Hajime Katō uses a small *kanna* for excising around raised porcelain patterns in bowls.

Tools for Impressed Decoration

The *kushi* ("comb") for *kushime* ("comb-grain" decoration) has been used in the Orient for centuries—probably as long ago as the Sung dynasty in China. Hand-cut boxwood combs are still used in Japan today, mostly for the traditional Japanese coiffure, and some of them are quite beautiful indeed. The potter may use a purchased boxwood comb or may make his own by filing teeth into a piece of wood or bamboo (*Fig. 28*). Steel

combs, sections of a steel hacksaw blade, and flexible steel-toothed scrapers are all used as well.

The use of the stamp as a decorating tool seems to have emanated from Korea during the Silla (in Japanese, *Shiragi*) period. The Korean bone or funerary bowls have a small stamped decoration, impressed with the end of a piece of bamboo. This decoration, called the *yoraku* pattern, resembles a curtain of beads that formerly hung in doorways. Whether or not this is the actual origin of the stamped decoration, the use of stamps first appeared in Japan on Seto pottery in the fourteenth century (*Fig. 29*).

The decoration impressed with the end of a stick of bamboo is the simplest kind of pattern that can be made. Stamps can be of any size or shape or degree of complexity that the potter wishes. They may be of wood, clay (which, of course, would then be fired before use), or plaster. The surface may be deeply carved or shallow; for most purposes, carving to a depth of 1/16 to 1/8 of an inch is enough for any pattern (*Fig. 86*).

The roller stamp is a carved cylindrical tool, its handle set in holes centered in the end of the cylinder. The wheel may be made of wood or clay (*Fig. 30*). If wood, it should be of a hard close-grained variety that does not deteriorate or splinter when damp or wet; if clay, it should be fine-grained and free of grog or coarse sand. The cylinder should be formed from plastic clay, carved when leather-hard, and biscuit fired before it is used.

The process, inherited from mainland Asia, of paddling a soft coiled piece to fuse the coils leads naturally into the use of paddles with a carved design to impress decoration on the clay surface (*Fig. 31*). The design possibilities to be carved into such paddles are practically limitless, and naturally, also, the two sides of a paddle usually are carved with different designs.

Even more ancient in origin is the process of rope-impressing the clay body surface when soft, as was done with the Jōmon pottery (*Fig. 2*). Some modern Japanese potters have expanded this process, using cords of different braids (*Fig. 32*) to obtain a variety of decorative, impressed texture patterns.

Brushes

It has been said of the Japanese potter that he was born with a brush in his hand. Nonetheless, he did not achieve his excellence overnight; it was, rather, the result of years of practice, beginning in early childhood when he used his brush exclusively for calligraphy. Today, among the younger generation, this skill is dying out; fountain pens and pencils have all but replaced the brush. Even so, insofar as pottery decoration is concerned, the brush continues to be very much used.

The *fude* is the standard Japanese brush for writing, painting, and considerable pottery decoration (*Fig. 33*). Small brushes are used for line work and the larger sizes (*dami-fude*) for washes of color (*Fig. 34*). The *dami-fude* of Arita, made from the hair of a deer's tail, is used as a dripping brush at Ryūmonji. Quite loose and sprawling, $2\frac{1}{2}$ to three inches long, the hair is firmly tied at the top with a twisted fiber cord that passes up through a bamboo tube handle held in place by a plug made of a smaller piece of bamboo, the end of which slides down inside the handle top. After use, the brush can be removed from the handle, washed, and hung up by the cord to dry (*Fig. 35*).

The *hake*, a wide, flat brush manufactured for repairing sliding paper screens (*shōji*) in Japanese houses, and actually a paste or starch brush, is employed very effectively at Onda and Koishibara as a patting brush for slip (*Fig. 34*).

Hakeme means "brush-grain" decoration, but often instead of the conventional *hake*, the potter will use a stiff broom-like brush (*Fig. 36*) to make the rough brush swirls and slip decoration enjoyed in Japan (*Fig. 110*).

Kilns

Mention has already been made of the original Japanese kiln (*kama*), which was built on the plains and first replaced by the *ana-gama* (cellar kiln) (*Fig. 37*), which in turn was succeeded by the split-bamboo kiln. Both the *ana-gama* and the split-bamboo kiln were sloping kilns built on a hillside, and both were imported from Korea. It was from the split-

bamboo-style kiln, as we have noted, that the present *nobori-gama* or "climbing kiln" developed.

Near Bizen we find the sites of three large *ana-gama*, three hundred, two hundred, and one hundred years old, respectively. The remains indicate that the floors of the kilns were probably eighteen inches or more below the present ground level. The walls and arch were so low that a man could not stand upright, and the long single chamber made control of firing difficult.

A semblance of control was achieved by the use of large jars, two to three feet high, which were a regular item of manufacture by the Bizen potters. At periodic intervals when stacking the kiln, a wall or baffle would be constructed from the jars stacked on top of each other. This divided the kiln chamber into a series of temporary sections. After the kiln was built, earth was piled against the outside walls until only three or four feet at the top and the doors remained exposed.

The main firebox was at the lower end of the kiln, and once the fire was well started, wood was dropped into the kiln through ports in the uncovered area above. The firing progressed by stages from the firebox at the lower end. The method was to put fuel into the first section above the firebox until the desired temperature had been reached, then to continue the firing, section by section, until the top end of the kiln had been satisfactorily heated.

The kiln at Tamba is of the split-bamboo type and has been called a "rifle kiln" or "beehive kiln" (*Fig. 38*). Its construction is similar to that of the *ana-gama*. It is built on a continuous slope, and the floor is below ground level. The walls and arch, though, are much lower than those of the *nobori-gama*; here it is not possible to stand upright. The ware chambers are a good deal longer, too, providing greater stacking area between doors, but the continuous slope of the floor requires leveling the ware when stacking the kiln. As in its *ana-gama* prototype, the practice of piling earth against the walls and dropping fuel through the roof has continued.

The *nobori-gama* or "climbing kiln" represents a more developed stage (*Fig. 39*). By far the most common type of kiln found in Japan today, it may have anywhere from three to twenty chambers. The firebox is below ground level at the lower end of the kiln, and steps, each with a separate chamber, are carved into a hillside. The chambers are con-

nected by openings in the separating wall at the ground level of the next higher chamber. Tomimoto explains the stacking and firing procedure for a nine-chamber *nobori-gama* as follows:

"Porcelain, which requires a reduction fire, is stacked in the first and second chambers above the firebox. The third chamber is called *ishi-tsugi*—that is, next to the porcelain chamber—and is fired with a middle fire, between oxidation and reduction. The fourth chamber is fired with a combination of middle fire and oxidizing fire. The fifth chamber and on through the ninth are fired with an oxidizing fire. After starting the kiln, it is first fired with large pieces of wood in the firebox for four hours. This is called *aburi,* or 'heating at a distance to dry.' In the next four hours, much more and finer wood is used to provide *seri-daki,* or 'racing fire,' which is the reducing fire. A great quantity of fuel is required at the beginning of *seri-daki* to insure much carbon and a reducing flame. At the end of *seri-daki* the chambers are individually fired in succession for three or four hours each, the wood being thrown into the respective chambers through a porthole in the door. The total firing time is usually between thirty-five and forty hours. After firing, the kiln requires from four days to a week to cool before the ware can be removed."

The downdraft kiln (*Fig. 42*) was brought to Japan from Europe after the Meiji Restoration. While it is used in some areas of the country, it is not truly Japanese. This type of kiln consists of a single chamber constructed on a flat surface, with fire pits on the outside or, if gas-fired, with burners coming through the wall on the sides. The flames that come up inside the wall below ground level are deflected towards the arched roof by a bag wall or short baffle just inside the kiln chamber. The flames strike the roof arch, which in turn sends them downward to circulate around the ware stacked in protective saggers. The fire passes through the floor, of a honeycomb brick construction, then enters an arched tunnel that leads to a smokestack close by. The small downdraft kiln used by Sōtarō Uno (*Fig. 43*) has no bag wall to deflect the flames toward the arched roof. For each firing, the kiln is stacked in such a manner that saggers of ware provide a temporary bag wall.

There are many very simple Raku or low-fire kilns in Japan. The Raku kiln is a cylinder, three feet in height, of loosely laid-up bricks or of special curved tile about two inches thick. If curved slabs are used, the

wall is of two thicknesses of slabs with a series of binding wires spaced at six- or eight-inch intervals around the outside. But when bricks are used, they are so laid that a four-inch thickness forms the wall (*Fig. 44*). The bricks are not cemented, but the outside surface of the cylinder is thoroughly plastered with fireclay mud. The firebox, overlaid with fireclay mud, is a brick tunnel that extends out two or three feet at ground level from an opening in the wall of the cylinder, usually about eight inches square. A cylindrical fireclay sagger with about a two-inch clearance between it and the wall of the kiln is inside the kiln. The sagger serves as a muffle and has either a flat or a domed lid with an opening through which the ware can be observed during the firing process.

Although similar in many ways to the Raku kilns, the small biscuit kilns do not have a complete muffle, and quite often biscuit sherds are used in lieu of lids simply by placing them on top of the ware that is to be fired (*Fig. 45*). It might be well to point out here, too, that wood is the only fuel used for either Raku or biscuit firing.

The construction of the kiln for making black Raku follows the same general plan as that for other Raku kilns (*Fig. 46*). But since more heat is required to fire the black Raku glaze, the kiln is smaller, and only one piece is fired at a time. In the early days of Raku ware production, a hand or foot bellows provided the forced draft for the higher temperature; today, the same result is achieved merely by attaching an electric blower to the firebox.

In recent years the electric kiln (*Fig. 47*) has been gaining wide usage in Japan, especially among the Kyoto art potters who produce overglaze enamel porcelain ware either commercially, or as art pieces (*see page 223*).

For centuries the Oriental has been educated to appreciate subtle differences: in the clay body itself, in body and glaze texture, in the color of the body and the glaze of his ceramic wares. He has also learned to admire and hold in reverence accidental results, especially those that occur during firing. This is universally true of what might be considered the native types of ceramic wares, those that hark back to their early prototype, the Sue ware. Later we shall see how the Japanese potter controls and uses accidental firing results to suit his taste for decoration, a tolerance generally restricted to wares for the tea ceremony and for flower arrangement.

The Clay

Among all of the world's potters there is probably none who is more conscious of the clay he uses than the potter of Japan. In the early days clay was very hard to transport, and therefore kilns were built at the sites of the deposits, at least one satisfying result being that a connoisseur, merely by looking at the bottom of a finished piece, could tell where it was made. Many of Ninsei's celebrated pieces were produced from a white clay found in the mountains near Kyoto. When the deposit was exhausted, he and, later, Kenzan were obliged to have their material transported from Shigaraki, on the far side of the mountains, by porters and horses.

But nowadays clay is easily brought to the potter's studio from distant places and, with the possible exception of the work of the *mingei* or rural potters and some tea-ceremony wares, Japanese pottery can no longer be distinguished as to origin simply by a brief examination.

There are only two words commonly used in Japanese to categorize clay ware—earthenware and porcelain—though some potters make a point of differentiating stoneware, as Hamada does. During the Tokugawa period, Shigaraki clay, having an overburden of quartz that was crushed with the clay, could be used for porcelain exactly as it came from the mine, and glazes fitted well. Now, however, if Shigaraki clay is used alone, the lime-glaze coating that the potters prefer for their porcelain wares crazes badly in large-mesh cracks. For this reason it has been the practice of Kyoto potters to buy a commercially blended body that the lime-glaze fits perfectly.

The earthenware bodies employed by most potters are natural clay bodies used just as they come from the clay deposit. Kumao Ōta of Koishibara has described how the preparation process for these clays is still done today in the more remote areas of Japan:

"The clay when dug is very soft rock that contains iron. After it is dug the clay is sorted for different grades. One grade is used for the front of the kiln, the lower part; another for the back, the top part. The light-colored portions of the veins are reserved for white slip.

"At present the village of Koishibara has twenty-five families, with

nine families making pottery. There are four six-chamber *nobori-gama*, with four families using two kilns and five families using the other two. Each of the nine families has two crushers, which are located on the stream that passes through the village. The canyon through which the stream passes is called Crusher Canyon. The crushers are made of pine trees that last about twelve years.

"A family can get about one ton of clay crushed in four days. In the morning and at sunset the potters check the crushers and add stone or mix the stone being crushed. The principle upon which the crusher operates is one of leverage. A vertical post is attached to the smaller end of a tree trunk to form a hammer that does the crushing. Usually some large rocks are firmly attached also to provide additional weight. Under the head of the hammer is located a large pit, which may be a bowl-shaped rock or a bowl-shaped pit lined with hard rocks. The clay to be crushed is placed in the pit.

"The large end of the tree trunk is hollowed out for a four- or five-foot length, forming a large bowl into which the water of the stream is diverted from a higher level (*Fig. 48a*). The fulcrum upon which the lever operates is the trunk of a small tree that passes through the crusher and is supported by four- to five-foot lengths of two medium-sized tree trunks, providing the bearing upon which the small tree trunk operates. As the water from the stream fills the bowl at the large end of the trunk, it tips, raising the hammer end of the trunk so that when the bowl empties, the hammer falls and crushes the clay (*Fig. 48b*).

"The operation is continuous. When the clay is crushed to the satisfaction of the potter, it next passes through a series of concrete settling tanks. Those at Ryūmonji are probably the most typical of the old system (*Fig. 49*). In the first tank the crushed clay is mixed with water, stirred thoroughly throughout the day, and then permitted to settle. All coarse gravel and sand settle to the bottom of the concrete tank.

"After another thorough stirring with a long paddle, the solution is dipped with a large, long-handled wooden dipper from the first tank to the second. As it is poured into the second tank, the solution is screened through a coarse wire screen that is covered with green pine branches. The process is repeated through four or five successive tanks.

"When the clay has reached the fifth tank, it is permitted to set, and

the water evaporates, leaving a thick smooth mud. The clay mud is then placed in biscuited drying bowls, where it remains in the open air until it is of proper consistency for storage in a concrete box with a wooden lid. Today, as it is stored, it may be covered by one or several layers of plastic before the wooden lid is placed in position."

In Kyoto, where demand makes it both practical and profitable, the clay is crushed, blunged (made into slip), and filtered commercially. The potter buys the commercial filter cake and lays it away in his storage box until he needs it. To use the clay, he first breaks it up into small pieces, pours a small amount of water over it, and beats it with a *kine*, a wooden mallet, until he obtains the plasticity and uniformity of texture he wants. Then he puts it through the *aramomi* or "press-wedge" process, a kneading movement (*Fig. 51*), after which the clay is stored for two or three days or sometimes a week. Just before the potter is ready to throw, the clay must pass through the *nejimomi* ("screw-wedge") process (*Fig. 52*), which produces a bullet-shaped mass from which all air bubbles have been removed and in which the granular structure is so arranged that it radiates from the center of the mass. Then the clay is ready for throwing.

The Glaze Materials

The Japanese potter's glaze materials can be divided into two categories: those that are indigenous to Japan and those that, through European influence, are common to Western and Japanese potters alike.

Native materials are more often than not, as at Koishibara, found only in one particular region. A good illustration of the materials used in a Japanese potter's glazes has been given by Kumao Ōta, who tells us that he and other potters in his district make their glazes from *akadani* stone (feldspar) taken from the mountains nearby, rice-straw ash from local fields, and common ash from their own fire pits, kilns, and hibachi. For black glaze they use iron hydroxide obtained from a coal mine in the region; for their green glazes, they use a material they call copper powder—probably an acetate of copper, since it is a dark, slightly brownish-green powder insoluble in water. The end of a copper bar is heated in the kiln and, when hot, is dipped into salt water. The salt water causes

a residue to settle from the copper, and the resulting powder residue is thoroughly washed and dried before it is ready for use in a glaze.

The potters of Ryūmonji follow a similar procedure. Hikaru Kawahara has explained the composition of their *iro-gawari* or transparent glaze in the following words:

"Three kilometers from Ryūmonji is a deposit of *tokusa*, which is of the nature of feldspar. One kilometer distant is *iwa* or *gun* (a combined silica and feldspar).

"These materials are dug as needed and carried by bar and basket to Ryūmonji, where they are crushed by a foot crusher. These two materials combined with kitchen wood ash, all in equal quantities, provide the transparent glaze. The black glaze is composed of ten parts of a natural iron oxide that is red and sandy and three parts of kitchen wood ash. For their green glaze they get copper oxide from an old pipe-maker who, in spite of the present use of iron and steel pipe, manages to make a living manufacturing bamboo pipe with copper joints. It is a matter of concern to the Ryūmonji potters that this kind of copper oxide is becoming very scarce. They may soon have to buy commercial copper oxide, which they consider inferior to their own copper powder."

There are a large number of other native glaze materials found in Japan, many of them more widely used than the ones cited in the accompanying chart. Glaze composition, however, is largely a regional situation, with the exception of those centers where Western technology has introduced such materials as barium carbonate, tin oxide, titanium dioxide, and other chemically pure ceramic glaze materials. Still, it is the use of the chemically impure native materials that has so much intrinsic appeal.

CHAPTER III

FORMING PROCESSES

WHILE pottery-forming processes are similar the world over, there are striking variations between one country and another. This is particularly true in Japan, where a feudalistic society protected the potters from outside influences and assured a continuation of practices, techniques, and processes still actively used today. Although, since 1868, Japan has patterned her political and economic life after the West, there is no reason to believe that the character of her art will not retain its essential integrity for many more generations. In many areas the thought processes of the West are still novel to the Japanese. Much may never be assimilated, and rightly so, but the concern with family, nature, tradition itself—the spiritual heart of a great people—these things have survived as living bonds uniting the people with their past.

Elbow-Forming

Probably the oldest technique of all is that of elbow-forming, used for the making of offertory vessels: small flat bowls or dishes, biscuited but unglazed, designed to hold oil for the lights that are placed before the shrines of the family gods. Tōtarō Sakuma of Mashiko says that at first leaves were used as containers; then models were derived from the shape of the hand, later the elbow, and, for larger forms, the knee. Sakuma points out that wares intended for offerings to family deities should have a physical basis. He says: "A potter's work must receive affection from his hands. All forms come from the human body. Many pottery forms are not made, but born of early ones."

There is a potter in Kyoto who still makes elbow-formed pieces, and the process could hardly be more artless. First she makes a flat pancake of clay, patting it between her hands. Then, holding it with her left hand, she shapes it by repeatedly bumping the clay against her right elbow until it is the form she wants (*Fig. 53*). After biscuiting, the bowl is filled with vegetable oil and put before the family shrine. The pithy center of the rush used for *tatami* mats serves as the wick.

Tebineri ("Hand-Pinching")

What the Japanese call *tebineri* or "hand-pinching" is one of the most interesting traditional forming techniques, employed for centuries and held in high esteem—a process in which a form is literally pinched from a ball of clay (*Fig. 54*). If a bowl with a rounded bottom is to be made by this method, a ball of clay the size of a small grapefruit will be held in the palm of the left hand and formed by the right hand. The thumb of the right hand is pressed vertically into the center of the clay to the depth the potter seeks; then the clay between the thumb and fingers of the right hand is pinched or squeezed firmly, forcing it to stretch. This pinching is repeated all the way around the bowl until a low, thick-walled cylinder emerges. The process is repeated a second time in order to reduce the thickness of the wall and increase the height of the bowl. Even pressure has to be maintained throughout the pinching process so that the pottery will have uniform wall thickness and height.

When the form is completed, it is inverted on a level surface, and a coil foot rim is attached to the base. If, during the pinching process, the clay has hardened somewhat, slip can be used to stick the foot to the bowl. Raku teabowls are made by this process. The pebbled, almost faceted surfaces and uniformly irregular lips are much admired by devotees of the tea ceremony.

Himò-tsukuri ("Coil-Building")

Japanese potters make many pieces of coil-built pottery, a technique developed long ago by the masterful potters of the Jōmon age, and as one might expect, there are some differences today, although minor, be-

tween coil-building in Japan and America. The American potter rolls coils between his hands and the flat surface of a tabletop; the Japanese potter rolls the coil between his two hands, held vertically (*Fig. 55*). Small coils are rolled by a very skilful manipulation of the fingers and the palm of one hand.

The base for a coil-built form is a ball-shaped wad patted out into a circular disc. As the first coil is pressed firmly into position by the palm of the right hand, the fingertips inside slide down, pushing some clay ahead to weld the inside joint; simultaneously, the thumb on the outside of the coil welds the joint on the outside with a wiping side-sweep of pressure (*Fig. 57b, c*). In Japan most coil-built pieces are scraped when leather-hard; in America the identity of the coil is often permitted to remain.

Tomimoto tells of very large coil-built pieces formed with the aid of a rather unique turntable or wheel:

"Some of these pieces, made on the island of Shikoku, are four or five feet high. The potter works on a wheel raised about three feet above the ground. He is assisted by a worker who lies on his side on the ground and turns the wheel shaft with his feet (*Fig. 12*). As the shape gets taller and larger, the potter shapes it with pressure from his hand inside the form, and his hip or side on the outside of the pot" (*Fig. 56*).

Some tea-ceremony wares are coil-built and are permitted to retain quite an irregular outside surface. Among such wares are the flower vases made by Chōtarō Ariyama, near Kagoshima in Kyushu.

Coil and Throw

At Koishibara, Onda, and Tamba, large bowls and jars are first roughly coil-built on the wheel, then shaped by throwing. The preliminary steps of the process are the same as for coil-building, after which the rough form is lubricated with slip and shaped between the potter's hands as the wheel revolves. This process dates back 360 years to the old Korean technique brought to Japan following Hideyoshi's invasion of Korea.

The Striking Process

The striking process, like coiling and throwing, is an old Korean method. Originally, in Korea, the form was roughly coil-built; then a straw pad or a pad of woven matting was used to beat the outside of the pot while the end of a short section of a tree branch was used inside as an anvil. Today, however, the coils are beaten between two blocks of wood. In *Fig. 57* the steps in the process are shown, as practiced by Tadao Nakazato.

Slab-Building

The slab-building process is one in which slices of clay are used to make ware. In Tokyo it is known as *sashimono* or "cabinet work"; in Kyoto, as *hari-awase*, "pasting together." The clay is first wedged and made into a block or mound at least big enough for the largest slab the potter needs. As soon as the clay is ready, it is placed on a flat level surface; then stacks of guide boards, the thickness of the desired slabs, are placed on two sides, directly opposite each other. A piece of fine copper wire held taut between the hands and resting on the guide boards is pulled through the clay, slicing it. After each slice is cut, a board is removed from the stack on each side of the clay. This is repeated until only the stack of clay slices remains (*Fig. 58a*).

The simplest way to make slab pieces is to hand-form the single slab. Many of the small flat plates used for serving the bean cakes accompanying tea are shaped by cutting square or rectangular slices to size, then bending the corners upward and permitting the clay to dry. When the slices are leather-hard or partly dry, the edges may be scraped or sponged to round them slightly. The piece is finished except for possible decoration and firing. Depending on the type of ware it is, it may or may not be glazed.

Hand-Pressing Single Slabs

Hand-pressing of a single slab of clay is only slightly more complicated than the hand-forming process. Many shallow rectangular bowl forms or

Fig. 53. Elbow-forming. This process could hardly be simpler. A handful of clay is patted into a small, fat pancake and then bumped against the bent elbow until the form spreads, thins, and is formed appropriately. The dish thus formed is then swabbed with a wet cloth. The potter pictured is the only one in Japan who now uses this process.

FORMING PROCESSES 105

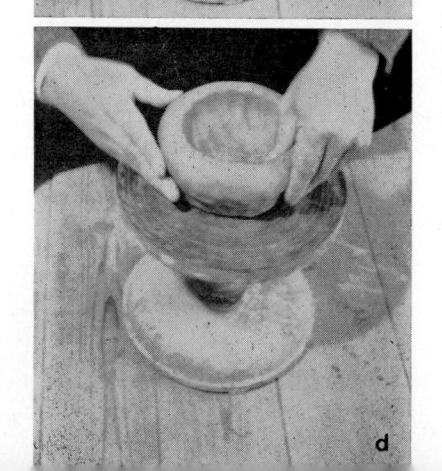

Fig. 54. The *tebineri* or "hand-pinching" technique is a process of literally pinching a form from a ball of clay. To make large forms, the pinching may be done with both hands.

Fig. 55. In making coil-built pottery, the Japanese potter rolls the coils between his hands, which are held vertically above the work being constructed.

Fig. 56. The versatility of the coil-building process is well demonstrated by the use of coils almost as thick as a man's arm in making these large pots on the island of Shikoku.

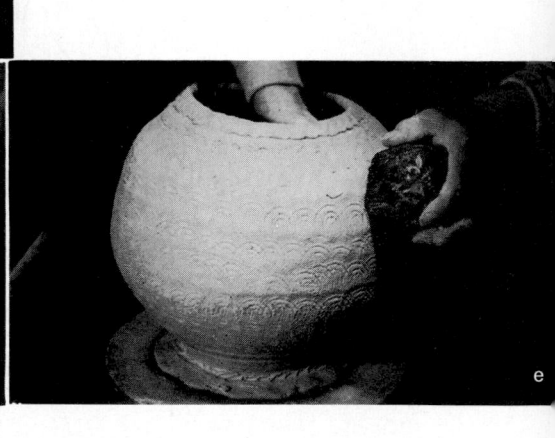

Fig. 57. Tadao Nakazato of Karatsu uses the old Korean striking process to produce outstanding examples of the potter's art.

(a) On the head of the kick wheel the potter uses a wooden paddle to form a pancake of clay for the bottom of the piece. Then he revolves the wheel and, with his fingernail, inscribes a circle in the clay the diameter of the base desired.

(b–d) The form is then roughly coil-built to the height of its shoulder.

(e) One block of wood is held against the clay wall on the inside. Both blocks of wood are carved to prevent them from sticking to the clay. The entire surface of the piece is beaten between the two blocks of wood to insure a complete union of the clay coils and to further develop the form.

(f) The neck of the form is then coiled and partly formed, and the wall of the piece is again beaten between the wooden blocks to develop the final form.

(g) When the body of the piece is completed, the neck is shaped and smoothed with a wet *naze-kawa* (chamois skin) as the wheel is revolved.

(h) A bamboo knife (*hera*) is used to remove excess clay from the base.

(i) The completed piece is removed from the wheel head.

Fig. 58. (a) The Japanese potter uses a wire pulled taut between his hands to cut slices of clay. Thickness is gauged by guide boards placed on opposite sides of the mass of clay.

(b) When slices are formed by hand, the edges may be supported by a coil of clay until the piece is leather-hard.

Fig. 59. A red Raku single-slab plate. The planed and faceted surface under the ochre slip, the carbon impregnated in a random pattern, and the free areas of gray Raku glaze combine with the casual shape of the plate to produce a controlled "spontaneous" effect.

Fig. 60. (a) Free assembly of slices is often used by members of young modern art groups to make sculptural forms. This one by Junkichi Kumakura is called "Contemplation of Space."

(b) Kumakura's "The Secret" is made from clay tubes that were formed from slices. The tubes were assembled and fastened together with slip.

Fig. 61. Square or rectangular porcelain bottles are usually cast and then individually decorated. The one shown here was made by Kiyoshi Suzuki.

Fig. 62. In this series of photos Hajime Katō demonstrates the throwing of a large bowl from a single ball of clay.

(a) Short sections of clay coil are used to attach a wooden platform to the center of the wheel head.

(b) The clay is wedged, made into a ball, and applied to the center of the platform with sufficient force to cause it to to adhere firmly.

(c) The potter centers the clay with uniform pressure from both hands clasped around the ball.

(d) With the fingers of the right hand in the well and the right thumb on the outside of the ball, the left thumb inside, and the fingers of the left hand on the outside, the potter spreads the ball of clay.

(e) With the right hand inside and the left hand outside, the clay is pulled up into a slightly flaring cylinder.

(f) The bowl is roughly shaped by the potter's hands.

(g) A large *kote* is used to smooth the inside and to further shape the bowl.

(h) As the bowl spreads, becoming wider and more shallow, a different-shaped *kote* is used to develop the final form.

(i) The rim of the bowl is smoothed with a wet *naze-kawa*.

FORMING PROCESSES 113

Fig. 63. For tall and narrow-necked forms, the *egote* is used to apply pressure from the inside as the piece is formed.

Fig. 64. The versatile *kote* is also used as a decorating tool at Ryūmonji.

Fig. 65. (a) For small bowl and cup forms, only the top two or three inches of the mound of clay on the wheel are centered.

(b) With his thumbs inside and the fingers of both hands on the outside of the ball of clay, the potter pulls up and shapes the form.

Fig. 66. Tōtarō Sakuma of Mashiko throwing a teapot body,
lid and spout from a single mound of clay.
 (a) Only the top of the mound of clay is centered.
 (b–c) The thumbs are used to start and deepen the well.

(d–f) A lip is formed on the thick-walled cylinder and an *egote* is used to pull
up the walls and shape the form.

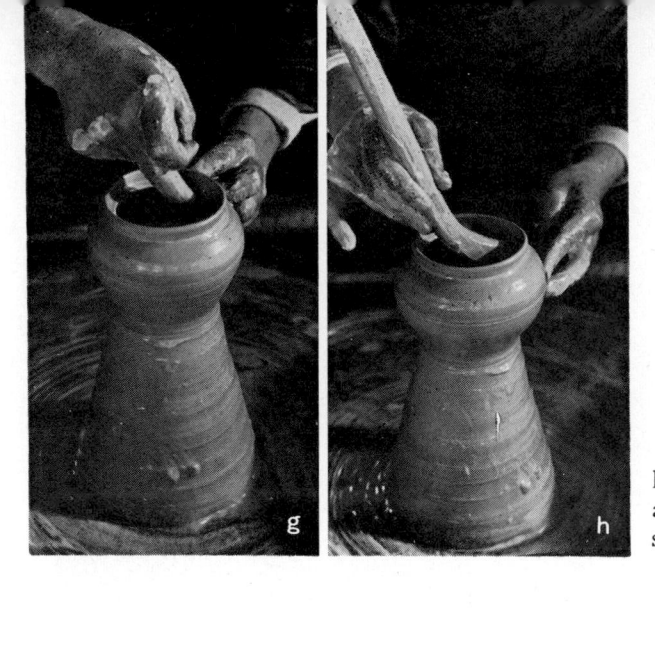

(g–h) The inner lip to support the lid of the teapot is formed with one finger, and the *egote* is used to finish the inside shaping.

(i–k) The surface of the piece is smoothed with a *naze-kawa*, and the pot is cut and removed from the mound of clay on the wheel.

(l) The lid of the teapot is thrown next.

(m) Trimming the lid to size with a cutting cord. Sakuma determined the size of the lid by visual inspection only.

(n–o) The top of the clay remaining on the wheel is drawn up into a hollow, narrow, pointed cone.

(p–q) A pointed *yari-bera* ("spear" *hera*) is used to form both the inside and the outside of the teapot spout and to cut the completed spout from the clay remaining on the wheel.

FORMING PROCESSES 117

Fig. 67. On the jigger wheel, the plaster mold forms the outside of the plate, while a wood and metal profile removes any excess clay to form the inside contour.

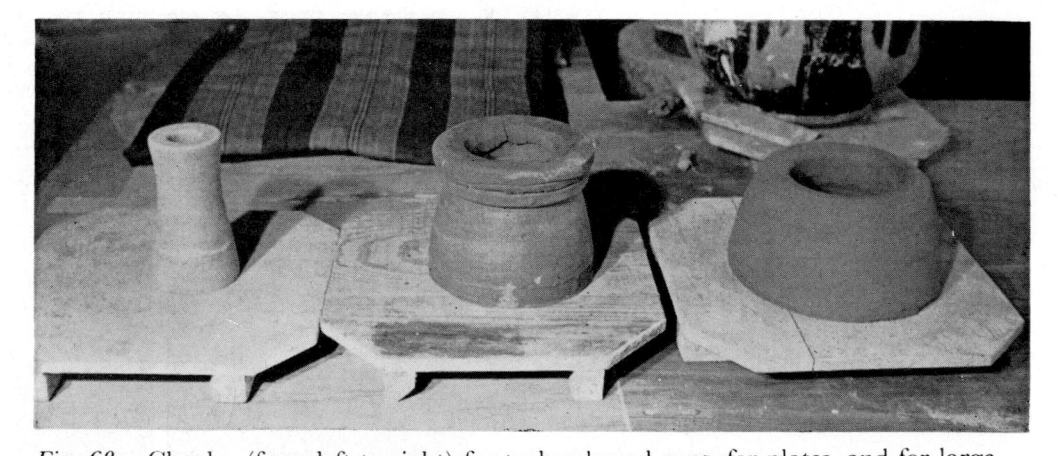

Fig. 68. Chucks. (from left to right) for teabowls and cups, for plates, and for large, wide-mouthed bowl forms.

Fig. 69. Toyozō Arakawa trimming a Shino teabowl.

(a) A chuck of the appropriate size is thrown.

(b) The leather-hard teabowl is inverted over the chuck and the shape is refined by planing with a *hera*.

(c-d) The foot shape is roughly cut with a *kanna* and then refined with the edge of the *hera*.

(e) A slender bamboo *hera* is used to carve out the center of the foot.

(f) The piece receives a final refining trim with the same slender *hera*.

square and rectangular cake plates are made by hand-pressing slabs or slices of clay into molds of slight depth. The slices are roughly cut to size; then, while still plastic enough to take the shape without cracking, they are firmly pressed by hand and the edges trimmed level with the edge of the mold. After they have dried long enough to retain their shape, the sharp edges are rounded by scraping or sponging.

When slices are not used, the clay may be beaten with a wooden paddle into a slab between two pieces of cloth. This procedure would be used for clay that is too soft to handle alone without losing its shape. After the slab has been formed, it is lifted into the mold by holding the cloth at the edges, then pressed by hand to the shape of the mold. When the clay has hardened sufficiently, the top piece of cloth is removed, and the edges are trimmed and scraped or sponged. The remaining cloth is used to lift the piece from the mold. At times, slabs so formed may be shaped by hand. If they are large slabs, the upward-bent edges may be supported by a coil of clay until they become leather-hard (*Fig. 58b*).

The Waraku Kawasaki workshop in Kyoto uses the drape mold for forming Raku plates. The drape mold is a low hump of plaster that forms the inside contour and the rim of the plate. First, a slice somewhat thicker and smaller in diameter than the finished plate is laid on the mold, and a piece of cotton cloth larger than the finished plate is put over the slice. The center portion is then beaten with a wooden paddle, and the sloping sides are pounded with the heel and palm of the hand.

When the form is completed, the edges are very solidly pressed into position with the thumbs. Next the cloth is removed, and the sides are again pounded with the palm of the hand so that the clay thickens and extends beyond the rim of the plate. With a wooden knife, the excessive thickness is sliced away to the contour of the mold. The cloth is put back over the form and once more pounded with the palm of the hand. Then, the cloth is removed and, using just enough pressure to cause it to stick, the potter presses a wad of plastic clay onto the center of the bottom of the plate. He then grasps the clay wad and, with a rocking motion of his hand, loosens the plate from the mold.

When the plate is loose, the wad of clay is taken off with a twist of the wrist, and six or eight small filbert-sized wads of clay are pressed against the bottom of the plate. A plaster bat is placed on top of the small wads,

and the plate is turned out onto the bat. The small wads will now loosen as the plate dries, and can be brushed off. Pieces made from a single slab are simple and uncomplicated and quite often possess great charm (*Fig. 59*).

But there are more complex forms, such as square, rectangular, octagonal, and hexagonal bottles, boxes, bowls, and trays, that used to be made by assembling and luting (that is, sticking together with slip) slices of clay. But cracks often developed at the joints either during drying or firing, and today the majority of such geometric forms are either pressed or cast in plaster molds.

The assembly process, however, has been adopted by young modern art groups whose primary interest is in making sculptural objects. Junkichi Kumakura's "Contemplation of Space" is an excellent example of assembling slices (*Fig. 60a*). Describing his method, he says that he first cuts slices and then experiments with various sizes of angles until he has the composition he likes. He lets the angles dry until they will hold their shape, then sticks them together with slip. The sculpture is assembled, dried, and fired lying flat. Kumakura's "The Secret" (*Fig. 60b*) is assembled in the same way from clay tubes or pipes that have been made from slices.

Hand-Pressing in More Complex Molds

Formerly, the cracks that developed in the corners of many geometric forms when they were made of slices of clay luted together discouraged and frustrated the potter, and hand-pressing generally supplanted the old method.

Perhaps the best examples of hand-pressing in molds are the famous square and rectangular bottles of Shōji Hamada and Kanjirō Kawai (*Plates 18, 21*). Made by pressing slices of plastic clay into plaster molds, the shape of the ware will determine the number of pieces the potter needs.

Most bottle forms are worked out from a three-piece mold that breaks or parts diagonally across the form, the third piece being used to make the bottom, and thereby permitting two sides to be pressed and joined in each half of the mold (*Fig. 24*).

The joints are sealed and, if necessary, the corners reinforced with a

coil firmly pressed and welded into position. The two halves are then assembled, but before the bottom is pressed, the joints made by the two halves are sealed from the bottom. Finally, the bottom slice is pressed and a thick slip used to stick it to the form. Hamada says he simply gives his pieces a "good, hard pressing, and very few joints crack," adding that the kind of clay with which the potter works has much to do with successful pressing.

Casting

Casting of slip in plaster molds is used by some potters who operate their studios as small factories and turn out square or rectangular bottles, bowls, and boxes of porcelain, but now and then an individual potter will make use of it for rectangular and square bottles (*Fig. 61*).

The process is one in which the slip is poured into an absorbent plaster mold; the water is absorbed out of the slip and builds up a thickened wall around the inside of the mold. When the wall has been built up to the desired thickness, the remaining slip is poured out. As the mold dries, the clay form shrinks and cracks loose from the inside of the mold. As soon as it has loosened completely, the hollow clay form is removed. Then the joints are scraped and sponged, and the piece is ready for firing.

Carving-Out

The potter who works with porcelain usually throws his pieces on the wheel, but when they are not circular, he may choose to make them by the *hori-dashi* or "carving-out" method. In making a carved-out piece, the potter forms his block from plastic porcelain that contains some rough sand to facilitate drying. All shrinkages have been considered, and the block is appropriately oversize for the finished product.

A framing square and a try square are used to check the block so that all sides are true; then the block is put in a dark place to age. Two or three times during the ageing process the block is beaten with a wooden paddle in order to bring the moisture in the clay to the surface. When the block is ready to be carved, all of its surfaces are checked again for

squareness. If still not perfectly true, it is planed with a wood plane and scraped with steel scrapers until exact. Then the portion of the block that is to form the lid is removed with a wire and the piece is carved with a *kanna*. A carpenter's marking gauge marks the wall thickness, lid flange, and foot rim on the block. The form, lid, and foot are hollowed out, but all finishing is done with the steel scraper, never with sandpaper.

Throwing

"Throwing on the potter's wheel" is a more expressive way of saying that the potter forms his ware by manipulating the clay with his hands as it revolves on the wheel head. Although today every individual potter has to master the throwing process for himself, its widespread adoption is a fairly recent innovation, dating back only some fifty years to when Leach and Tomimoto set out to acquire the skill and for their efforts were roundly laughed at by the so-called potters of the day. In those days throwing was considered a menial job, unworthy of the potter's attention; nowadays, it is, so far as the lay world is concerned at any rate, the potter's most exciting task, though Leach's and Tomimoto's purpose was altogether germane to the art itself. Still, it may be considered dramatically. Take, for example, the Japanese potter's everyday business of making a single piece from a ball of clay on a power wheel that turns clockwise. The process is illustrated in *Fig. 62.*

In the beginning, the prepared ball of clay is dropped with sufficient force onto the head of the wheel so that it will adhere firmly to the wooden surface. The potter sits cross-legged on a bench, level with or slightly above the wheel head, and applies slip to the surface of the clay; he centers the clay on the wheel, clasping it with both hands and applying uniform pressure.

As soon as it is centered, he forms a hole, called a well, in the top center of the ball with a downward pressure from the ends of both thumbs; meanwhile, the fingers of both hands are clamped around the revolving clay. The potter leaves enough clay between the ends of the thumbs and the wheel head to form the bottom of the piece. Then as soon as the well is the depth he wants he applies outward pressure from the ends of the thumbs, which begins to spread and stretch the ball.

Slip is again applied to both the inside and outside surfaces, and the position of the hands is altered: the thumb of the left hand in the well, the fingers of the left hand on the outside surface of the ball; the fingers of the right hand in the well, the thumb of the right hand on the outside of the ball. The clay ball is stretched and spread until the bottom of the well is the desired diameter.

Now the clay in the ball is pulled up into a cylinder, stretched and thinned upwards, the right hand inside, the left outside, using the tips of the fingers to apply pressure as the hands are brought upwards. When the cylinder has reached the height and wall thickness the potter wishes, the piece is shaped: tall, wide-mouthed forms with the *dango* held in the right hand and used to apply pressure from inside while the fingers of the left hand support the clay on the outside against too much pressure; tall and narrow-necked forms with the *egote* (*Fig. 63*); bowls or plates, which are made from wide and low cylinders with relatively thick walls, with the *kote* (*Fig. 62g, h*). The *kote* can also be used for decoration (*Fig. 64*).

For small bowl and cup forms, however, the Japanese use a throwing process—frequently just with the left hand—that is unique to the Orient. A large quantity of clay is smacked and patted into an approximately centered conical mound on the wheel head, and, with the wheel spinning, only the top two or three inches of the mound is centered (*Fig. 65*).

Quickly, the potter centers the clay and with a deft turn of the wrist depresses the center of the top with the knuckle of his left thumb, thus starting the well. Next he inserts the thumb of his left hand and, with the clay between the thumb and fingers, makes the well the depth he desires. With the clay passing between the thumbs inside and the fingers of both hands outside, he pulls up the cylinder with an outward and upward motion and shapes the form—all in a single operation. Then, with the thumb and the first finger of the left hand, he makes a deep groove below the intended foot of the piece, cuts it loose with a cutting thread, and sets it off to one side. The process is repeated a number of times until all of the clay has been used (*Fig. 66*).

Jigger Wheel

The *kikai-rokuro* or jigger wheel is restricted to mass production. Here the mold is made to fit firmly and solidly into the bowl-shaped wheel head, and as the wheel head revolves, the mold turns as an integral part of the wheel. The mold can form either the inside or the outside contour of the piece to be jiggered.

The molds for plates provide the outside contour of the form, while a wood-and-metal profile template is used to scrape away excess clay and provide the inside contour (*Fig. 67*). Plates are made from slices pressed and patted firmly against the surface of the mold. After a complete bear-ing surface is assured, pressure is again applied to the clay surface while it is wiped with a wet sponge. Then the template attached to a movable arm is pulled down to scrape away excess clay and complete the form.

At the Noritake factory in Nagoya such forms as cups are first thrown as thick-walled cylinders on the potter's wheel. The cylinders are taken to the jiggerman, who drops them, one at a time, into a mold that forms the outside contour of a cup.

With one motion of his hand, the jiggerman spreads the clay against the plaster wall of the mold and with the other pulls down the template that removes excess clay and forms the inside of the vessel. The mold with the cup form in it is brought from the wheel to a moving belt that carries it to a dryer; in a good leather-hard condition, the cup is removed and a handle attached. Meanwhile, the mold is ready to be used again.

Trimming

Trimming (*kezuri*) serves several purposes: removing excess clay, estab-lishing the bottom thickness, as well as the size and shape of the foot rim, and refining any parts of the form. When the Japanese potter throws a pot, he also throws a chuck that he uses later on when the piece is leather-hard, sufficiently dry to handle without losing its shape, and ready to be trimmed (*Fig. 69a*). For bowls and plates the chuck is a wide, low, thick-walled cylinder over which the form will fit, the cylinder

supporting the inside bottom of the piece and holding it above the wheel head (*Fig. 68*).

The chuck is centered on the wheel, fastened to the wheel head with a coil of plastic clay pressed firmly around its base. The bowl is inverted over the cylinder and centered by smacking it two or three times with short, quick slaps of the palm of the hand on the side that extends beyond the chuck.

After the bowl is centered, the bottom is given two or three firm pats to make sure it is seated properly; then it is ready to be trimmed. All excess clay is removed first (*Fig. 69*), thereby determining the diameter of the foot and providing the roughed-out contour of the lower part of the form. The center of the bottom is then recessed, resulting in a raised foot rim whose edges are rounded to prevent chipping. Finally, all finishing cuts are made on the outside contour, and the piece can now be dried and fired.

Pieces with narrow necks are centered inside a tapered, somewhat funnel-shaped chuck, but the trimming process is the same (*Fig. 68*).

A word, however, might be said of the *kanna*, the tool used in trimming. Filed to the shape and cutting edge desired by the potter, it is held so that the filed knife edge cuts rather than scrapes the clay.

CHAPTER IV

DECORATING PROCESSES

Decoration Resulting from the Forming Process

OFTENTIMES the techniques employed in the forming process result in the decoration or ornamentation of the ware itself. In any study of the decorating processes of modern Japanese potters, one perhaps should begin with those techniques that are used either knowingly or unwittingly, yet provide decoration on the surface of a piece after it is formed.

The Striking Process

In early times the Korean potter used a pad of straw or matting fitted to his right hand to beat the outside of a coil pot; later on, a wooden paddle, either carved or wrapped with cord to keep it from sticking to the clay, replaced the straw pad, the markings serving as decoration in both instances.

Today, however, two blocks of wood or a block of wood and a carved wooden paddle are used (*Figs. 31, 57e*). The potter starts with a thin pancake of clay on the wheel, then marks a circle of the desired diameter for the bottom of the pot by turning the wheel and holding his fingernail on the clay surface. The piece is built with coils to its approximate size and shape, but before the neck is shaped the entire surface of the piece is beaten with a paddle or with one of the two wooden blocks, the other acting as an anvil inside.

This first beating assures complete adherence of all the coils and prevents cracks from developing later. The neck is constructed from coils

and the piece beaten again to achieve its final form, though the neck itself is not beaten but rather smoothed by the wet *naze-kawa* or chamois leather. Using a wooden knife, the potter removes the excess clay surrounding the base, and the piece is now ready to be dried and fired.

Squeezing and Pressing

Squeezing or pressing the form after it is thrown and partly dry also appears to have originated in Korea. When it is leather-hard, two opposite sides are pressed and flattened, and sometimes a wooden paddle is used to make a more uniformly flat surface. The bottles by Shimaoka seen in *Fig. 70*, for example, were first pressed and then paddled.

Many of the early pieces most highly regarded in the tea ceremony were those to which some accident had occurred during either the forming or the firing process. Frequently too much pressure was exerted when the ware was lifted from the wheel, causing the side to be indented, or too much heat during firing would cause the clay on one side to soften, thus producing a distorted shape.

But since such imperfections were valued, the potter, in turn, deliberately impressed one side of a piece with his thumb as he removed it from the wheel. The piece shown in *Fig. 71* is a modern example of conscious distortion taken, perhaps, to its full extreme.

Impressed Trimmings

The pressing of trimmings (shavings of clay) onto the surface of the unfinished pot is a process found among the *shudei* ("red clay") teabowls made at Tokoname. A pottery village of the Chita Peninsula, Tokoname is in an area that has mountains of clay. At the beginning of the Meiji period, Chinese specialists were imported there to teach the red-clay technique. Many of the small factories in the area today make clay pipe and tile, their workmen chipping the clay with iron wedges and sledge hammers from the mountainsides only a few feet away. Individual potters, however, make use of a clay from under the fields.

The clay is very plastic, sticky, and fine-grained, having a very high shrinkage (over thirty percent) during drying and firing, and for this

reason requires great skill in throwing and trimming. Any irregularities in wall thickness will cause distortion of the finished form.

The teabowl shown in *Plate 6* would seem to contradict the above statement. However, the fact that it is a teabowl influenced the potter to deliberately produce the casual inaccuracy. In fact, it was thrown with great accuracy and then permitted to dry until hard enough to trim—that is, until the clay was no longer sticky and the form was hard enough not to lose its shape when handled.

After trimming the form, but before trimming the foot rim, the potter coated the outside of the piece with slip; then he scooped up some of the trimmings (similar to shavings of wood) in both hands and stuck them to the slip on the surface of the bowl. The rim was next thinned by pinching it, and at the same time it was bent outward in order to develop the "accidental" irregularity prized by devotees of the tea ceremony.

When the piece was completely leather-hard (in other words, when forty to sixty percent of the moisture had evaporated), it was polished with a soft and very smooth cloth, and then the foot was trimmed. When dry, it was fired once but was not glazed. *Shudei* wares are never glazed.

Cloth-Texturing

Nunome ("cloth-texture") is representative of a very old Oriental process that may have its origins in the pressed forms of Korean pottery, since these suggest the possibility that the potter's hands were covered with cloth or that matting pads were used to prevent the clay from sticking to the hands when the form was pressed. (Earlier Chinese pieces show cloth texture, indicating that perhaps a cloth pad was used at times during the beating or striking process instead of a straw or matting pad.) Later, to make clay slabs for square or rectangular pieces, the clay was beaten out by hand on a piece of cloth that prevented it from sticking to the table surface. The small plate shown in *Fig. 72* was beaten between two pieces of cloth and then pressed into a mold or hand-pressed with these cloths left in place. The cloth texture provides a background for brush decoration.

Slumping

Slumping means that some part of the pot has sagged, thus distorting the shape. The phenomenon of a slumped pot is not new to the Western potter. Still, for him to find it esthetically desirable and for him to deliberately work to achieve slumping would run counter to his philosophy as a potter. Slumping will result naturally from one of three causes: lack of understanding of the material, lack of ability to work with the material, or lack of understanding of the firing process of the kiln. Tōyō Kaneshige of Bizen tells us that the first Bizen slumped pots were accidental results of firing. He explains:

"Bizen clay is a reddish clay, which indicates a fairly high iron content of 3.2 percent. The method of stacking Bizen clay bottles is to lay them on their sides and stack them as cordwood is stacked.

"Bizen ware is never glazed except by natural glaze effects resulting from firing. Since no glaze is used, the potter wants a good hard fire for his ware (cone 10 to 11), often firing seven days and nights to achieve the degree of vitrification he wants.

"The more vitreous the clay becomes, the weaker any thin spot in the form becomes. As a result, in a long-necked form the weight of the neck resting on one side of a thin shoulder will sometimes cause that shoulder to sink inward or fold over on itself, and the neck will tip toward one side of the form. The tea-ceremony people have found this accidental kind of form attractive, and the resulting demand has caused a greater number of potters to deliberately distort their wares while forming them" (*Fig. 73*).

Rib-Marking and Stretching

If a study is made of many of the Japanese decorative arts, an absence of symmetry will be found. The piece shown in *Fig. 74* is a strong, vigorous shape in which the regularity of the skilfully thrown form has been eliminated by the casual sweep of a rib over the liberally slipped surface of the pot. The result not only eliminates the regularity of the form but also provides an interesting variation of line and texture.

It would not occur to most Western potters to make a piece and then wait until the clay had hardened to the point where stretching it would cause it to crack. But the Japanese potter will sometimes decorate a pot by waiting until it is sufficiently dry to cause the outside to separate in fissures when pressure is applied inside.

Burnishing

Burnishing—that is, achieving a hard body without glaze—is the process by which a glossy or a shiny surface is produced through rubbing. Gen Asao, also known as Sōzen II, is a master of this technique. In 1944, the Japanese government appointed him technical expert and preserver of the art of *unka* ("cloud-flower") ware. He explains that, although he was able to study pieces of this ancient pottery, he still had to develop his own techniques for its production. He describes his work as being like biscuit (once-fired clay) work. He uses earthenware clay, obtained near Kyoto, which fires satisfactorily at a low temperature. But if he wants to make elegant, warm, soft wares, he uses natural clay as it is found. Sometimes he uses white clay and adds varying amounts of ochre clay for red or yellow ware.

Unka ware is named for the so-called cloud (*un*) and flower (*ka*) pattern produced on its surface through carbon impregnation. The ware is first coiled, then thrown on the wheel to avoid any possibility of cracking. When it is half dry, it is polished with a very smooth pebble from the foot of a waterfall. This burnishing presses the clay particles more closely together, causing the surface to become smooth and glossy. The ware is fired in a temperature range from 600° to 900° C., and the cloud-flower pattern results from the firing (*Fig. 75*).

Tomimoto explains two ways of securing the carbon impregnation that produces the decoration. The first is the use of an overreducing flame creating a very smoky atmosphere in the kiln during firing. To get the cloud-flower decoration by this process, the pieces being fired must touch each other so that the carbon impregnates the clay at these points. The other way is to remove the pieces from the kiln while they are quite hot and, as soon as they are taken out, to touch or rub the surface with a wad of cotton that has been dipped in vegetable oil. The oil soaks into

the pores where, as it burns, carbon is entrapped. The entrapped carbon is the cloud-flower.

Burnishing with a pebble is the technique that has been used for many years by Maria Martinez, a Pueblo potter, at San Ildefonso in New Mexico.

The Tokoname potters burnish their *shudei* (red unglazed) pots with steel. As has already been mentioned, the *shudei* pots are made of clay that is dug from under the fields. It includes natural iron, but since the potters want a strong red color they add iron oxide to the clay. After mixing, the clay is screened wet, then dried to the desired plasticity for throwing.

When the thrown ware is leather-hard, it is very carefully trimmed, and following the trimming process the pieces are burnished with metal tools. The burnishing procedure is to press a flat, smooth metal surface against the clay as the pot revolves on the wheel.

Not all clay can be burnished, but that used by Rakuzen Asai and the the other Tokoname potters is very fine-grained, and pressure from the smooth metal surface presses the particles more closely together to produce a shiny surface on the clay (*Plate 5*).

Asai explains that the firing process is somewhat complicated, since there is no biscuit firing and the clay is so fine-grained that breakage is a constant danger. At first the kiln is stacked and fired from five to seven hours with empty saggers. This dries the saggers and prevents breakage when the ware is fired. Then the ware is stacked in the saggers while they are still hot. The kiln, an eight-chamber *nobori-gama*, is fired by a very slow oxidation fire until the desired temperature has been reached.

The oxidation firing schedule calls for thirty minutes' firing without flames in the kiln, then for the addition of wood every thirty minutes until firing is completed. Wood is used for the firing of all *shudei* ware.

Firing takes eight days, and the kiln cools for ten days. When the ware comes from the kiln, it is polished with very fine sandpaper and is then ready for sale.

Cord-Cutting

The twisted cutting cord, when used by a skilful potter, provides a shell pattern on the bottom of the pot. Tsunezō Arao, a Kyoto potter, a member of the *Mingei* Association, and a former student of Kanjirō Kawai, makes use of the cutting cord in a unique manner (*Fig. 76*).

The plastic clay is centered in a solid cylindrical column on the wheel, the diameter of the clay column being the diameter desired for the plates to be made. As soon as the clay is centered, the wooden handle of the cord is grasped in the left hand and held directly in front of the potter's body. With the other end held in the right hand, the cord is stretched taut and held against the revolving clay column to inscribe a groove about 1/8 inch deep. Just as soon as the groove diameter is complete, the end of the cord in the right hand is loosely flicked against the column, where it adheres and is carried around as the clay revolves.

When the revolving clay column has carried the end of the cord one-half to two-thirds of a turn around, the wooden handle is quickly pulled toward the potter, pulling the cord through the clay column and cutting a slice from the top. The slicing process is repeated the full length of the column, spacing the cuts the desired distance apart for slices of appropriate thickness. As soon as the slices have hardened enough to handle without damage to the cord pattern, they are pressed by hand into a shallow plate mold.

Wire-Cutting

Cutting slices with an expanded wire spiral—a nichrome heating element, or a screen door spring—is a method used by Shindoku Tsuji. Tsuji is a graduate of the Tokyo Institute of Technology, and for some years after graduation worked as an engineer in a factory. Like Hamada and Kawai before him, he became interested in pottery as a creative outlet, then left the factory to start his own studio. He feels that he has an almost neoclassic style to which he has added his own expression. He does not feel that he is a *mingei* potter, though some people consider his work as being in the folk art idiom.

In making a wire-cut platter (*Fig. 77*) from a slice of clay, Shindoku prepares a rectangular or cylindrical block of clay the size of the desired platter. Then, using guide boards of the proper thickness for the finished piece, he cuts slices, alternating a straight piece of wire held taut between the hands and an extended coil of nichrome wire. The wire-cut platters can be pressed by hand in shallow tray molds or be formed by hand. If pressed, the smooth side of the slice is pressed against the mold, with the wire-cut pattern forming the inside surface of the platter.

Neriage (Clay Mosaic)

Tsuneji Ueda, also a student of Kanjirō Kawai, calls *neriage* a clay mosaic. In many respects it resembles mosaic: the pattern usually covers the entire surface of the main body of the piece and is the same on the outside as on the inside. Ueda describes the process as one of layers of different-colored slices of clay pressed firmly together. The stack is cut vertically, placed on a cloth, and the surface of the variously colored slices firmly rubbed together with the palm of the hand. The clay is then turned over and rubbed as vigorously on the reverse side. The slab of different-colored clays thus produced is finally pressed in a mold. The resulting piece is a *neriage* product (*Fig. 78*).

Arao speaks of his process as alternate-colored clay coils pressed together and cut in sections. The sections are then pressed in a mold (*Fig. 79*).

The different-colored clays used must have the same shrinkage and firing characteristics in order to avoid their cracking apart during drying and firing. The process as shown in *Fig. 81* combines a low-fire, white earthenware clay with a portion of the same clay stained to provide a brown body. The two colored clays are cut into thin slices, the slices of white clay being two-thirds the width of the brown slices. A white slice is placed between two brown ones, and they are pressed and paddled firmly together. The layered slices are next alternately folded and pressed firmly together. The folded slabs are then placed on end and sliced. Finally, the small slices are pressed into a mold to form a bowl.

Fig. 70. These bottles by Shimaoka of Mashiko were first thrown and then pressed and paddled on opposite sides to flatten them into oval forms.

Fig. 71. A vase for flower arrangement by Toyozō Arakawa. Conscious distortion is carried to its natural and artistic limit. The production of successful distortion of this kind, whether conscious or accidental, can be considered one of the real challenges and adventures of the potter. The vase pictured is in the collection of Sōfu Teshigahara, head of the Sōgetsu School of Flower Arrangement.

DECORATING PROCESSES 137

Fig. 72. A small cake plate shows cloth-impressed texture on both its inside and its outside surface. The cloth texture provides a background for brush decoration.

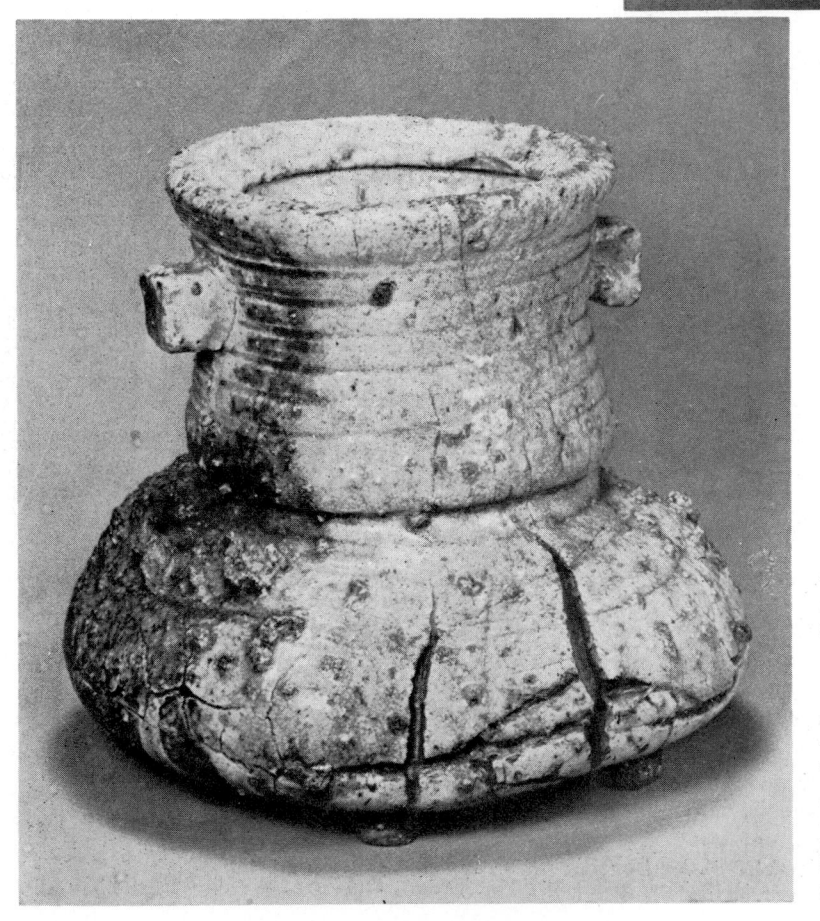

Fig. 73. The long, hard firing given Iga pots often resulted in natural distortions of the form. This "old" Iga tea-ceremony water container has been given the name "Torn Pouch." The piece is in the collection of the Gotō Art Museum, Tokyo, and is a registered Important Cultural Property.

Fig. 74. In this strong, vigorous porcelain pot by Ryūzō Asami, the regularity of the skilfully thrown form has been eliminated by the casual sweep of a rib over the slipped surface.

Fig. 75. The "cloud-flower" decoration of *unka* ware is seen in this burnished vase by Gen Asao.

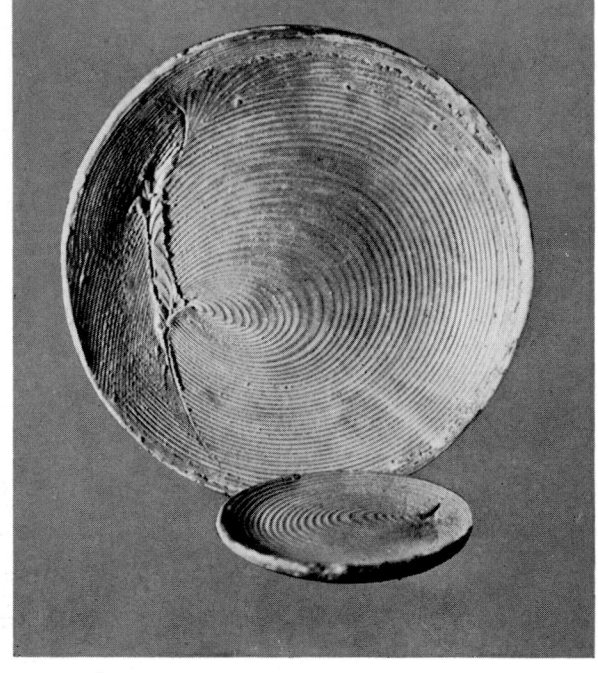

Fig. 76. Tsunezō Arao, a Kyoto potter, makes use of the cutting cord in a unique manner, as displayed in these plates.

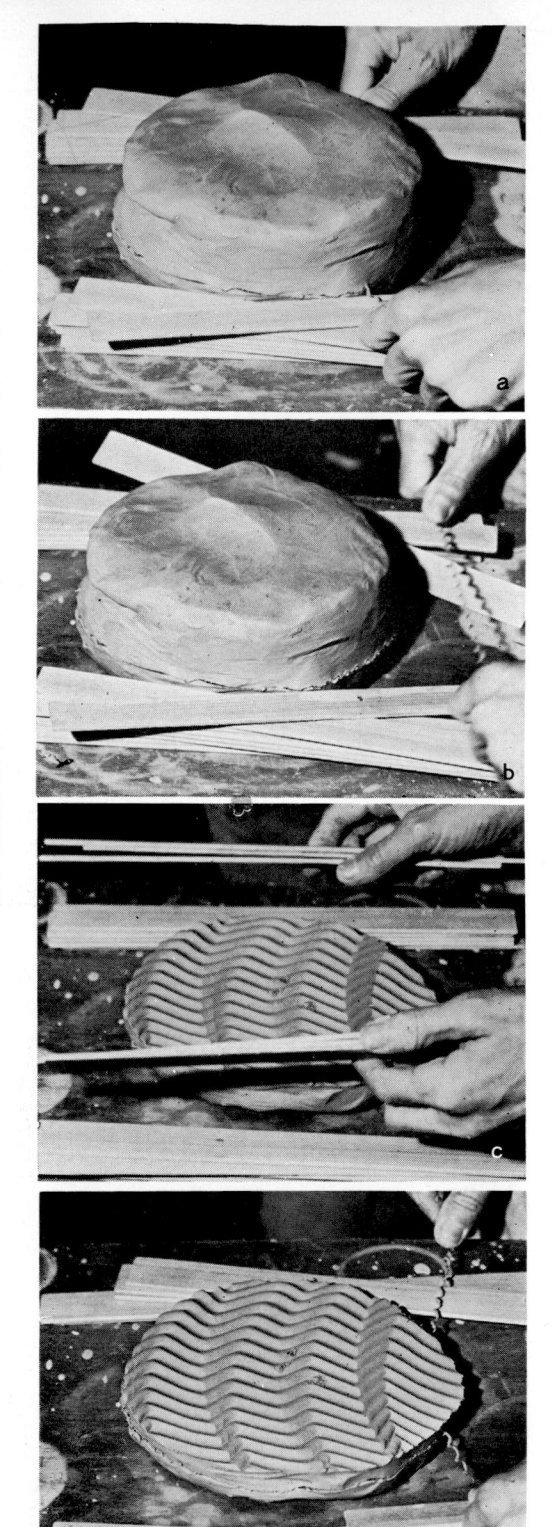

Fig. 77. In making wire-cut platters, Shindoku Tsuji prepares a block of clay the size of the desired plate. Then, using guide boards of the proper thickness for the finished piece, he cuts slices, alternating a straight piece of wire held taut between the hands and an extended coil of nichrome wire.

Fig. 78. This piece by Tsuneji Ueda was made by the *neriage* process, which he describes as the use of layers of different-colored slices of clay pressed firmly together.

Fig. 79. Tsunezō Arao speaks of his *neriage* technique—displayed in this bowl—as a process in which alternate-colored clay coils are pressed together, cut into sections, and then pressed in a mold.

Fig. 80. Ichirō Kimura of Mashiko uses the *neriage* process to make bottle forms.

144 JAPANESE CERAMICS

Fig. 81. The *neriage* process as shown in these photos combines a low-fire, white earthenware clay with a portion of the same clay stained to provide a brown body.

 (a) The two colored clays are cut into thin slices.

 (b) A narrow white slice is placed between two brown slices, and they are pressed and paddled firmly together.

 (c) The layered slice is alternately folded and pressed together.

 (d) The folded slabs are placed on end and sliced.

 (e) The slices are pressed into a mold to form a bowl.

Fig. 82. The new *neriage* process by Kunio Uchida, as shown in these pieces, employs a technique in which sliced coils of colored clay are pressed into the surface of a partly thrown form, after which the final shaping is completed on the wheel.

Fig. 83. A teabowl from the Asahi kiln at Uji showing *ishihaze* ("stone-explosion") decoration. Small pieces of rock in the clay explode, producing miniature mountain peaks on the surface of the finished piece.

Fig. 84. A vase by Shimaoka of Mashiko showing the *goma* ("sesame seed") iron-spot decoration that occurs naturally with the iron-rich clay of Mashiko. Potters in other parts of Japan add an iron-bearing rock to the clay to produce a much more densely spotted *goma* decoration than the example pictured here.

Fig. 85. Iron-spot *goma* can also result from an additive to the glaze as well as to the clay body. With this piece by Shigeya Iwabuchi of Kyoto, oak leaves were burned in a large iron drum, and the resulting mixture of ash and iron scale from the drum was used as a glaze ingredient.

DECORATING PROCESSES 147

Fig. 86. Small stamps of simple design used in various combinations can provide an almost infinite variety of decorative patterns. Kanzan Shinkai of Kyoto uses stamps to decorate both large and small areas, often applying stamped coils and slices to a piece by the *hari-tsuke* process. Here he uses a combination of stamps on a shaped slice to produce a whimsical, decorative tile.

Fig. 87. When individual stamps are used for impressed decoration, they may be very simple, or be complex units as on this piece by Ryōzō Taniguchi.

Fig. 88. Sakuma of Mashiko uses the roller stamp to impress a continuous pattern on his pottery forms.

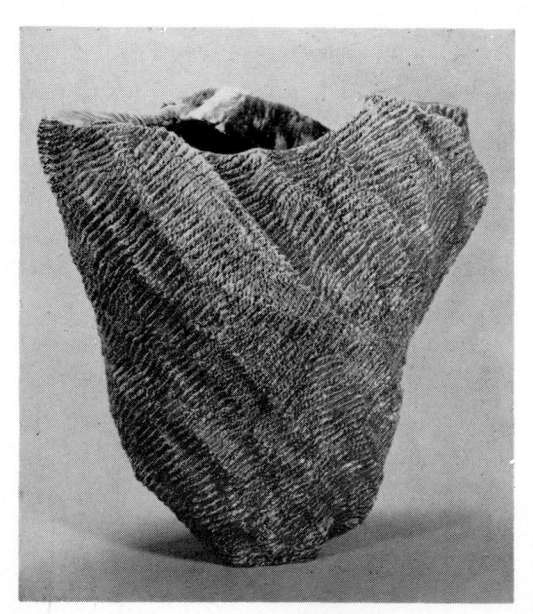

Fig. 89. This hibachi by Sakuma of Mashiko shows impressed roller-stamp decoration.

Fig. 90. This rope-impressed piece by Mineo Katō recalls the rugged character of the early Jōmon pieces.

Fig. 91. Ropes of different braids provide a variety of decorative surface textures when rolled across wet clay. The same rope produces a different design when wrapped around a stick. The rope examples shown here from the Shimaoka workshop were all rolled horizontally across the wet clay slices.

Fig. 92. Rope-impression as used by Tatsuzō Shimaoka of Mashiko becomes a type of rope-pattern inlay when slip is used to fill the impressed areas.

DECORATING PROCESSES 151

Fig. 93. Shin Fujihira utilizes an applied and modeled decoration that is a type of appliqué.

Fig. 94. The decoration on this vase by Yaichi Kusube has been modeled by carving.

Fig. 95. Vase by Hajime Katō. The sprigged-on decoration is done by pressing plastic clay into a mold that is used as a stamp to stick the motifs to the slip-covered surface of the leather-hard piece.

Fig. 96. (a) Hajime Katō uses either a large *kanna* or a strap-iron knife to bevel the background around the birds in this pattern. This raises them above the background so that, when glazed with celadon glaze, they appear to float on the surface of the piece.

(b) Peonies done in this style on Sung porcelains are called *uki-botan* ("floating peonies"), and the technique is called by the same name.

Fig. 97. (a) Katō incises the foliage pattern with a small *kanna* to produce a pattern on a lower level than that of the surrounding background. When glazed with celadon glaze, the foliage appears to sink into the body of the piece.

(b) Peonies done in this style on Sung porcelains are called *shizumi-botan* ("sinking peonies"), and this name was given to the technique.

DECORATING PROCESSES 153

Fig. 98. Combing is done in wet clay with a bamboo comb. Sometimes, as in this piece by Shindoku Tsuji, the cylinder is combed and then shaping is completed from inside with an *egote*.

Fig. 99. *Suribachi* (earthenware mortars for kitchen use) made by Hanjirō Mizuno of Seto are combed with a spring-steel toothed scraper when leather-hard.

Fig. 100. Mishima decoration is first
stamped and then covered with a thin
wash of different-colored slip that may or
may not be removed from the raised sur-
face of the piece. This plate by Shimaoka
shows a combination of stamped, stylized
chrysanthemums and carved, free circular
lines. The stamped and carved areas have
been filled with white slip.

Fig. 101. The ware of Taira
Agano is first carved and then
inlaid with a different-colored
clay. Agano ware represents a
continuation of the Korean
inlaid ware of the Koryo
dynasty.

Fig. 102. When large areas of different-colored
clays are imbedded in the surface of a pottery
form, as in this dish by Seitoku Kawai, the
technique is called *hari-tsuke*.

DECORATING PROCESSES 155

Fig. 103. This large piece by Yūzō Kondō shows the inlay of two clays of different color on the same piece.

Fig. 104. On this Tamba saké bottle, an engobe has been used to provide a white ground for decoration with a dark slip.

Fig. 105. Calligraphy in wax resist on a hibachi by Tetsu Yamada. The characters were painted in wax on the green piece. When the cobalt-stained slip was applied it did not adhere to the wax-coated areas.

Fig. 106. An example of the sharp definition and fine lines possible with latex resist. Bowl by Shigeya Iwabuchi.

DECORATING PROCESSES 157

Fig. 107. There are two styles of bamboo tube. One is a giant "fountain brush," while the other trails a raised ridge from a small bamboo spout. The latter type, pictured here, is used at Tamba.

Fig. 108. In the decoration of this Tamba saké bottle, white slip was trailed on top of black glaze.

Fig. 109. Korean Yi dynasty *hakeme* bowl. These bowls set a standard in decoration and the *hakeme* ("brush grain") has been a favorite decoration on teabowls and saké cups for three hundred years in Japan. Yet most potters admit that they cannot truly duplicate the spontaneity and flow of these simple Korean bowls. As Dr. Sōetsu Yanagi stated, the Korean potters made their bowls "without noticing."

Fig. 110. Modern *hakeme* bowl with iron underglaze decoration.

Fig. 111. White slip and iron underglaze *hakeme* serve as the background for a design of autumn grasses in iron pigment on this modern wall plaque by Ichirō Kimura.

DECORATING PROCESSES 159

Fig. 112. (a) Yūzō Kondō using a thin *fude* to paint cobalt underglaze on porcelain. The design was first painted on with diluted commercial red ink, which burns away during firing. Other inks leave a residue that discolors the piece.

(b) Kondō using a medium *fude* to paint areas of thin cobalt wash, after the stronger cobalt design areas were painted. The intensity of the cobalt dictates Kondō's painting speed, the type of brushstroke, and the size of the brush.

160 JAPANESE CERAMICS

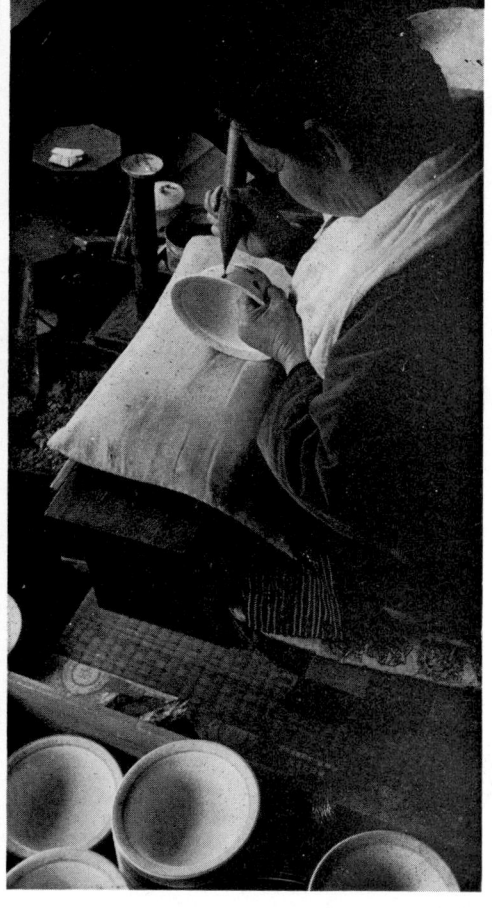

Fig. 113. Toyozō Arakawa painting iron under-glaze decoration on earthenware teabowls. The spontaneous nature of this iron underglaze decoration demands rapid and flowing brushstrokes with a *fude* full of pigment.

Fig. 114. The versatile tip of the large *dami-fude* used at Arita can be used to paint decoration of great delicacy.

DECORATING PROCESSES 161

Fig. 115. A Shinano ware bowl showing dabs of white slip applied with a broad, short-bristled *fude.*

Fig. 116. Slip-patting with a *hake* at Koishibara.

162

Fig. 117. The *dami-fude*, when used as a dripping brush, produces a freely controlled pattern of white lines and dots on the dark body of the ware, illustrated here by a covered bowl from Ryūmonji.

Fig. 118. Painting with a reed as done by Tarōemon Nakazato shows Japanese slip decoration of great sensitivity and strength. These small cake plates display this process at its best.

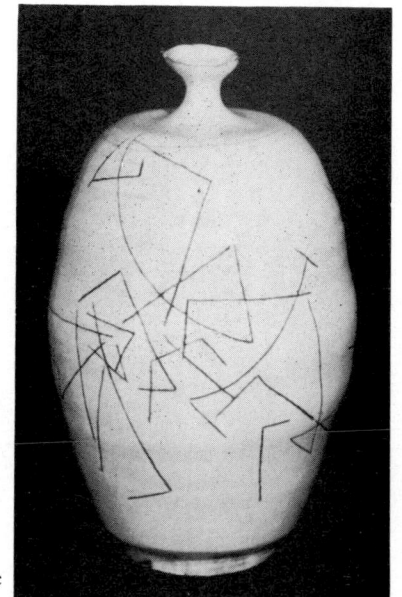

Fig. 119. A sgraffito-decorated bottle by Hikaru Yamada. The decoration, done with a steel tool, gives a hard, cool feeling.

DECORATING PROCESSES 163

Fig. 120. The jumping *kanna* either has a thin spot near the end or is of a form designed to cause it to chatter when in use. Here it is used to produce *kasuri-mon* decoration at Koishibara.

Fig. 121. Large *kasuri-mon* decorated jar from Onda. Arcs of thin, running glaze have been poured over the *kasuri-mon* (chatter-marked) engobe, producing a controlled, yet free and natural decoration.

Fig. 122. This teabowl was decorated by dipping the brown clay form into white slip.

New *Neriage*

The new *neriage* process as used by Kunio Uchida has a close relationship to inlay. The procedure, as explained by Uchida, is begun by throwing a cylinder and only partly shaping it. Then small coils are made of a contrasting-colored clay and the coils sliced their full length. The slices are firmly pressed against the surface of the partly thrown form, and when the slices are embedded flush with the surface of the wet clay cylinder, the piece is thrown a final time.

When the form is leather-hard, the entire surface is scraped to remove any spots of undesired color and to insure a smooth, even surface. Sometimes the coils may provide more than one color, as in *Fig. 82*. This is accomplished by rolling the coils in powdered clay of a still different color, which adheres to the coils' surface. After the slices are imbedded in the plastic form, two contrasting colors result.

Ishihaze ("Stone Explosion")

When pieces of stone are heated in the kiln, their density and moisture content will cause them to explode or shatter. The wares made by Kaneshige at Bizen, and some of those made by Nakano at Karatsu, are outstanding examples of pieces made of clay from which only the large rocks have been removed. The clay is not screened, so that many small pieces of rock remain in the plastic mass. During firing, the rock explodes, causing the clay wall to develop small humps or mounds resembling miniature mountain peaks with cracks radiating from the hump (*Fig. 83*).

The clay used at Iga is screened, but small pieces of rock resembling coarse sand are mixed with it after screening. The size of the rocks or their composition is such that they do not shatter, but after the repeated firing to which the ware is subjected, they come to the surface of the clay. For centuries this coarse, sandy surface quality of Iga ware has been one of its identifying characteristics.

Goma ("Sesame Seed")

Goma (literally, "sesame seed") are iron spots. Against a light-colored background they give the effect of sesame seeds in the clay. The vase shown in *Fig. 84* is made of Mashiko clay. When the product is glazed, the glaze dissolves iron from the clay, thereby producing much darker brown or black spots on a piece made of a lighter-colored clay. In most parts of Japan an iron bearing rock must be added to the clay to produce *goma* spots, but at Mashiko this effect occurs naturally. *Goma* can also be produced by glaze containing iron scale (*Fig. 85*).

In America crushed granite from the Quyle kilns at Murpheys, California will give a similar result when mixed with a stoneware body and fired to cone 9 or 10.

Decoration of Ware after Forming but before Firing

AFTER it has been formed, the ware may be decorated in any number of ways. Most often the potter relies on a single technique for an individual product, although, of course, there are instances where more than one technique has been used on a single piece. Some potters prefer to rely on decorative effects that result either from the nature of the material itself or from the techniques employed in the forming process. Other potters will choose a method of decorating after the ware has been formed, but before the biscuit firing. The unfired piece may be decorated while the clay is still plastic or when it is leather-hard or, in some cases, when it is completely dry.

The Stamping Process

We have seen how the *yoraku* pattern was stamped on funerary bowls by the ancient Korean potters. The stamp they used was the hollow end of a piece of bamboo, and this may have been the origin of impressed decorations on Japanese ceramics today. Later we shall see how its

development led to *mishima* and inlay as decorating techniques, but here we are concerned only with the stamped pattern.

The simplest type of stamp is the single unit stamp (*Fig. 86*), which may be combined with patterns from other stamps or repeated in any desired combination. The stamp may be very deeply carved or quite shallow. Without exception, carving 1/8 to 3/16 of an inch should be adequate for impressing any pattern.

Usually all sharp corners and edges on the stamp are rounded to avoid cutting the clay while the pattern is being impressed. There are some potters who prefer to use sufficient pressure while stamping in order to definitely cut the surrounding clay and provide another dimension to the finished decoration.

The clay form that is decorated by stamping should be sufficiently dry so that it does not stick to the stamp, but not so dry that it cracks when the necessary pressure is applied. When the stamp, is used, the wall of the form where the stamp is impressed should be supported on the inside by the palm or fingers of the left hand, the stamp being impressed on the outside by the right hand. Thus it is possible to gauge the amount of pressure used for each impression and to keep the impressions uniform in depth. Ryōzō Taniguchi makes use of the stamp for nearly all of his decorated wares. He believes decorations must become a visual focal point on the form and that elaborately decorated forms are not in good taste. Consequently, he decorates small areas with the aim of making the pattern both effective and harmonious with the shape of the piece (*Fig. 87*).

The Stamping Wheel and Roller Stamp

The stamping wheel can be of any size desired. Kenji Funaki of Fujina makes very effective use of a wooden wheel, about an inch in diameter and 1/4-inch wide with 1/8-inch holes drilled in the center. The edges of the wood have been filed and sanded until the surface resembles that of a smooth rubber tire.

Tōtarō Sakuma of Mashiko uses roller stamps for impressed patterns on his ware (*Fig. 30*). The rollers are about two inches long and $1\frac{1}{4}$ inches in diameter. He states that either wood or clay can be used to make

the roller, but he prefers the clay ones. They are first formed as solid cylinders, then carved when leather-hard and biscuit fired before they are used.

The larger size provides a surface that can be carved with a much more complex pattern than is possible on the small wheels used by Funaki. When the roller is used, the inside of the wall of the form being decorated is supported in the same way as when individual stamps are used (*Fig. 88*). The hibachi by Sakuma shown in *Fig. 89* was impressed by the roller when leather-hard. The entire surface of the piece was then coated with brown slip. As soon as the slip was no longer sticky, only the surface of the stamped area was painted with white slip, the impressed areas remaining brown to emphasize the stamped design. The piece was biscuited when dry, and the decorated surface was sanded to sharpen the pattern, glazed, and then glost fired (glaze fired). The splashes of glaze were thrown, to trail down from the rim of the hibachi.

Rope-Impressing

The prototype of contemporary Japanese rope-impressed pottery is, of course, the early Jōmon ware. Among the leading potters of Japan, there are a number who work in the Jōmon style, each making pieces of a distinctly individual nature.

Mineo Katō of Sanagi village, near Seto, makes utilitarian ware glazed with Shino white and Oribe green glaze. For his individual pieces, Katō employs the striking process, coiling the form and then changing the shape by beating it with a paddle wrapped with rope (*Fig. 90*). The resulting surfaces are deeply rope-marked and the shapes rugged and angular, recalling much of the character of Jōmon ware.

The pottery of Tatsuzō Shimaoka of Mashiko provides an excellent contrast with the work of Mineo Katō. Shimaoka uses the wheel and the press mold, and his forms are therefore more symmetrical than Katō's. One of his favorite techniques is the old Korean method of pressing or paddling two sides of a bottle to create an oval form (*Fig. 70*).

Shimaoka dates his interest in the Jōmon technique from his early experience with Hamada. As Hamada's student he saw many Jōmon pieces excavated in the Mashiko area, and under Hamada's guidance he

made duplicates of these originals for use in primary-school education. Luckily, Shimaoka says, his father was a maker of the heavy cords used to fasten the *haori* coat worn over the kimono in traditional Japanese attire. But Shimaoka also uses short lengths of bamboo about 1/2 inch in diameter, around which cord is wrapped and tied in various patterns. The cord-wrapped bamboo is used in the same manner as the rope for impressing patterns in the clay.

For use in decorating, the rope is cut into approximately six-inch lengths. The short piece of rope is then dipped in water and rolled by hand over the surface of the leather-hard piece (*Fig. 91*). The amount of pressure applied by the fingers and palm of the hand while rolling the rope determines the depth of the impression. After the surface has been impressed, a thin coating of slip of a contrasting color is painted over it. When the slip has partly dried, the piece is scraped to remove the slip coating from all surface areas except the impressions. The result is actually a type of rope-pattern inlay (*Fig. 92*).

The Jōmon-type ware that was made by Tsunezō Arao was similar to that of Shimaoka in that he used rope and also *koto* string (from a Japanese musical instrument related to the harp) wrapped and tied around a short piece of bamboo, although he occasionally used pieces of carved bamboo to make the impressed pattern. His rope-impressed pattern more nearly approaches the pattern of the Jōmon than does that of either Shimaoka or Katō, since it is neither inlaid with slip nor glazed.

Modeled Decoration

Most modeled decoration is achieved by attaching coils to the surface of the leather-hard pot and using slip as an adhesive agent. When firmly attached, the coil is modeled or impressed with stamps. The work of Kanzan Shinkai (*Fig. 86f*) shows this technique used to develop a whimsical decorative pattern on tiles.

Shin Fujihira, who dislikes fat, voluminous forms, prefers to coil-build his pots. He feels that by coil-building he can more easily develop angular forms with sharp edges which, he says, match his spirit. His decorating technique is called *hari-tsuke* (literally, "sticking on"), which is a kind of appliqué. The decorative motif is cut from a thin slice of clay and then

attached to the surface of a half-dry pot that has been deeply scored with a sharp-pointed tool and liberally painted with thick slip. The cutout motif is placed on the slip and pressed into position, starting at the center and working toward the outer edge. When firmly attached to the pot, the decoration is modeled in low relief. Fujihira believes that decoration is equally as important as form, but that the decoration must be simple. He prefers simple human, animal, and bird motifs. He says they are particularly appropriate on his angular pots (*Fig. 93*).

Yaichi Kusube uses a modeling technique that is related to carving. His love of nature is reflected in the decorations modeled below the surrounding surface of the pot. The outline of the decoration is first incised on the surface of the pot with a sharp knife. The incised line keeps the edge from chipping as the area inside the incision is carved and modeled in low relief (*Fig. 94*).

Sprigged-on Decoration

Sprigged-on decoration has been used to identify the ware of Koishibara and Onda from a very early date. The plum flower is the official seal for Koishibara; the chrysanthemum, the seal for Onda.

The sprigging-on process is one in which the decorative motif is carved into a piece of wood, plaster, or leather-hard clay that is later biscuit fired. The carved material thus becomes a stamp in reverse.

The carved area is filled with plastic clay, after which slip is applied to the surface of the leather-hard piece at the spot where the decoration is to be sprigged on. The clay-filled stamp is pressed firmly against the slip while the wall of the piece is supported on the inside. The result is a raised, modeled decoration stuck to the surface of the ware. The piece shown in *Fig. 95* was thrown and coated with white slip; then the decorative motifs, made of the same clay as the body, were sprigged-on to the coated surface. Such a procedure can provide both harmony and a pleasant contrast between form and decoration.

Carving

Carving has played a part in Oriental pottery decoration for centuries. During the Sung dynasty in China, many porcelain wares were decorated with *uki-botan* ("floating peony") and *shizumi-botan* ("sinking peony") designs (*Figs. 96, 97*) and always covered with a celadon glaze. In those days the Sung potters produced these effects by cutting with a knife into the leather-hard clay. Later on, the *uki-botan*, which would correspond to excised decoration (where the background of the piece is lowered by carving to produce a decoration in low relief), was done by combing. The *shizumi-botan*, which would correspond to our incised decoration (where the decorative motif is lowered), continued to be done with a knife.

Most Japanese carving is combing. It is done in wet clay with a bamboo comb (*Fig. 98*), a technique nearly always used to decorate plates. If combing is done on leather-hard pieces, such as the common household food mortars shown in *Fig. 99*, a wooden or a metal comb may be used, or it can be done with a spring-steel toothed scraper such as American potters use.

Zōgan and *Mishima* Inlay

Zōgan and *mishima*, as terms signifying decorative processes, are used interchangeably by Japanese potters. Since there is no real distinction made between the two, the process is usually called *mishima*, referring to the writing in the calendars or almanacs printed at the Mishima Shrine in the town of Mishima. This name was conferred upon a type of ware imported centuries ago from Korea. The story is that the decoration on the Korean ware so closely resembled the tiny cribbed writing in these almanacs that the decorative process assumed the same name.

We have seen how the unglazed *Shiragi* (Silla period) funerary bowls were decorated with a single stamped pattern called *yoraku*. A change in style in the period following the *Shiragi* was to cover the piece entirely with white slip. Doubtless, during the period of transition many pots were stamped and then covered with white slip. Occasionally the slip was

thin and not refractory enough to withstand the high temperature at which the ware was fired. When this situation occurred, the thin slip coating settled into the pattern, where it thickened, and the thicker area remained white. On the ridges around the impressed pattern, the thinner coating of slip, as it melted, absorbed iron from the body and turned brown.

By the time of the Koryo (in Japanese, *Kōrai*) dynasty, the *mishima* process was well developed. Tomimoto has explained the reason for the profusion of Koryo *mishima* in existence today:

"In the Korea of the Koryo dynasty, the king had prohibited the use of blue-and-white porcelain ware by commoners or anyone not of noble rank. It was during this period that the *mishima* ware came to be called *reihin* (beautiful ware) because of its elaborate decoration. In fact, many of the pieces were decorated on the bottom as well as on the other surfaces. An old Korean book describes in detail the women, houses, and servants presented to the Chinese ambassador of the period. Among the house furnishings, the number and kinds of pieces of *reihin* are meticulously recorded."

Some Japanese potters, for their own satisfaction, make a distinction between *mishima* and inlay. They classify as *mishima* any pattern that has first been stamped or impressed and then coated with a thin wash of slip that may or may not be scraped from the raised surface of the piece when partly dry (*Fig. 100*). When a piece has been carved, and the carved areas have been filled with a different-colored clay, they call it inlay (*Fig. 101*).

The procedure for inlay is first to carve the pattern into the leather-hard clay. The depth of the carving should be about one-third of the wall thickness of the piece. For linear patterns, an umbrella stay filed to a sharp-edged V or U shape is used.

When large areas are to be inset, the technique is the same *hari-tsuke* process described on page 169—that is, to scratch and roughen an irregular surface so that the different-colored clay can stick. Large areas of different-colored clay set in a piece are not technically inlay.

In the following paragraphs, Tomimoto explains the technique of setting large areas of clay of contrasting color in a piece.

"Where large areas of inset clay are desired, the areas are scratch-

roughened with a needle point to the desired depth for the inset. Next a thin slice of clay of a contrasting color that has the same shrinkage as the body of the piece is cut to the size and shape of the scratch-roughened area. The slice should be slightly thicker than the prepared scratch-roughened area. The prepared area is coasted with slip, and the cut-out slice is placed in position.

"Starting at the center, the inset slice is pressed and rubbed into position until it is firmly joined with the piece. When the piece is leather-hard, the inset portion is rubbed vigorously with a bamboo tool, particularly on the edges, where the additional thickness will cause it to spread beyond the cut-out boundaries.

"When the pot is about two-thirds dry, the surface is scraped until it is level and the outline of the inset is sharp and clear (*Fig. 102*). Where lines or small carved areas are inlaid, the carved areas are filled with contrasting-colored clay that has the consistency of thick mud. The carved-out areas are filled until a bead or ridge extends well above the surface of the piece. The piece is then set aside until the wet clay inlay does not stick to the hands. The surface is then worked over with a bamboo tool, using considerable pressure.

"The procedure is to rub the clay ridge until it flattens and any possible air pockets are forced out of the decoration. After the decorated piece has set and is thoroughly leather-hard, the surface is scraped with a sharp knife blade until the contrasting-colored clay is flush with the surface."

If two colors of inlay are desired, they may be applied in successive operations. If the two colors are separated by space, they may be applied at the same time (*Fig. 103*).

Some of the fine old Korean inlays were done by first inlaying with white clay and then inlaying the black clay in the white. The black clay was colored by additions of cobalt or a combination of nickel and iron.

The inlaid pieces of the Koryo (*Kōrai*) dynasty have the pleasant soft gray or gray-green color that many Westerners associate with celadon glaze. Tomimoto says that the *Kōrai* pieces were made of earthenware clay that contained iron. During firing they were strongly reduced up to the point where the glaze melted. Reduction was then stopped, and firing was completed with an oxidizing fire. This method of firing reduced

the iron in the body, and the melted glaze kept it in a reduced state. The soft gray or gray-green of the reduced body, so essentially a part of *Kōrai* inlaid ware, shows through a transparent, colorless glaze.

The Use of Slip

When slip of one color is applied to the surface of a piece of pottery made from a different-colored clay, many interesting decorative effects occur.

The potters of Japan apply slip to leather-hard greenware (unfired) pieces, to dry greenware, and to biscuited pieces. Tomimoto explains that if the slip shrinks less than the clay in the body of the piece, the ware should be biscuited, then the slip applied. If the shrinkage of the slip is greater, the addition of powdered quartz or powdered grog to the slip will reduce its shrinkage. When the slip shrinks the same amount as the body of the piece, application to leather-hard ware permits both the clay body and the slip coating to shrink together.

Through experimentation, the potter finds which slip can be used either on leather-hard, dry, or biscuited clay. The liquid consistency of any slip must be considered at the time of its application. Slip that is too fluid will not cover the body completely, and slip that is too thick will pile up in a rough, unsightly coating on the surface of the pot. There are many methods by which slip can be used to decorate ware, and each method achieves its own unique result.

Engobe: To use slip as an engobe is to cover the surface of the piece completely with a coating of slip of a different color than that of the clay body. In Japan, where a large proportion of the clays used by potters fire red or brown, and where iron oxide or a rock with a very high iron content is a favorite decorating medium, it is frequently desirable to cover the dark clay body of the piece with a white engobe (*Fig. 104*). The engobe provides a white ground that contrasts with the iron decoration. In addition, the effectiveness of transparent colored glazes is increased when the dark clay body has been obscured by a coating of white engobe (*Plate 19*).

Engobe may be applied by brushing the slip onto the piece, by dipping the piece into the slip, or by pouring the slip over it.

Wax Resist and Slip: Wax painting is a comparatively new technique

for the Japanese potter. The process is one in which a water-resistant wax is painted in a pattern on the surface of a leather-hard piece. Next the slip is applied over the wax-decorated surface. Where there is no wax, the slip adheres to the clay, while the waxed areas reject the slip (*Fig. 105*). During subsequent biscuit firing, the wax burns out. If the slip is being applied to the biscuited piece, it is necessary to give it another low-temperature firing to burn away the wax before glazing.

Tomimoto's recipe for his favorite wax composition calls for a combination of slightly more than one-half kerosene and slightly less than one-half candle wax. The kerosene and wax are placed together in a small pan and heated over a very low heat until a smooth, homogenized liquid solution results. The solution is kept heated while it is being used. After the waxed areas have dried, the slip is painted over the entire surface of the piece. As the slip is applied, a dew or droplets will remain on the waxed areas. This dew may be left for a softer effect if desired, or it may be removed with a piece of damp paper used as a blotter. Damp paper toweling also works very well.

In recent years liquid latex has become a popular substitute for wax. The latex has the advantage of being easily peeled from the surface of the clay when the decoration is completed. The outlines resulting from the use of latex are sharper and harder (*Fig. 106*), but some potters consider this a disadvantage.

Slip Trailing: Slip trailing is the process of trailing slip onto the surface of a leather-hard or biscuited piece so that a raised ridge of contrasting color is achieved. At Tamba (Tachikui) a bamboo tube is used to inscribe poems in white slip on the surface of black-glazed saké bottles.

The bottle is thrown and biscuited, and a coating of black glaze is applied. Before the ware is fired, the slip is applied with a bamboo tube (*Fig. 107*). In using the tube for decorating, the potter fills it only to the point where, by tipping it slightly, he can make the slip run out of the spout. The bottle is held in the hand so that complete positional control of the surface being decorated, as well as control of the tube, is possible. After decorating, the bottle is fired and the slip permanently imbedded in the glaze coat (*Fig. 108*).

Kumao Ōta of Koishibara has developed much skill in handling the

bamboo tube as a decorating tool, but he says that in recent years he has abandoned it for the rubber syringe. The syringe, usually infant size, is completely filled with slip. It is important to note, however, that any air present in the bulb will come out as a bubble when the tube is squeezed and will mar the trailed line.

Slip Painting: To the Western potter, slip painting means the application of brushstrokes of slip in a pattern upon the leather-hard surface of a pottery form. To the Japanese potter, it has a much broader meaning, primarily because of the variety of brushes available and the different effects made possible by their use.

The *hakeme* brush is a very coarse miniature broom made from the tips of rice stalks or similar material (*Fig. 36*). It was first used in Japan by the potters of the Karatsu area, following the invasion of Korea (1592–98), when the daimyos brought Korean potters as captives to Japan and established them in their fiefs (*Fig. 109*).

The *hakeme* brush is used for what the Japanese call the "rough touch" and is often used to apply white slip in a swirl on a dark body (*Fig. 110*). Sometimes decoration in iron oxide may be applied over the *hakeme*— that is, "brush-grain"—background (*Fig. 111*). *Hakeme* decoration has a particular appeal for the devotees of the tea ceremony and is universally used today throughout Japan.

The *fude* or regular writing brush has become a popular tool for Western artists, and there are probably few of them who have not seen or used one in their work. It is a flexible, well-tapered brush that can be easily removed from its bamboo handle. Its shape is such that the tip can be used to paint a very fine line while the body of the brush acts as a reservoir for slip. This permits a number of strong, vigorous brushstrokes without the need of refilling the brush. Skilful use of the brush permits combinations of both strong, bold patterns and more delicate and sensitive lines (*Figs. 112–115*).

The wide, flat *hake* is used as a slip-patting brush at Koishibara and Onda. The process, originating in these two villages, has now spread to Mashiko, and requires much practice before the skill can be acquired. When the piece to be decorated by slip-patting has reached the early leather-hard stage, it is recentered on the wheel and, with the wheel in motion, the *hake* is used to scoop enough slip into the bottom of the bowl

to complete the decoration. Then, holding the handle of the *hake* at approximately a thirty-degree angle, the potter moves it into position so that one edge is in the center of the bowl being decorated. As the piece revolves, the brush is raised and lowered in a rapid succession of patting motions (*Fig. 116*). If the radius of the piece is greater than the width of the brush, the procedure may be repeated toward the rim, the second patting overlapping the first.

The *dami-fude* as used at Ryūmonji is a dripping brush. The brush is suspended on its hanging cord about 1/2 to 1/4 inch below the bamboo handle, where it swings freely. When it is filled with slip and swung with a circular motion over leather-hard ware, a freely controlled pattern of lines, arcs, and drops is applied to the piece. The brown clay of Ryūmonji, when decorated with white slip in this manner, was considered by Sōetsu Yanagi to be one of the distinctive *mingei* products of Japan (*Fig. 117*).

The Nakazato family of Karatsu has a 360-year tradition as potters. Through excavations of old kiln sites, Tarōemon, the present head of the family, has found many examples of the old traditional ware as it was made for the Mizuno clan and later for the Ogasawara clan, who were the protectors of the Nakazato family. Over the early opposition of his father, Tarōemon set out to master the traditional Karatsu techniques.

Among the wares produced by Tarōemon at present are some particularly sensitive and strong small cake plates that are decorated with slip of a very high iron content (*Fig. 118*). The decoration is painted with a reed cut to resemble a quill pen and used as a quill pen. The slip for painting is thin and watery.

The reed, which is similar to the cattail plant that grows in American swamps, can be gathered and used either when green or after it has dried. When dry, it has a hard shell with a soft fibrous center that helps hold the slip for painting.

Sgraffito: The technique of coating a piece made of brown clay with a white engobe and then, when it is leather-hard, scratching or carving in patterns through the engobe to reveal the body color underneath, has been used for centuries in the Orient. As a decorative technique it probably reached the height of its development in China during the Sung dynasty. The scratching or carving may be done with a wooden,

metal, or bamboo tool. If a bamboo or a wooden tool is used, the decoration has a soft, warm feeling, while a metal tool produces a decoration with a hard, cool feeling (*Fig. 119*).

Kasuri-mon: The use of *kasuri-mon* or chatter decoration—that is, a dark background with a pattern of small white spots—is another technique dating back to the Sung dynasty. The Sung potters made use of a white body covered with a dark slip, but at Koishibara and Onda the potters have reversed the process. Probably because the body they use fires a dark brown, they coat it with white slip, and the decoration appears as dark-brown spots over a light background.

The technique is, in a sense, related to sgraffito. When the piece is leather-hard, it is completely coated with white engobe, and when the engobe coating has reached just the right degree of dryness, the piece is again centered on the wheel, and a very flexible *kanna* (trimming tool) is used to make "jumping" marks (*Fig. 120*). A dull *kanna* or one that has a thin spot near the end will chatter. Some Japanese potters call such a tool a "jumping" *kanna*.

As the wheel revolves and the cutting edge of the tool is applied to the surface, it bounces or jumps. Each time the tool edge touches the clay, it digs out a small gouge that shows the brown body through the white slip (*Fig. 121*). When the wheel turns slowly, the marks are larger and more widely spaced. If the speed of the wheel is increased, the marks are smaller and closer together.

Dipping: Partial dipping in slip of a contrasting color is a very popular decorating technique with Japanese potters. The reason for this is probably the Japanese people's general aversion to things perfectly symmetrical. This love of the asymmetrical, when carried over into the decoration of pottery by dipping it into a pan or vat of slip, can result in some very attractive wares (*Fig. 122*).

Decoration Resulting from Firing

ONE of the most potent influences on the development of Japanese pottery was the system of feudal patronage. The protection of potters and the control of their products by the daimyos tended to freeze the potter's ware in a traditional style. As we have noted elsewhere, it also insured the

continuation of certain types of pottery that otherwise would have disappeared.

Bizen Ware

We shall consider as the chief example of this the wares made at Bizen, where the Kimura and Kaneshige families lived under the protection of the Ikeda clan. Though the manorial lords provided them with food and clothing, a house, tools, and a kiln, they in turn were obliged to remain on the fief. They were not free to live elsewhere.

Bizen has been a pottery-producing center for over a thousand years. Tōyō Kaneshige, who represents the seventy-eighth generation of continuously producing potters in the village, says of Bizen:

"The quality of the ware changed from period to period, depending on the taste and wishes of the clan leader. The Bizen ware of a thousand years ago was Sue ware, a thinly potted, unglazed gray and black product. The Sue ware of the area was made as offering vessels or, as the Japanese say, as presents to the gods."

During the Kamakura period (1185–1333), a very thick-walled utilitarian type of pottery was made. Kiln improvements had increased the hardness of the ware, but lack of control in the firing and the resulting reduction caused the clay, which had a high iron content, to turn black, with occasional red areas where more complete oxidation had prevailed.

By the end of the Momoyama period, considerable sculpture was being produced at Bizen. Kaneshige owns a clay-slab lantern made during the fifth year of the Genna era (1615–23), a registered national treasure of excellent workmanship.

At the beginning of the Edo period, the Bizen potters greatly developed their techniques, but the character of their work deteriorated. The quality of their ware deteriorated still further during the Meiji period, when they lost the protection of the daimyo and the age was characterized by the wholesale importation of Western civilization.

As a member of one of the two old families of Bizen, Kaneshige was personally concerned over the debasement of Bizen ware and was determined to revive its quality. Over the years he has been so successful that he is now honored with the highest tribute his country can pay to

an artist, for he is one of Japan's five living "intangible cultural properties" in the ceramics field. Kaneshige believes in the traditional foundation of his work, and his desire is to produce modern individual work founded on the basic traditions of Bizen ware. He points out that glaze has never been used in all the long history of Bizen ware.

There are four kinds of firing common to Bizen, but the same clay is used in each case. In any situation where the final product is completely dependent on firing, control of the kiln is of the greatest importance.

Kaneshige has had many trying experiences. His desire to restore the fine ancient qualities of Bizen ware required a thorough understanding of those processes that had been permitted to die out over the years. When he was sixteen, Kaneshige stacked and fired his own salt-glaze kiln, an operation that was entirely unsuccessful. Then he used saggers, and at twenty-one started stacking his ware on shelves. But he found open shelves were not the answer, since they interfered with the free play of fire currents in the kiln. In ancient times the Bizen potters, for reasons of economy, used no firing supports, but stacked their ware like cordwood in the kiln. Kaneshige concluded that quite possibly this was the answer to his problem, and in recent years he has used no supports in firing. The results have been increasingly satisfactory.

Fire-Change

Varying the fire in the kiln results in what is known as *higawari* ("fire-change")—a word denoting both the process and the pieces produced by this process—that is, pieces whose colors have changed from the color or colors that would be obtained by straight oxidation firing. Oil-spot *temmoku* is one example of *higawari* (also called *yōhen*: *see page 198*), but at Bizen, where no glazes are applied to the ware before firing, this process is of unusual interest. The general opinion among Japanese potters is that the changing-fire process is neither dependable nor controllable. Kaneshige concedes that it is very difficult to manage and that few good pieces come out of a changing-fire kiln in one firing. More recently, however, he has become more skilful, and he now believes his firing technique is even better than that of the ancient Bizen potters.

The changing-fire process is one in which there are periods when the

fire is permitted to burn very low, as well as periods of intense stoking of the kiln to produce a vigorous fire.

Accompanying the vigorous and mild fire is careful control of the dampers. During firing there are periods when the air is shut off altogether, alternating with periods when the dampers are opened completely. *Higawari* therefore results from changing from a mild to a vigorous fire several times during a single firing, as well as from several periods of reducing and oxidizing atmosphere in the kiln (*Plate 1*).

Kaneshige fires his kiln to cone 10 or cone 11 over a period of seven days. He uses only pine wood for fuel, the ash of which is very soft. The pine ash, with its high calcium, potassium, sodium, and magnesium content, provides a glaze material that melts readily at the high temperature at which he fires. By opening the dampers while charging the kiln with fuel, he causes the draft to pick up the ash as soon as it is burned. The ash flies through the kiln chamber, falling on the ware, where it fuses with the clay body to produce *goma* (*Plate 2*). (Iron-spot *goma* decoration was described on page 166—at Bizen *goma* means the sesame-seed-like effect caused by falling ash.) This falling-ash glaze is considered by Kaneshige to be very elegant and strong.

The *ao* Bizen (blue Bizen) is the result of reduction firing as described above. Bizen clay has a high iron, potassium, and sodium content. The long firing period, the absence of glaze, and the control of the reducing atmosphere in the kiln produce blue Bizen ware. The blue color is the result of the reduction of red iron oxide (Fe_2O_3) in the clay to a lower form of oxide (FeO), or possibly sometimes to metallic iron particles (Fe) in the clay.

Hidasuki ("Fire-Cord") Decoration

The word *hidasuki* is made up of the words *hi*, meaning "fire," and *tasuki*, meaning the cord used by Japanese women to tie back their kimono sleeves while they are working. The cord is continuous and makes a circle about two feet in diameter. It is draped around the neck to form a loop on each side over the breasts. The arms are then passed through these loops. The cord holds the kimono sleeves against the body, leaving the arms bare and free of any encumbrance.

Tasuki (cords) made of straw and soaked in salt water are wrapped around Bizen pots before firing. During the firing process the straw burns away, and the sodium from the salt is deposited on the surface of the ware. The sodium melts and combines with the red clay to form a bright-red streak of glaze on an otherwise unglazed surface (*Plate 3*). Also, Asai Rakuzen of Tokoname has experimented with seaweed, using it in the *hidasuki* manner of Bizen (*Plate 4*).

Iga Ware

In Japan, the wares of Bizen and Tokoname are two of the best known among native Japanese pottery. There is, however, another ware that has a long history of evolution and, through the efforts of Taneo Kikuyama, continues to be produced today.

The history of Iga ware is somewhat complex. Kikuyama, in his *History of Igayaki Pottery* (1950), reports that the ware dates back six hundred years, but that its popularity as tea-ceremony ware began when Kobori Enshū founded a school of the tea cult and, through the Tōdō clan, lords of the area, arranged to have various utensils made by the Iga potters, under his instruction. Such wares are now known as Enshū Iga.

During the latter part of the seventeenth century, the Tōdō clan became involved in treason against the state, and because of government restrictions, Iga ware had, by the eighteenth century, become extinct. During the early part of the nineteenth century, there was a revival for a period of about twenty years, after which the production of Iga ware again ceased. In 1937 Kikuyama started a thorough study of old papers and documents and existing old Iga ware. He sold his house and built himself a three-chamber *nobori-gama*. Through persistent study and hard work he re-established a product that has the character of the original Iga pottery (*Plate 7*).

Kikuyama explained that Iga ware has four special characteristics: "One is the expression of the blue-green part like a beetle; one is the expression of the red skin, which is the unglazed part; and one is the *koge* or 'scorch' that results from baking. There is a special quality of one more element. During firing, stones come to the surface of the clay. These stones are like stars."

Iga ware is made from two clays. One comes from the mountains near Iga, and after it is crushed and screened, ball clay is blended with it. Some of the small stones that have been screened out are returned to the clay mixture. They become the "stars" mentioned above.

The ware is fired from ten to thirteen times to 1500° C. Each firing requires thirty hours to reach maximum temperature, and then the kiln is cooled for two days before the ware is removed. The ware is inspected, any completed pieces are set aside, and the remaining ware is restacked and fired again.

The kiln holds about three hundred pieces, and if it has been a good firing, between five and ten of these will be selected as finished products. The kiln is fired about seven times a year, when the weather is good for firing. Nothing but pine is used for fuel, and no glaze whatever is applied to the ware.

The process for producing Iga ware would seem to require: (1) Careful placement of the ware to insure oxidation of the iron-bearing body to produce the red unglazed skin at some spot on the piece. (2) Falling pine ash to build up a glaze coating through repeated firings. (3) Placement of the piece so that some part of the surface gets very heavy reduction, probably during the final firing.

During the final firing, therefore, the areas of carbon impregnation occur where the smoke and carbon are most intense; the green color from reduced iron in the pine-ash glaze is produced where the carbon and smoke are less concentrated. The stones would gradually make their appearance on the surface of the piece as more and more of the clay combined with the ash to produce the glaze.

CHAPTER V

UNDERGLAZES, GLAZES, AND OVERGLAZE ENAMEL DECORATION

Underglaze Decoration

UNDERGLAZE decoration in the eyes of the Japanese is limited to the use of cobalt, iron, and sometimes copper pigments. The use of underglaze pigments on the dark clay bodies used by Chinese potters of the Sung dynasty resulted in an unsatisfactory product. The desire for a white-bodied ware to be used for food and tea prompted the Sung potters to use a white engobe over the dark clay. Celadon and *temmoku* glazes, when applied over the white engobe, had clearer color and more life.

By the end of the twelfth century the Sung potters had perfected a white-body ware called *ting-yao*, which was only one step away from true porcelain. There is literary evidence to the effect that underglaze painting in blue started at this time. It was, however, not until the Ming dynasty that underglaze blue, along with overglaze enamel decoration, reached a high level of perfection (*Plate 33*). During the period of its development, the techniques of both porcelain production and the use of underglaze pigments had spread to Korea, where the blue-and-white was reserved for imperial use (*Plate 31*).

In 1510 a Japanese potter, Gorōdayū Shonzui, went to China to study porcelain manufacture. He remained at the Ching-te-chen porcelain center for five years, and when he returned to Japan brought with

him porcelain clays and *gosu* (natural cobalt), as well as a knowledge of Chinese blue-and-white production methods. He set up his kiln in Hizen Province near the town of Arita, where he made porcelain from Chinese materials until his supplies were exhausted.

After his death in 1550 no more porcelain was produced until Risampei discovered Izumi-yama stone in the Arita area early in the seventeenth century. Izumi-yama stone could be used for porcelain just as it was found, without additions or adjustments. In 1712 porcelain stone was found on the island of Amakusa, and the same stone is still used today for most porcelain products.

The Chinese originally made use of underglaze pigments on the raw unfired body of the ware before the pieces were glazed with a transparent glaze and completed in a single firing. At the present time most porcelain wares are biscuit fired before decoration, although some individual techniques are developed on the green ware.

Sometsuke (Blue-and-White)

The purity and stability of the *sometsuke* style of decoration has endeared it to the Japanese. Other colors which they like and use, such as red, green, and mauve, run when used as underglaze colors. They have therefore been reserved as *uwae* (upper pattern of colors on the glaze). Thus, *gosu* (natural cobalt), painted on the porcelain biscuit and subsequently covered by a coating of transparent, colorless glaze, provided the basis for the blue-and-white ware.

Much of the beauty and charm of the painted blue-and-white porcelain is the result of skilful use of the brush in applying the pigment. The painting must not be done slowly, or else a clumsy, labored, amateurish decoration results. However, the painting need not be done quickly, but rather with certainty, facility, and smoothness (*Fig. 112*).

In preparation for painting, the powdered natural cobalt is ground with a boiled green-tea solution. The grinding is done with a porcelain pestle on a frosted plate-glass slab. The green-tea solution is made by boiling the tea and then permitting it to set until it is the consistency of thin syrup.

When the *gosu* is mixed with just the right amount of tea solution,

the brush will move freely and smoothly during painting. After the painting is completed, the piece should dry for about half an hour before it is ready to be glazed. The tannin in the tea keeps the decoration from spreading when the glaze is applied. The work of Tomimoto (*Plate 34*) and Yūzō Kondō (*Plate 35*) shows painted blue-and-white decoration at its best.

Tomimoto had developed an inlay technique for blue-and-white. The pattern is incised into the surface of either a leather-hard or a dry porcelain piece. The incising should be done with the sharp point of a chisel or a dental tool. Skill is required to avoid chipping or blurring the pattern while carving. *Gosu*, when painted on greenware, will spread.

The inlay technique assures a sharp, clear-cut pattern. After carving is completed, a small *fude* is used to inlay the pigment in the incised line. The surface of the piece is then scraped to remove any pigment not in the carved line, and the piece is ready for biscuit firing. The inlaid blue-and-white is an exclusively modern type of product (*Plate 36*).

Another modern technique, which was first developed by Leach, is the etched blue-and-white. The procedure for etched blue-and-white decoration as used by Tomimoto is to first coat the entire surface of the leather-hard piece with boiled Japanese green tea. The tea coating is permitted to become completely dry. A carefully sharpened chisel or a nail sharpened to a fine cutting edge is used to engrave through the dry tea coating. All crumbs and chips of dry tea should be carefully brushed from the surface to avoid concentrated spots of color when the cobalt is applied.

The cobalt is prepared by grinding it with water on a frosted glass slab. The large *fude* is then loaded with the cobalt-water solution and the entire surface of the piece covered with this wash solution.

Where the line is engraved, an etched line of intense color will result. The tea coating over the rest of the surface will soften slightly under the water solution and absorb sufficient cobalt for a soft, thin color-wash background. The entire effect will resemble an etching on paper. After biscuit firing the piece is ready for glazing.

Leach's procedure differs in that he does not use tea as a wash, but simply brushes the engraved surface with a weak wash of *gosu* (or of a well-ground combination of two parts black cobalt oxide and ninety-

eight parts raw ochre, as an alternative), then adds stronger pigment where needed.

Tomimoto used *gosu* for all of his blue-and-white decoration. *Gosu*, which is an impure cobaltous pebble found in some creek beds in the Orient, contains, in addition to cobalt, manganese and iron in fairly high percentages. Tomimoto found the *gosu* he used in a creek bed in Shikoku.

After biscuit firing, the *gosu*-decorated porcelain is glazed with a lime glaze and fired to approximately 1300° C. (seger cone 8 or 9) in a reducing fire, or, as Tomimoto said, "to fly off the iron and manganese."

Oxidation firing causes *gosu* to turn black, while reduction firing results in the soft gray-blue characteristic of old Oriental blue-and-white ware. At present no *gosu* is available from China, and it is extremely hard to find in Japan. Imported cobalt oxide from Europe and America is used by most potters, with a resulting harsh, hard blue color after firing.

Occasionally other pigments are used for decoration under the glaze. Yūzō Kondō has in recent years used a combined decoration of *gosu* and a copper mineral, which, after reduction firing, results in a blue, white, and red product.

Iron

Iron oxide or some iron-bearing clay, rock or mineral is universally used as a decorating medium in Japan (*Fig. 123*). It may be used under the glaze coat or applied over or upon a previously applied coating of unfired glaze, usually on an earthenware body. The use of iron as an underglaze material or as a decorating medium came originally from Korea. Some of the early Karatsu pieces are almost indistinguishable from Korean ware, and are called, appropriately, "Korean" Karatsu.

Copper

Copper compounds may be used in a manner similar to the various iron compounds, but copper-red underglaze decoration is utilized sparingly in Japan, often appearing either in combination with or as complement to iron and cobalt underglaze decoration (*Plates 22, 23*). Though there is ample precedent for the use of copper-red underglaze in the Korean Yi

dynasty ware (*Plate 32*) and in Chinese ware during and after the T'ang dynasty, the reduction firing necessary to produce the elusive and delicate copper red (copper usually turns green in oxidation firing) was either not mastered, not favored, or was ignored by the early potters; in Japan this underglaze made its widespread appearance with the advent of the modern art potters.

Commercially, the factory owned by Shin Fujihira makes a ware with copper-red decoration under a common ash glaze. Copper oxide is mixed with slip and trailed on the leather-hard piece or mixed with a small amount of glaze and inlaid in lines incised in the green piece prior to biscuit firing. The ware is glazed with a glaze composed of forty percent feldspar, thirty percent common wood ash, and thirty percent rice-straw ash and is fired in a reducing fire.

Monochromatic Glaze Decoration

IN ANY feudalistic society there are extremes of social stratification, which, when well established, perpetuate themselves. In Japan the impotence of the imperial court and the contrasting power of the shogunate govern-ment provided two top-level strata of culturally accomplished individuals: hereditary court noblemen and the daimyos or landed gentry. Over a period of time the decline of the wealth of the daimyos forced them into a secondary position, while a newly created wealthy commercial class became the arbiters of national culture.

A natural corollary of wealth is leisure, and leisure provides opportunity for development of the appreciation of the arts that we call culture. Throughout the history of Japanese ceramic art we repeatedly find the influence of top-level social strata on the potter's products. We find it in the wares of Kakiemon, Nabeshima, Kutani, Satsuma, Awata, Ninsei, and Kenzan—all of which are stylistically elaborate blue-and-white porcelain, or overglaze enameled porcelain and earthenware.

This would seem to indicate a class preference for elaborate and richly decorated wares. At the same time, the esthetic that arose from Zen Buddhism and became associated with the tea ceremony cultivated an appreciation of extremely unpretentious and severely simple ware, es-pecially tea utensils. The selection of a potter's ware for tea-ceremony

use assures its continuation as a simple unassuming product, usually undecorated and bearing a single-color glaze.

The single-color glazes, when made from natural regional materials that contained impurities, would frequently have variations in color intensity or possibly change color entirely, depending on the uniformity of application and fluidity of the glaze. *Temmoku* glaze, which is a full rich purple-black when applied heavily, may be brown where the application is thin. Also the same glaze, when heated sufficiently to make it flow, may develop "rabbit-fur" streaks, and when cooled slowly may develop "oil spots" (*Plate 14*).

Celadon glazes are usually uniform in color and rely on the white purity of the porcelain body. It is of interest that Tamba, which was a Sue pottery village, should also have a long tradition of techniques characteristic of the Korean pottery villages. Until the Meiji period such wares were largely limited to regional distribution. This fact no doubt contributed to the continuation of what might be considered a local style. More widespread distribution would have brought consumer pressure to bear, which in turn would have influenced the potter's style, though the techniques would probably have continued to exist.

Glazed wares were first made in Japan as early as the Nara period (710–794), but the form and colors (yellow, green, and white) were so characteristic of the wares of the Chinese T'ang dynasty that for many years they were thought to be Chinese imports.

The Nara period ware, low-fired earthenware glazed with a lead glaze, was made in kilns owned by the government at Nara and Kyoto. It was made exclusively for the use of the imperial court and court-connected Buddhist temples. In addition to the three-color ware, there were single-color pieces glazed with a green lead-bearing glaze that continued to be made until the twelfth century.

Early in the ninth century, the use of celadon glaze was imported from the continent to Owari Province. The Owari kilns, which were located in the Seto area, were the most advanced of all the traditional Sue ware kilns in Japan. They were capable of reaching the temperature necessary to mature the feldspathic type of celadon glaze. By the twelfth century, the kilns in Seto had developed to the point that the center of celadon manufacture was shifted there. With the transfer of celadon manufacture

to Seto, the area became Japan's greatest center of ceramic production, an eminence held for four hundred years.

The discontinuation of production of the T'ang-style wares at Nara and Kyoto marked the elimination of the use of lead glazes in Japan until the sixteenth century. By that time, Kyoto had become the center of the tea ceremony, with a corresponding predominating demand for tea vessels in that area.

About the middle of the sixteenth century, Chōjirō Raku created a special type of tea-ceremony ware. Raku was guided by the famous Kyoto tea master, Sen-no-Rikyū in his production of a low-fired, soft-bodied ware with a lead glaze. The design of the ware was based on Korean Yi dynasty teabowls, and the glaze was the lead glaze of the Ming dynasty. The ware of Chōjirō was made in three colors: *kuro* Raku (black Raku), *aka* Raku (red Raku), and *shiro* Raku (white Raku).

Raku Ware

Chōjirō Raku's memory was honored by Hideyoshi Toyotomi when he granted to Jōkei, Chōjirō's son, a gold seal bearing the character *raku*, which signifies "enjoyment of leisure." Over the centuries Raku has come to mean a low-temperature ware with a lead glaze.

There are a number of small factories throughout Japan in which Raku ware is made. A report of the process as practiced at the Waraku Kawa-saki factory in Kyoto will explain its manufacture in general.

The Kyoto Raku factories have added other colors to the original black, red, and white. The most common of these are green, yellow, and blue. At the present time, however, Raku tea-ceremony bowls are predominantly glazed either red or black.

The body for Raku ware must be a high-temperature clay to which about twenty-five percent grog (pulverized burned clay) has been added. The combination of a high-temperature body and grog provides a body that can withstand the sudden heat and cold shock to which all Raku wares are subjected during manufacture.

Usually a white or cream-colored stoneware clay or fireclay is used. Raku teabowls should be made *tebineri*—that is, without the wheel. They are made by coil-building and pinching, and an occasional bowl or caddie

can be found that has been sliced and carved out of a solid mass of clay.

However, the Kawasaki tea-ceremony bowls are thrown; then the walls are cut and pinched to give them the desired irregularity of form. Raku teabowls must be thick-walled so that they can be held comfortably.

Other forms of Raku ware made by the Kawasaki factory are large and small plates, small teacups, mugs, fruit or flower arrangement bowls, incense burners, and flat platters. These forms may be thrown or pressed, depending on their shape and the potter's preference. After trimming, those pieces that will be red Raku are painted with yellow ochre before biscuiting. All pieces are biscuit fired to 850° C. over a period of ten hours.

The red bowls are biscuit fired at the top of the kiln. Those pieces that will be glazed with other colored glazes are placed in the lower part of the kiln.

The black shadow pattern found on red Raku teabowls was originally accidental. During biscuit firing, two pieces that were touching would, at the point of contact, trap carbon from the atmosphere in the porous ochre slip. When glazed, the rapid glost fire sealed the trapped carbon markings under the glaze coating. Today, those carbon markings have become a characteristic part of red Raku ware (*Plate 9*).

The present-day Raku potter has incorporated into his process a special firing that insures random placement of carbon spots on the red bowls. After the bowls are removed from the biscuit kiln, they are piled in a rectangular fireclay box with a bottom perforated by many holes. The box is raised about eight inches above the ground so that wood can be burned under it. After the wood is burning briskly, charcoal is dropped into the box among the piled-up pieces (*Fig. 124*). As the bowls become hot, the charcoal ignites, and carbon impregnates the ochre slip in a random pattern. The bowls are removed from the box and immediately dipped in water or simply permitted to cool (*Fig. 125*). They are then ready to be glazed with the transparent Raku glaze.

Raku glaze must be thickly applied, and the necessary handling before firing may damage the glaze coating. To avoid damage and chipping or peeling of the thick glaze, *funori* (seaweed solution) is mixed with it. *Funori* retards the drying of the glaze coating, thus permitting several coats of glaze to be applied without difficulty. As soon as the

first coat will not stick to the fingers, a second coat is applied. This is repeated for three or four coats.

After glazing, the pieces are placed on edge on a fireclay shelf about ten to twelve inches above and to the back of the kiln that is being fired (*Fig. 44*). Biscuited tiles about $1/2 \times 10 \times 10$ inches are placed on top of the plates, as well as on the edge in back of them, resting against the ware. The tiles thus form an open-front box that collects and holds the heat from the kiln.

The Raku kiln is fired with wood. The fire is started at the throat of the firebox, and when the wood burns to red coals, these are pushed under the muffle. As firing progresses, the potter, through an opening in the lid of the muffle, periodically reads the increasing redness until the correct temperature for firing the ware has been reached. As soon as the inside of the muffle is of the proper redness (approximately 850 °C.), the glazed ware is placed in the kiln. Plates are placed on edge on special racks made of biscuited clay. The racks are so constructed that the glazed rim of the plate rests on the rack and the surfaces of the plates do not touch one another.

The potter wears long, loose, very large mittens made of multiple thicknesses of cloth. The mittens are soaked in water and wrung out before wearing. The ware is placed with long-handled tongs (*Fig. 126*).

The time required for firing varies from forty minutes for the first kiln load to twenty-five minutes for the fourth. After the fourth load of ware, the firing remains relatively constant.

The ware is carefully watched through the opening in the muffle lid until the glaze is satisfactorily mature. It is then removed from the muffle with the long-handled tongs that have been dipped in water and partly dried on the potter's apron (*Fig. 127*). As soon as the ware is removed, the kiln is reloaded with ware from the drying rack, and more wood is put on the fire, and the process repeated.

Black Raku and Other Lead Glazes

The black Raku teabowls are fired differently. The black glaze that was developed by Chōjirō has as its main ingredient Kamogawa-*ishi* (Kamo River stone), found as pebbles in the Kamo River. At the present time the

pebbles are very scarce, but the ingenious Japanese potter has discovered a source for the necessary material. Tomimoto informs us that many of the old tombstones are made of the same stone, mined centuries ago in the nearby mountains. It is easy to imagine a Raku potter setting forth on a dark rainy night, armed with a hammer and a charm against evil spirits. His objective: to chip himself a supply of glaze material in the nearest cemetery. (Kamogawa stone, however, can be purchased in powder form from ceramic supply houses in Japan.)

Kamogawa stone contains iron and manganese, and if the glaze is not cooled quickly, it changes from black to reddish brown (*Plate 8*).

The black Raku glaze is much more refractory than the glaze used for other Raku wares. It is composed of ten parts of Kamogawa stone and from three to ten parts of *shiratama*, a Japanese frit. The variation of the *shiratama* content from three to ten parts gives it a variable temperature from 1000° to 1250° C. Tomimoto made use of a coating of transparent Raku glaze over the black before firing. The kiln for firing black Raku teabowls has a muffle twelve inches in diameter and fifteen inches deep (*Fig. 46b*).

The kiln at the Kawasaki factory is set completely below ground level (*Fig. 49a*), and the bellows formerly used for forced draft has been replaced by an air compressor. This type of arrangement is necessary in order to reach the required temperature. The bowls are fired one at a time for approximately eight to ten minutes. As soon as the glaze is melted to the potter's satisfaction, the bowl is removed from the kiln with the tongs and immediately submerged in a tub of water that is approximately body temperature. The water cools the bowl quickly and causes the glaze to craze.

Crazed glaze is a requirement for Raku ware. A tea master who is partial to its use would tell you that bowls with uncrazed glaze disturb the esthetic and calm atmosphere of the tea room through the harsh, loud sound of the tea whisk as the tea is beaten in the bowl.

In spite of the popularity of Raku ware, lead glazes are not of particular interest to the Japanese potter. The only other kilns that use them extensively are the Funaki kiln (*Plate 11*), the Marusan factory, and the Yumachi kiln, all located in the Fujina area near Matsue (*Plate 10*).

The ware of the Marusan and Yumachi kilns (*Plate 12*), while most

This was burned, and the result was a combination of lime and ash. The combination was ground by an ox mill, and the mixture used as ash. A good glaze composition was ten parts by volume of feldspar and twelve parts by volume of ash.

"When clay containing a high percentage of iron was added to the glaze, and a smaller quantity of ash was used, a *kaki* ('persimmon-colored') glaze resulted. When additional ash was used in the *kaki* glaze, a black *temmoku* would result (*Plate 13*).

"*Temmoku* glaze must be thickly applied. When the lower part of the pot is left unglazed, the glaze will flow to a thick roll at the top of the unglazed portion. When the glaze flows, some streaks of *kaki* will appear where the glaze has thinned. These streaks are called 'wild rabbits' fur.'

"If there is too much iron in the glaze, crystal spots will appear on the surface. The spotted *temmoku* glazes are called *yuteki temmoku* or 'oil-spot' *temmoku* (*Plate 14*). The entire group of *temmoku* glazes are called *yōhen temmoku* or 'kiln-change' *temmoku*. These iron-bearing glazes should be fired in a reducing atmosphere to produce *temmoku*. If an oxidizing atmosphere is used, for example, the light-brown *temmoku* glazes will be yellow Seto and the reddish-brown ones will be amber-colored.

"The Japanese term *temmoku* is the name given a type of brown through black teabowl made during the Sung dynasty at the Chien-yao kilns in the Chinese province of Fukien. *Temmoku* is the Japanese pronunciation of Tien-mu Shan, the name of a mountain in Chekiang Province in China where several Ch'an Buddhist (the Chinese precursor of the Japanese Zen Buddhism) temples were located. During the Sung dynasty, the Ch'an Buddhists made exclusive use of this type of teabowl.

"The original *temmoku* bowls are made of a dark stoneware body with a thick purple-black glaze. The glaze would sometimes have light-brown streaked lines or brown, reddish-brown, or silver spots. The thick roll of glaze at the start of the unglazed portion was a characteristic feature of the originals."

These Chien-ware bowls became popular tea-ceremony utensils in Japan, and have been imitated by Japanese potters continuously since their first importation from the mainland.

concerned, since it is located only one kilometer from Ryūmonji. Kitchen wood ash, rice-straw ash, and a red sandy iron oxide from their fields complete their glaze materials (*Plate 20*).

Chōtarō Ariyama, at Kagoshima, has his workshop on the seacoast near hot springs where many kinds of rock and clay are readily available. He uses *kasasa* feldspar (a natural stone), sand, and clay for his glaze. For some glazes he also uses camphorwood ash, pine ash, and bamboo ash.

Satarō Samejima, at Naeshirogawa, uses a natural stone called #2 *yusha*, which contains twenty-one percent iron oxide. He also uses #2 *shaju*, which has a 5.9 percent iron content. These materials are combined with common ash to make the black Satsuma glaze (*Fig. 128*). Somoda clay used at Naeshirogawa for *soba* glaze (a greenish-yellow glaze resembling the color of *soba*, Japanese buckwheat noodles) is comparable to Mashiko clay, which is a powdered building stone with a high iron content.

Each area has its own regional materials from which glazes are made. Mashiko powder has gained some popularity throughout eastern Japan as a glaze material, as has *kimachi* stone in western Japan.

With the discovery of the necessary materials for porcelain, the development of *seiji* ("green celadon") was assured. During the Yi dynasty (1392–1910) nearly all Korean pieces were made of white clay with a glaze containing a small amount of iron. The result, when the ware was fired in a reducing fire, was a pale-green glaze on a white body. Such a glaze, when fired in a reducing fire on a body containing a higher percentage of iron, dissolved more iron from the body and incorporated it into the glaze, producing a deeper green color. Tomimoto stated that the Sung dynasty celadons were the result of ash and feldspar applied to a clay body containing the correct amount of iron for a good green color (*Plate 15*).

In the following paragraphs Tomimoto explains the composition and use of several famous glazes, basing his information partly on the writings of Père d'Entrecolles (1663–1741), a missionary in China who described in his writings the process for making ash.

"In China the potters use fern ash. Fern is a very hard refractory ash because of its high silica content. The procedure for preparing the ash was to stack about one foot of fern, then place on top of it a layer of limestone, then another foot of fern and a layer of limestone until the stack of alternate layers of fern and limestone was about six feet high.

UNDERGLAZES, GLAZES, AND ENAMELS 197

Shino ware are *e* Shino ("picture" Shino) (*Plate 16*), which is painted with iron-oxide decoration under the glaze, and *nezumi* Shino, or "gray" Shino, which is covered with a dark-brown iron-oxide slip through which patterns are incised in the sgraffito manner (*Plate 17*). Both types of ware are glazed with the white Shino glaze. When fired in a middle fire, the brown engobe-coated ware becomes gray, with a white decoration where the slip has been scratched away. If it is fired in an oxidizing fire, the glaze turns white.

Shino glaze is usually somewhat uneven in application, and where it is thin, the iron oxide stains it red. The tea masters call these red stains *hi-iro* ("fire color") or *koge* ("scorch"). Pieces bearing such marks are much sought after by tea-ceremony devotees.

Oribe ware grew out of the original Shino product. The decoration continued to be painted in iron, with the pattern becoming much more complex over the years. The glaze changed from a thick, white, unevenly applied coating to a smoother, transparent glaze. This ware is known as *e* Oribe ("picture" Oribe) and is the basis for the most famous of all Oribe wares. The term *ao* Oribe ("green" Oribe) describes the process in which a portion of the piece, after glazing, is dipped into the green Oribe glaze (*Plate 18*).

Other feldspathic glazes of Japan have evolved over the centuries. They have had as their basis either a Chinese or a Korean prototype, or they have been introduced from Europe within the last century. The former make use of natural regional minerals and plant ash to a large extent, while the latter are made from chemicals and minerals on a carefully calculated scientific basis.

The glazes made of regional materials have particular interest, primarily because of the variations in the composition of rocks and minerals in different regions. For centuries the *mingei* potters of more remote areas have been using the materials at hand, which can be easily transported by bar and basket.

Both Koishibara and Onda potters use *akadani* stone, a natural feldspar, which they transport themselves from a mountain in the region, and both use *sabi-tsuchi*, "iron-rust clay," as a glaze material. Ryūmonji uses *tokusa*, a natural feldspar, which is transported three kilometers. This area is more fortunate where *iwa* or *gun* (a combined silica and feldspar) is

interesting, shows the marked influence of English slipware, and the bright-yellow glaze seems to strike a discordant note in Japanese pottery.

Feldspathic, Ash, Iron-Bearing and Other Leadless Glazes

We have noted above how, in the ninth century, celadon glaze was imported from the Asiatic continent to Owari and how, during the twelfth century, its manufacture shifted to Seto, which became the ceramic center of Japan. The chief glazes used by the Seto potters during this period were the *ki-zeto* (yellow Seto) glaze and *ame*, an amber-colored glaze. Both of these glazes were originally types of celadon and were basically ash glazes containing iron. The yellow glaze contained a smaller amount of iron than the amber-colored one. Either the Seto potters did not understand the principles of reduction or they preferred the yellow and amber colors to the green and gray-green that would have resulted from controlled reduction firing.

Along with the yellow and amber glazed wares of the period we find *temmoku*-type bowls (the glaze for which contained a much higher percentage of iron than either the yellow or amber glazes) being made at Seto. Toward the end of the sixteenth century the amber glaze was replaced by a brown glaze now known as *ko-zeto* ("old" Seto) glaze. The growing popularity of the tea ceremony and the resulting demand for tea utensils during the latter part of the sixteenth and the early seventeenth century resulted in a great increase in *temmoku* teabowls and imitations of Chinese Ming tea jars and caddies.

Toward the close of the sixteenth century the Karatsu potters started to make a hard-fired pottery. It was glazed with either an opaque, milky-white glaze or a transparent yellow-green glaze. The white-glazed ware became known as Seto Karatsu. Nakazato says the glaze was composed of nothing but feldspar. The yellow-green glaze was a type of primitive celadon and probably contained wood ash. It was also during this period that Shino ware and Oribe ware were first made at the Mino kilns near Seto.

Shino ware was made of a clay containing a low percentage of iron and firing a pale cream color. The glaze is a thick white feldspathic glaze, becoming semi-transparent when thinly applied. The two main types of

Among the potters imported by the daimyos were some who were skilled in working with porcelain. And with Risampei's discovery of porcelain stone at Izumi-yama, porcelain manufacture spread rapidly throughout the country.

Once porcelain was available, there was no longer a limitation as to the types of decoration or glaze that could be used. Over the years, the various centers where ceramics are produced have established prefectural experimental stations where potters and technicians are constantly at work solving problems for the pottery producers of their area. Kyoto is one of the large manufacturing centers of ceramic products in Japan and, as such, maintains a research institute.

Salt Glazing

Although the process of salt glazing—*shio-gusuri*—originated in Germany, Kakō Morino feels that, after thirty years of use, it has become a true Japanese technique for him. At first he simply fired his ware to its maturing point and then salted it. That is to say, he threw common rock salt (NaCl) into the firebox, where it vaporized. The sodium combines with the silica and alumina in the clay to form a glaze on the surface of the ware.

Over a period of ten years Morino became dissatisfied with the results he was getting. His dissatisfaction led him to experiment with white engobe and a black pigment composed of manganese and iron. He likes the bleeding-through of colors he gets from the engobe and pigment under a salt glaze.

However, he feels that pottery form as well as decoration should express the age in which we live, and his constant experimentation with both leads to many variations (*Fig. 129*). His procedure for salt glazing in his single-chamber downdraft kiln is as follows:

He fires with gas until the kiln reaches 1300° C. At this temperature he turns off the gas and uses wood as fuel. Then the first charge of salt is thrown onto the wood. Each time he salts, he loses about fifty degrees of temperature. He continues firing until the kiln is again up to temperature, salts a second time, and so on for three saltings over a period of three hours. Then he turns off the kiln.

Salt glaze is a transparent colorless glaze unless impurities such as

iron are absorbed by it from the clay body, or unless coloring pigments, such as iron or cobalt, are applied to the clay before firing.

Shōji Hamada says that in his Mashiko kiln, which is a three-chamber *nobori-gama*, he fires up to 1300° C., then salts under oxidizing conditions (*Plate 19*). Some potters prefer to manipulate the dampers so that reducing conditions are present before and during the salting process. Reduction before or during salting can produce interesting variations in body color and glaze texture.

The first few times a kiln is used for salt glazing, most of the sodium from the salt is absorbed by the bricks in the kiln (*Fig. 40*). After a few firings the inside surface of the kiln becomes coated with glaze, and from then on the process goes smoothly.

In a kiln that has been used for several years, as Hamada's has, salting becomes a simple process. He finds that at the present time a single salting is sufficient. He uses wood for fuel, and he throws salt on the wood from each side of the two chambers. He does find, however, that a two-chamber kiln has disadvantages for salt glazing. Sometimes the second chamber gets too much salt by the time both chambers have been salted.

Superimposed Glaze Decoration

SUPERIMPOSED glaze decoration requires that the glazes used fuse at the same temperature, that none of them be excessively fluid, and that they work well when one is applied over the other, without boiling, blistering or bubbling, especially when they are used in patterned combinations. In the recent work of American potters, use has been made of one glaze over another, specifically because they do boil during firing. As long as the boiling glazes have an opportunity to smooth themselves out before the kiln is turned off, such boiling or bubbling can result in attractive color texture or mottling (*Fig. 130*).

Dipping

After the first coating of glaze has been applied to the pot, it is permitted to sit until the glaze coat no longer glistens. It is then ready for the super-

Fig. 123. A Karatsu "cylinder" teabowl with iron underglaze decoration. Iron decoration can be spontaneous and bold, or be elegantly delicate as on this teabowl, harmonizing with the size, shape, thickness and "feel" of the piece.

UNDERGLAZES, GLAZES AND ENAMELS 201

Fig. 124. To produce the shadow pattern on red Raku ware, charcoal is dropped into a fireclay box with the biscuited pieces. The burning wood under the box ignites the charcoal, and carbon impregnates the ochre slip in a random pattern.

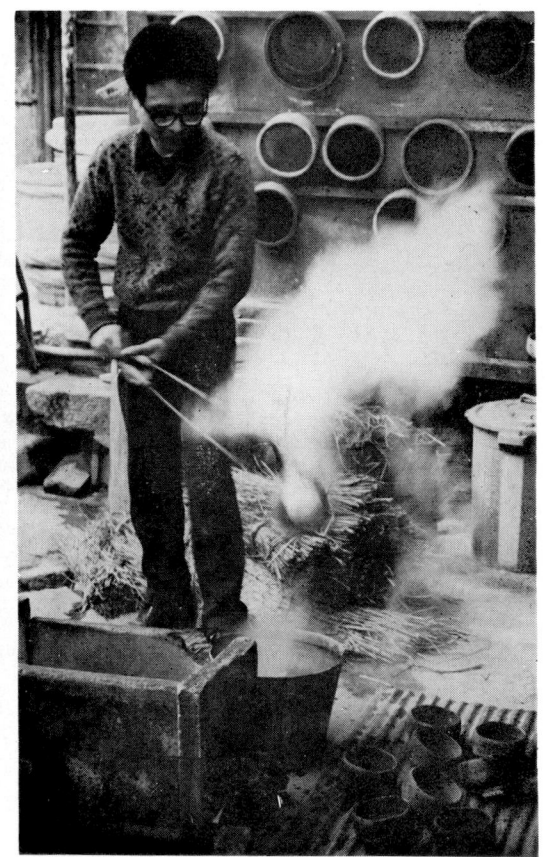

Fig. 125. After removal from the charcoal firebox, the red Raku bowls may be allowed to cool, or may be dipped immediately into water as pictured here.

Fig. 126. Long-handled tongs are used to place glazed Raku ware in the kiln and to remove it after firing. Special kiln mittens are also used by the Raku potter. (a) kiln mittens; (b, c) tongs for red Raku and Raku glaze colors other than black; (d) tongs for black Raku; (e) black Raku kiln charcoal tamper.

Fig. 127. Waraku Kawasaki taking a red-hot piece from the kiln. It will be set on the fireclay slab at the lower right to cool. The percussive sound of the cooling plates is likened to the sound of the metal windbells hung outside Japanese homes in summer.

UNDERGLAZES, GLAZES AND ENAMELS 203

Fig. 128. This blind *choka* (a pot for a strong, sweet-potato liquor) by Satarō Samejima of Naeshiro-gawa is an excellent example of **black Satsuma.**

Fig. 129. Large coil-built piece by Kakō Morino. A thin salt glaze over areas of colored slip provides a pleasing contrast.

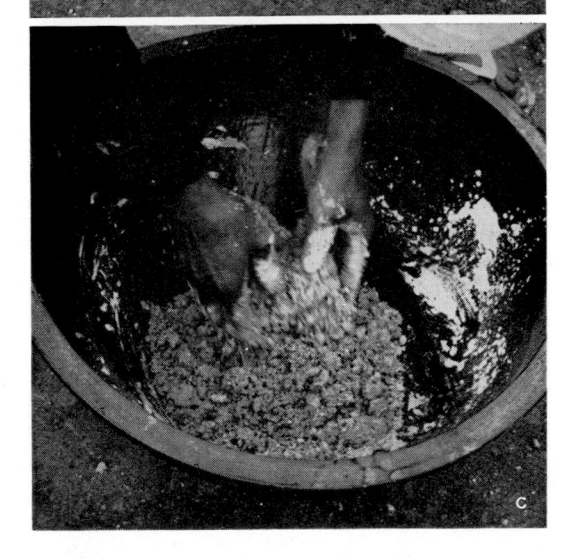

Fig. 130. The superimposed glaze mottling produced at Ryūmonji is called *donko* glaze.

 (a) The white glaze is carefully sifted.

 (b–d) The white glaze is mixed with *funori* and applied thickly on the biscuited piece.

UNDERGLAZES, GLAZES AND ENAMELS 205

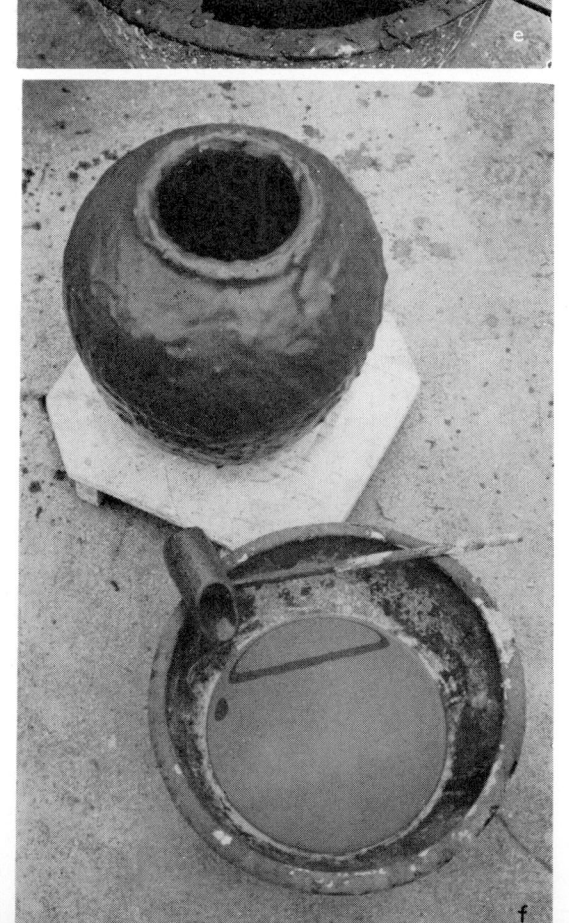

(e–f) An equally thick coat of black glaze is poured over the piece.

g

(g) The finished *donko* glaze piece.
This mottling process is unique to Ryūmonji.

Fig. 131. The decorative pattern
on this Mashiko mug was scratched
through the first glaze coat, after
which the piece was dipped in a
second glaze of a different composi-
tion.

UNDERGLAZES, GLAZES AND ENAMELS 207

Fig. 132. The neck of these saké bottles from Tamba (Tachikui) are decorated with superimposed glaze dipping.

Fig. 133. A large bowl by Sakuma showing thrown glaze decoration. Glaze throwing requires much practice before true understanding and mastery of the technique can be achieved. The glaze on this piece was thrown with a large *dami-fude*, and, Sakuma states, the piece was inspired by the violent summer thunderstorms that occur in the Mashiko area.

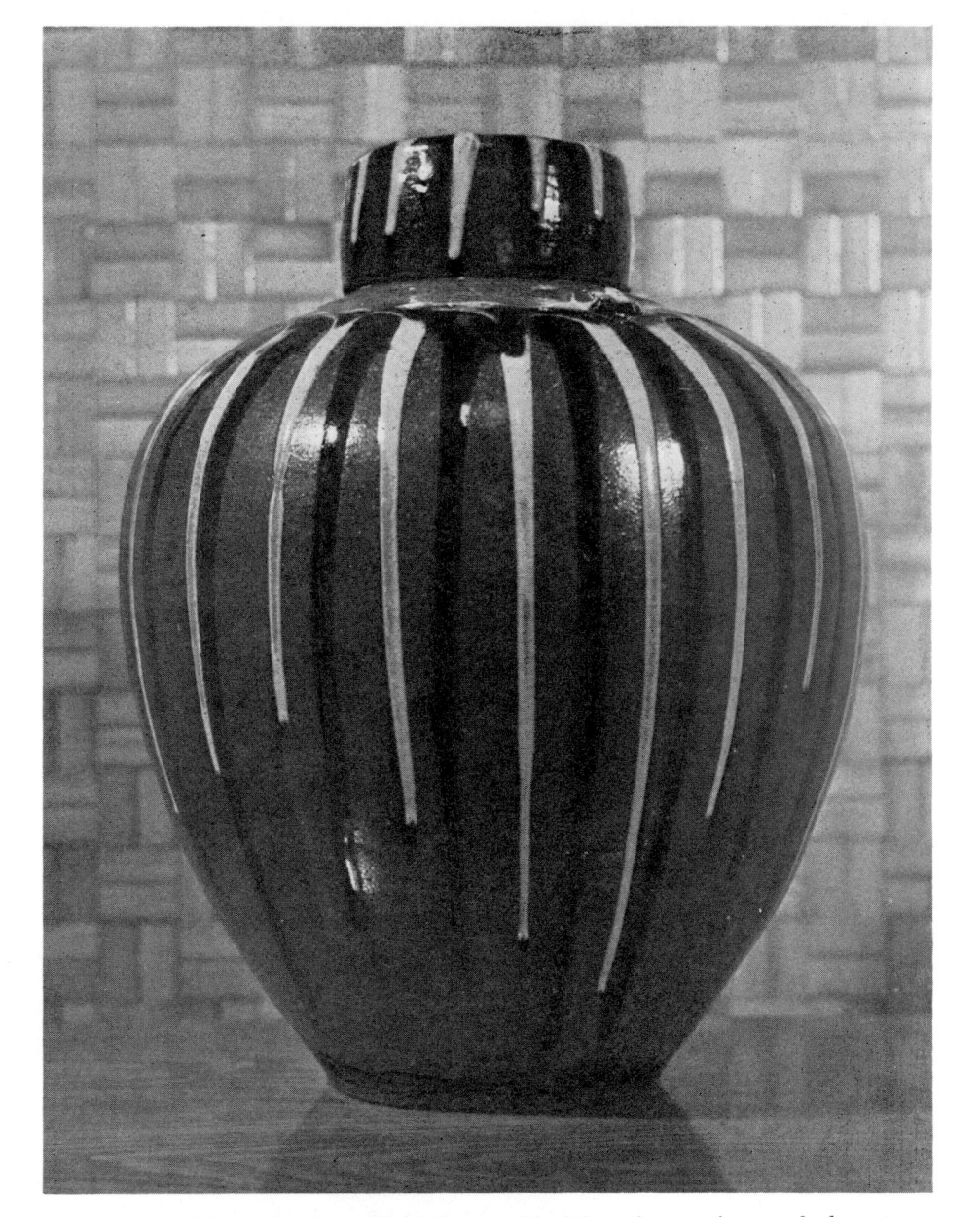

Fig. 134. This tea jar from Koishibara with dripped, superimposed glaze decoration and a monk's-hat cover was awarded a grand prize at the Brussels World Fair.

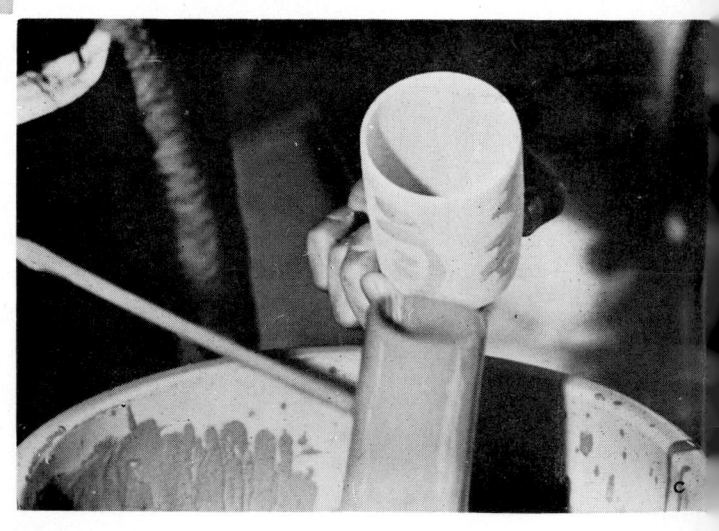

Fig. 135. Wax resist process by **Tetsu Yamada**. (a–b) The liquid wax solution is painted on the biscuited piece.

(c–d) Glaze is ladled into the piece and the excess poured out.

(e) The piece is then inverted and dipped into the glaze, which adheres only to the unwaxed surface.

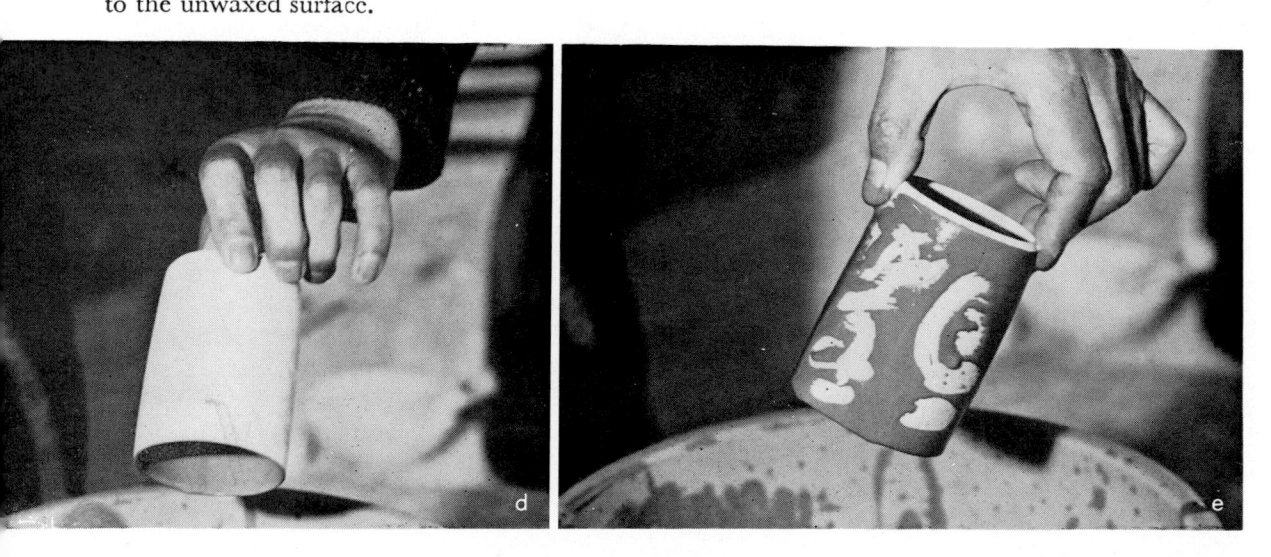

UNDERGLAZES, GLAZES AND ENAMELS 211

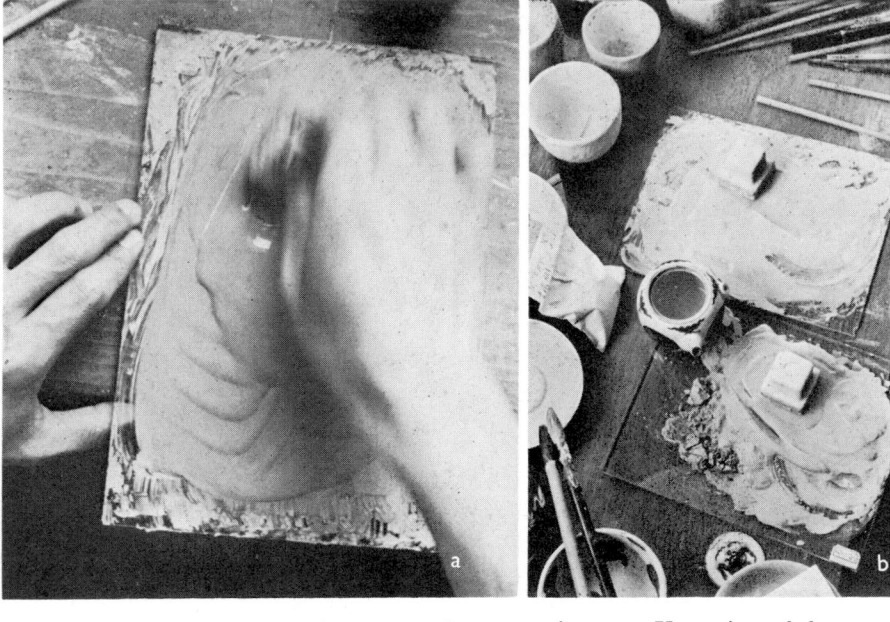

Fig. 136. Overglaze enamel preparation at a Kutani workshop. The overglaze enamel is ground with a small porcelain pestle on a glass plate.

Fig. 137. Painting overglaze enamel on Kutani porcelain.

imposed glaze dip. If the first coat of glaze were permitted to dry completely before dipping into the second glaze, both glaze coatings would peel off as they dried.

The decorative style of dipped pots has many variations. The glaze-coated pot may be grasped by the foot and submerged neck down to the desired depth in the different-colored glaze. When removed, it is held neck down until the excess glaze has dripped back into the tub.

The pot may be decorated in panels on the sides of the form by holding it by the neck and foot and dipping it lightly on two, three, or four sides in the tub of glaze. The potter's preference may be for the casual result, where part of the shoulder and neck are submerged in the second glaze color, as on the Tamba saké bottles shown in *Fig. 132*. More elaborate decorations are also possible. At Mashiko, the form may be dipped completely after decoration has been scratched through the underglaze coat (*Fig. 131*).

Painting

The painting by brush of one colored glaze over a previously applied coating of unfired glaze of a different color can be a very free or a very laborious technique. The process is described by Tomimoto as being of European origin.

The Dutch, after importing the Chinese blue-and-white, wanted to copy the Chinese product. Not understanding the porcelain body or, more probably, not having porcelain available, they used a white-tin enamel and painted cobalt, mixed with a little glaze, on top of the white enamel coating. After the decoration was completed, a thin coat of transparent glaze was applied over it before firing.

The work of Kanjirō Kawai probably shows the free Oriental brush-painting style of superimposed glaze painting at its best (*Plate 22*). The rectangular vase shows the use of common limestone glaze applied over the biscuit, after which cobalt oxide, copper oxide, and iron oxide, each separately mixed with a small amount of glaze, are painted onto the glaze coating. When the piece is fired, the colored glazes sink into and combine with the glaze coating.

The piece shown has been fired in a reducing fire that has changed

the copper from green to red and has to a limited degree influenced the color resulting from the cobalt and iron. Tomimoto explained the technique as first glazing the piece, then painting the entire glazed surface with *funori*. Ten minutes later it is painted with oxides in a small amount of glaze.

The Japanese potter's skill and patience in the execution of elaborate and detailed superimposed glaze-painted decorative patterns is unsurpassed. Magosaburō Tokuriki has done more to develop the technique than any other potter in Japan. His work has all of the refinement of overglaze enamel decoration but is entirely different in quality. His primary interest in superimposed glaze painting as a technique for individual work has been in the use of pure color and in patterns that are unique and uninfluenced by tradition.

The development of such decoration requires careful planning in color harmony, pattern, and glaze composition. The process as it is used by Tokuriki involves the following steps:

First, carefully planning a decorative pattern that is harmonious with the form.

Second, selecting colors based on a color palette previously developed through experimentation.

The base coat of glaze, of whatever color desired, is prepared and applied to the biscuited piece. The base coat of glaze should contain a large amount of *funori*. The *funori* hardens the glaze coating and protects it against damage when handled during the decorating process. When the glaze coat is completely dry, the decorative pattern is sketched on its surface with either a soft lead pencil or Japanese ink. The decorating colors are then painted in pattern on the glaze coating.

The jar in *Plate 24* was first painted with a matt black glaze coating. When the black glaze was dry, the decoration was painted in green glaze, starting with the top and bottom rows, where the green color is strongest, and ending at the middle. After painting each row, the green glaze was covered with white glaze, the quantities of white increasing toward the middle of the pot. The body of the piece is half Shigaraki white stoneware clay and half porcelain. The glazes have a common limestone glaze base, and the piece was fired at 1225° C. in an oxidizing atmosphere.

Dripping

The technique of superimposed glaze dripping—*nagashi-gusuri* (literally, "glaze which is made to flow")—is particularly popular with the *mingei* potters of Koishibara, Onda, and Tamba, where it has been used as a decorative process for centuries. The technique usually consists of first applying an engobe of white slip. After biscuit firing, the piece is glazed with transparent glaze, and after this the different-colored glaze or glazes are dripped, from a syringe or from a bamboo tube, around the rims of bowls or on the shoulders of jars and bottles. On occasion, the white engobe may be omitted, and two colors of glaze may be used (*Fig. 134*).

Trailing

Superimposed glaze trailing has a strong resemblance to glaze dripping in that it makes use of the same tools: the syringe and the bamboo tube. The difference between the two is that the glaze trailing is in a controlled pattern, while the dripped glaze relies on semi-control and gravity for its effectiveness. As in any superimposed glaze decoration, the glazes must be harmonious in combination yet must provide sufficient contrast to be interesting as well.

The plates from Ushinoto in *Plate 21* show *kimachi* stone used for the base glaze coat, with a refractory ash glaze trailed in pattern on top of the dark-brown glaze.

Throwing

Kumao Ōta explains that throwing glaze is a very old traditional technique of Koishibara. He favors engobe-coated pieces because he feels that the white engobe gives a very soft appearance and provides a background for thrown, colored glaze. To become skilful at throwing glaze requires long experience and careful study in order to produce a result where the thrown glaze is in harmony with the form. Ōta says that experience and study is the foundation leading to the ability to throw glaze in such a manner that the result is dynamic, free and uncontrived.

The glaze to be used for decoration is scooped up by the handful or in a small cup and thrown on the surface of the unfired glaze coating of the piece. A large *dami-fude* can also be used (*Fig. 133*).

Wax Resist and Superimposed Glaze

The use of wax resist in combination with superimposed glazes is a favorite method of Tetsu Yamada, who has great skill as a calligrapher. He is also considered by many to be one of the most accomplished makers of teabowls in Japan. Neither of these accomplishments is surprising, since Yamada was a Buddhist priest and master of a temple when he was twenty-two. At thirty-four he started seriously to study pottery, and ten years later gave up the priesthood.

The wax-resist technique consists of first glazing the biscuited piece with a coating of glaze of the color desired for the decorative pattern. The glaze should contain *funori*. When the glaze coat is dry, the decoration is painted on with wax (*Fig. 135a, b*). After the wax has hardened, a coat of a different-colored glaze is applied over the first coat of glaze.

The wax prevents the second glaze from adhering to the decorated areas (*Fig. 135c–e*). When fired, the decoration appears in the color of the first glaze coating, while the background for the decoration is the color of the second glaze. Kanjirō Kawai has also developed wax resist and superimposed glaze to a delicate complexity (*Plate 23*).

Glaze Inlay

The work of Suiko Itō best represents the technique of glaze inlay. The process requires great skill and patience, and is particularly suited to porcelain. In the past, his work has been entirely in porcelain with green, yellow-green, or copper-red expertly inlaid under the commercial lime glaze to which he added twenty percent common ash (*Plate 24*).

The carving is done when the piece is leather-hard to avoid chipping. After biscuit firing, colored commercial lime glaze containing *funori* is brushed into the carving. When the colored glaze is completely dry, the surface is scraped and sanded free of any color not in the carved areas. The piece is then ready to be glazed and fired in a reducing fire.

Overglaze Enamel Decoration

BY THE middle of the seventeenth century, overglaze enamel decoration (painting on top of the fired glaze with very viscous, low-fire glazes and subsequently firing the decorated ware at a low temperature) was started in Japan by Kakiemon I. His style was the style of the Chinese enameled wares of the Ming dynasty.

The present thirteenth-generation Kakiemon Sakaida hopes to continue the traditional work, with a modern sense added. He finds that foreigners have a preference for the style of the three-hundred-year-old traditional work: thus it is necessary for his studio to produce both types of ware.

In the years before his death in 1963 at the age of eighty-four, the father, the twelfth-generation Kakiemon, limited himself to the mixing of the *kaki* ("persimmon red") color from which the name Kakiemon originated. At that time, the thirteenth-generation Kakiemon was competent in mixing the color, but his father was not satisfied with the color the son mixed. The elder Kakiemon explained that making the color is very difficult, and that even to tell his son how to do it was so complex that he preferred to do it himself. The *kaki* color is made from iron oxide and other materials that must be mixed and ground properly. Even the hand action in grinding is important.

The body for Kakiemon ware is made from three types of porcelain stone from three mountains in the Arita area. The stone is very carefully selected for purity, crushed and screened, then mixed. Only about thirty percent of the clay is used. The remaining seventy percent is waste. In this way iron spots from the body are eliminated. The glaze contains ash of *isu* (*Distylium racemosum*) bark and leaves, and the overglaze enamels, other than the red, are old Chinese compositions (*Plate 37*).

About fifty years after Kakiemon I had started the first overglaze enamel decoration in Japan, the Imaizumi family of Arita became decorators of a fine type of porcelain product for the Nabeshima clan. At first the Nabeshima ware was only blue-and-white. Early in its history the enamel technique was learned from the Chinese in Nagasaki. The Imaizumi family received six hundred *koku* of rice and one hundred

ryō of money as payment for their work. They were the only enamel workers who had clan protection in Arita. All of the others who worked in enamel did so commercially.

The procedure followed in the production of Nabeshima ware is of unusual interest. Three hundred years ago the colored Nabeshima was made in the Okawachi mountains. After the ware was biscuit fired, it was brought by Nabeshima clan retainers to Arita to be decorated. While the enamel-decorated ware was being fired, the Nabeshima samurai stood watch at the house. When completed, the ware was guarded as it was returned to the clan castle in the mountains.

Imaemon Imaizumi is the twelfth generation of the family. He explains that, after the clan system was abolished in 1871, they started to make their own clay bodies and fired in a cooperative kiln for about twenty years. Around 1890 they built their own kiln, but in 1897 a poor business venture forced them to sell their house.

There followed a period of repeated failures because of insufficient knowledge of firing and poor kiln design. At the age of thirteen, the twelfth Imaemon was sent to the industrial school in Arita to study ceramics, and spent four years studying kiln construction and firing. After graduation he built a small single-chamber kiln that his mother called the Imaizumi "family treasure kiln." The new kiln was the means of reviving the family fortunes.

The traditional Nabeshima ware continues to be made. The old Nabeshima style is a flat bowl form with a high foot, which has a traditional blue-and-white comb-tooth pattern under the glaze and three underglaze blue patterns on the outside of the bowl. The inside decoration is in underglaze blue and overglaze enamel color. The glaze has an orange-peel texture resulting from the *isu*-wood ash in its composition. The most characteristic color of Nabeshima enamel is a blood red that is made from iron oxide. For Imaemon it is the easiest color to make.

In the early days of Japanese porcelain, both Kakiemon ware and Nabeshima ware contributed much to the fame of Japanese ceramics both at home and abroad.

While these wares were becoming established in Western Japan, another type of porcelain was attracting attention in Kaga Province (now Ishikawa Prefecture), where the house of Maeda had instituted

the Kutani kilns around the middle of the seventeenth century. Kutani ware was a bold, vigorous product in color, form, and style of decoration (*Plate 38*). It was from these two great centers of production that the blue-and-white enameled porcelain techniques spread throughout Japan.

Upon the introduction of the overglaze enamel technique into the Kyoto area, the potters of the region started to use overglaze enamel on earthenware. This enameled earthenware became known as Kyō ware. Kyō ware, as it developed, became Kiyomizu ware. The early Kiyomizu ware exerted great influence on the ware of many other areas, the most notable of which are the Kyoto Awata ware and the white Satsuma of Kagoshima.

Though Tomimoto worked in Raku and Awata ware, he was thoroughly convinced that porcelain was as truly Japanese folk pottery as the *mingei* peasant wares. If we examine the history of many of the remote kilns, we find that, as a general rule, at some time in their past porcelain had been manufactured. As the first "individual" potter of Japan, Tomimoto selected as the area for his specialization the blue-and-white porcelain and the overglaze-enamel porcelain.

In the early days of Japanese pottery, there was a good white clay in Kyoto that was used for porcelain, but it has long since been used up. Later it was the practice to transport white clay by horseback over the mountains from Shigaraki. After Ninsei (three hundred years ago), an excellent porcelain clay was found in Kyushu. This clay was in the form of a soft stone, known as Amakusa stone, that had previously been used as a sword-sharpening stone. It was crushed by water mill and used for porcelain. At the present time Amakusa stone is used throughout Japan for porcelain bodies.

The Kyoto artist-potters have no machines for preparing bodies, so they purchase prepared, commerical, ball-mill-ground porcelain bodies, which in some ways are inferior to the old water-mill-ground bodies. The clay particles are too fine and are rounded by milling. When crushed, they retain a flat angularity. The rounded particles work best for casting but, coupled with excessive fineness, will cause thrown pieces to crack in the center after drying. Clay for use on the wheel must be plastic. Amakusa stone is not a plastic clay, so another clay with a high degree of plasticity must be added.

UNDERGLAZES, GLAZES, AND ENAMELS 219

In Japan there are two kinds of fireclay. The first, *kibushi-tsuchi*, "wood-knot clay" (ball clay), causes a dull feeling in porcelain. The porcelain is discolored and not a pure porcelain color. The second, *gairome-tsuchi*, "frog-eye clay" (fireclay), is mined near a granite area. The granite has decomposed, and all impurities have been washed away, leaving only the purified clay stata. The upper strata of ball clay deposits are *gairome*.

Overglaze Enamel Wares
(Earthenware and Kōchi-yaki)

The *uwae* (upper pattern of colors on the glaze) has persisted in the traditional form and style of Ninsei in the contemporary Awata ware of Kyoto and the white Satsuma of Kagoshima Prefecture. Tōzan Itō of Kyoto is the third generation bearing the name Tōzan and the last of the traditional Awata ware potters.

Itō explains that the original clay used for Awata ware was Kyoto white clay, which had a very special quality and which is no longer available. When fired, this Awata clay was pinkish tan in color with a fine-mesh-crackled, transparent glaze decorated with overglaze enamels. At the present time Itō uses Shigaraki white clay mixed with other clays, and the result approaches the clay of the old Awata ware. The body color and the fine-mesh crackle are the greatest problems in making Awata ware, but he has solved them satisfactorily (*Plate 30*).

Tomimoto also worked with Awata ware, and explains the process as follows:

"A special point of Awata ware is the pale reddish-yellow color, which permits the use of white enamel in the decoration. A piece made of Shigaraki clay with a little iron in it is biscuit-fired to Seger cone 8 and glazed with lime glaze containing about ten percent ash. The ware is fired in an oxidizing fire. The enamel can be applied thickly to Awata ware, since when it is fired at 700° C. the melted enamel color sinks into the crackle of the glaze, which expands during the decorating firing. Enamel on Awata ware will not peel regardless of how heavily it is applied."

The white Satsuma ware is similar to Awata ware in appearance. It

has a creamy fine-mesh crackle glaze with overglaze enamel decoration, but has a whiter body (*Plate 29*).

Kōchi-yaki derives its name from Cochin China, and *kōchi*, as used by the Japanese, apparently means South China, where the ware originated. In Japan, Kōchi-yaki means green and other color-glazed wares decorated in low relief. Tomimoto thought of Kōchi-yaki as resembling majolica: Italian Renaissance pottery. The porcelain is glazed inside with a high-temperature glaze and then fired in a high-temperature biscuit fire that matures the glaze inside. Enamel colors are then applied directly on the biscuit on the outside of the piece. If thick, intense colors are desired, they are built up in successive thin layers and fired after each thin application. Red enamel cannot be used for Kōchi-yaki since it relies greatly on the glaze for adherence to the piece. Mauve, yellow, green, and transparent colors are used (*Plate 26*). The Chinese Ming dynasty potters used impressed lines and slip ridges to prevent the mixing of the different colored enamels used in decoration.

Overglaze Enamel Painting

Some of the fine Japanese overglaze enamel-decorated pieces rely on a combination of underglaze blue and overglaze enamel color for their pattern. Others may be complete with enamel color alone, while still others make use of the blue underglaze, enamel and gold, or gold and silver. The porcelain piece is first biscuited and then glazed and glost fired.

The Glaze

The early Japanese overglaze enameled wares were glazed with a high gloss glaze, and there was no peeling. Enamel peeling often occurs after the glaze firing. The lime glaze now used on porcelain was a European import during the Meiji period of industrialization.

Tomimoto found that the lime glaze would often cause the enamel to peel, so he experimented with an adjustment. After repeated experiments, he found that the addition of twenty percent common ash (used by the dyeing industry) solved the problem. The ash must be very thoroughly washed.

The iron in the glaze will cause a pale green color to develop when the ware is fired. The green color provides a pleasant contrast with the red enamel color (*Plate 39*). Before being painted with enamel, the glaze surface is painted with a very thin solution of bone glue, or it may have saliva rubbed over it. After the glue coat is dry, the general plan or outline of the decoration is sketched on the surface with a soft lead pencil or with *sumi* (Japanese ink).

Preparation of Enamel

The red enamel is ground with water on a rough glass slab, and a porcelain pestle is used for grinding (*Fig. 136*). Ordinary plate window glass may be roughened with emery cloth before use. If the glass is not roughened, the pestle will slip on the surface. After it has been thoroughly ground, the enamel is thinned with water, and one coat is painted over the glazed surface of the pot (*Fig. 137*). When dry, the pot is fired to 800° C. This process is repeated until the desired intensity and uniformity of color have been secured. It may require three or four separate applications and subsequent firings. The red-enameled surface is used as a base for the application of gold and silver.

Other colors are mixed with *funori* solution instead of water and applied over the glue-covered glaze surface. To get a uniform color and a uniform surface is extremely difficult (*Plate 40*). For thick color application a large brush is used. The enameled piece is fired to or at 800° C.

It is of interest to note that, in the past, cheap export wares were enameled by painting the glaze surface with lacquer. When the lacquer was partly dry, red enamel powder was dusted on from a cloth bag. This insured an even coating, since the lacquer would hold only sufficient enamel to coat the surface.

Enamel with Gold

The primary purpose of the red-enameled surface is to provide a ground or foundation for decoration in various metals. Any metal can be used, but the most common are gold and silver.

Gold must be fired at a lower temperature than the enamel upon which

it is applied. If it is fired at too high a temperature, its weight will cause it to sink into the enamel, and the pattern will be lost. Gold will adhere to enamel at about 600° C.

The kiln for firing gold is of simple construction. The contemporary kiln is heated by electricity. Steam in the kiln during firing may cause loss of color in the gold, or it may cause the gold to peel from the enamel after firing. Tomimoto recommended the use of the electric kiln for biscuit firing some ware prior to firing the gold-decorated pieces. His suggestion was: "Fire the biscuit to 800° or 900° C., permit the kiln to cool, remove the biscuit, and immediately stack and fire the gold. If there is no ware to be biscuited, pre-heat the kiln to full red heat, cool, then stack and fire the gold at once."

The lid of the kiln has an observation port through which the ware can be watched during firing. Test pieces are suspended on nichrome wire hooks around the observation port (*Fig. 47*). During firing, when the potter, through observation, thinks the ware is approaching maturity, he removes a test piece and checks it with an agate burnisher that has been dipped in water. If burnishing removes the gold from the enameled test piece, he continues firing for an additional five to ten minutes, then checks another test piece. He continues checking test pieces until the gold does not come off when burnished. Then the kiln is turned off, and the ware permitted to cool. When the ware is removed from the kiln, all of the gold decoration is slowly and gently polished with the agate burnisher and water. After burnishing is completed, the surface is polished with a clean linen cloth (*Plate 41*).

The final ten minutes of firing are the most important. The ware must be very carefully watched during that period.

In preparing the gold for painting, the gold powder is placed in a small shallow metal tray about three inches in diameter. Water and a thick glue solution are added to the powdered gold. The tray is then placed over a charcoal fire or an electric hot plate that will provide a low heat. The solution is stirred with a common Japanese brush cut off about 3/16 of an inch below the handle. When the solution is smooth and warm, the decoration is painted. The gold should be applied thickly and must be very fine-grained for any fine lines of decoration.

UNDERGLAZES, GLAZES, AND ENAMELS 223

Gold leaf is very thin, and about five thicknesses should be used for satisfactory results in most decoration.

Here Tomimoto advised: "Stack the layers of gold leaf on top of each other; then place them between two pieces of paper, upon the outside of one of which has been drawn the outline of the desired decorative motif. Fasten the paper-covered gold leaf with three or four paper clips or staple it together.

"With very sharp scissors, cut through the paper and gold, following the drawn outline. Apply a thin glue solution to the enameled surface and press the cut-out gold firmly and smoothly onto the glue-coated surface. Follow the same procedure for firing as for painted gold. After firing, burnish with an agate burnisher and water. Polish with a clean linen cloth."

Enamel with Silver

The following are Tomimoto's suggestions regarding the use of silver: "Silver melts at a lower temperature than does gold, and must be fired with equal care. Silver powder is prepared and applied in the same manner as gold, and the firing procedure is the same, except that firing will be completed at a lower temperature. After burnishing, wash the silver with soda or toothpowder and polish with a chamois. The main disadvantage in using silver is that in time it will tarnish and turn black."

Enamel with Gold and Silver

The use of gold and silver on the same piece has always been a difficult process. The difference in the melting point of the two metals makes two firings necessary. The old method was first to apply and fire the gold and then to apply and fire the silver at a lower temperature. The probability of spoiling the whole piece during the second firing was so great that few potters would attempt to use the two metals together.

The problem was solved by Tomimoto, and its solution will probably rank as one of the great accomplishments of all time in the overglaze decorating field.

The first step in solving the problem was the addition of powdered

gold to the silver. This raised the melting point sufficiently so that both gold and silver decoration could be fired in a single fire. The silver had a yellowish color which Tomimoto considered undesirable. After much experimentation he found that ten percent platinum powder added to the silver-and-gold combination restored the silver color and adjusted the fusion point so that a single fire for both metals was possible (*Plate 42*).

This was an important discovery. At least as important, however, was the discovery that, in adjusting the fusion point of silver, he had found a combination of metals that gave a good clear silver color, yet did not tarnish.

In continuing his experimentation during recent years, he found that it was not necessary to add gold to the silver. He then used silver powder to which twenty-five to thirty percent platinum powder had been added, with equally satisfactory results in fusion point and non-tarnishing qualities.

Gold can be used satisfactorily on any color of enamel. It was Tomimoto's opinion, however, that it lacked strength when it was used with colors other than red. The fusion temperature of gold when used on other enamel colors is lower than it is when used on the red background. As a result, other colored enamels, when used in combination with gold, must be fired separately from the red-and-gold combination.

All gold and silver firing was formerly done with pine wood as fuel. Today, pine wood is too difficult to get, and wood firing takes so long that an electric kiln is used.

CHAPTER VI

TEA AND THE JAPANESE POTTER

TEA, WHICH is native to southern China, was first used as a medicinal herb. In ancient times, as Kakuzō Okakura tells us in *The Book of Tea* (from which the following history of tea has been adapted), it was believed capable of "relieving fatigue, delighting the soul, strengthening the will, and repairing the eyesight." It was also used externally in paste form as a poultice for rheumatism, as well as an internal medicine.

The Taoists made use of it and considered its use essential to achieve immortality. The Buddhists used it at first to prevent drowsiness during the long hours of meditation, and later as a ritual.

The Buddhist monks of the Southern Ch'an sect (the Chinese precursor of Zen) were greatly influenced by the Taoist doctrines and ultimately developed the practice of a formal gathering in front of the image of Bodhidharma, where tea from a single bowl was drunk "with the profound formality of a holy sacrament." This ritual was the basis for the development of the Japanese tea ceremony.

Tea has passed through a number of developmental stages, which might be compared to periods in the development of art. They may be considered as the block- or cake-tea period, the powdered-tea period, and the leaf-tea period. The ways in which tea has been used indicate the emotional tones of definite eras. Cake tea was an expression of the classic feelings of the T'ang dynasty, and during this period it was boiled. Powdered tea expressed the deepest romantic feelings of the Sung dynasty, and was whipped with a bamboo whisk. Leaf tea expressed the natural-

istic feelings of the Ming dynasty, and throughout the leaf-tea period, which still prevails, tea has been steeped.

Tea was not native to Japan, but as early as A.D. 729 the Emperor Shōmu served tea to one hundred monks at his palace in Nara. It was not until 801, however, that the monk Saichō brought the first seeds to Japan and planted them on Mt. Hiei.

Again, in 1191, the Zen priest Eisai, who had gone to China to study the Southern Ch'an school, returned with additional seeds and planted them in different places. The rapid spread of the Southern Zen philosophy carried the tea ritual and the tea ideal of the Sung Chinese to all parts of Japan. By the fifteenth century the tea ceremony had become an independent secular performance, largely because of the patronage of the Shogun Yoshimasa Ashikaga. But it was more than a performance; it was the stage, the matrix, the nourishment for the growth of a unique esthetic that subsequently came to permeate Japanese thought and art, and it created a taste and appreciation of ceramics still very much alive today.

With the secularization of the tea ceremony, there arose certain individuals whose understanding of tea and depth of perception of beauty led to their designation as tea masters. These men interpreted the formalities and the esthetic of tea, and thus set the standards of the tea ceremony and of an aristocratic taste, which later diffused and spread throughout the population of Japan. They selected the utensils to be used in the ceremonial serving of tea, and, rejecting the extraordinary, they favored the unpretentious items of everyday life that originally had no connection whatever with tea. These men saw and appreciated the unusual beauty in the common, the simple, and the ordinary. They were true connoisseurs and, as such, selected items that the Japanese describe as *shibui*—literally, "tastefully astringent," but better defined by Sōetsu Yanagi as having "a profound, unassuming, and quiet feeling."

Over the past five centuries the tea ceremony has continued in Japan. Throughout that period of time it has had a lasting effect on the work of the Japanese potter. In the late sixteenth or early seventeenth century the tea master Kobori Enshū selected the seven kilns whose ware he felt best suited to the needs of the tea ceremony. The seven kilns he chose were Takatori, Agano, Shidoro, Akahada, Zeze, Asahi, and Kosobe.

The first six types of ware continue to be made today, and although the seventh kiln, Kosobe, has been demolished, there is today a movement under way to rebuild it and revive production.

In addition to these kilns, the majority of individual contemporary potters produce tea-ceremony ware. In fact, the potter who does not is the exception. Some potters, such as Ariyama and Nakazato, limit themselves almost exclusively to making wares that have some connection with the tea ceremony.

Says Kakuzō Okakura in *The Book of Tea*: "Our pottery would probably never have attained its high quality of excellence if the tea masters had not lent to it their inspiration, the manufacture of the utensils used in the tea ceremony calling forth the utmost expenditure of ingenuity on the part of our ceramists."

There is probably no other single factor that has influenced ceramics to such an extent or over such a long period of time as has tea.

TECHNICAL INFORMATION FOR THE POTTER

TABLE OF PYROMETRIC CONES

PYROMETRIC cones are elongated trihedral pyramids composed of the various materials (chemical and mineral) used in ceramic bodies and glazes. They are made in graded series and composed so as to deform at approximations of set temperatures. They measure heat work that has been accomplished in the firing chamber of a kiln during a single firing cycle, but cannot be used a second time. Their deformation (bending) is the indication of completion of the firing of the ware.

The Seger pyrometric cone is of German origin, and the Orton Standard pyrometric cone is of American origin. The following table presents a comparison between the Seger and Orton cones and their approximate temperatures of deformation.

Seger Pyrometric Cone	Centigrade	Fahrenheit	Orton Standard Pyrometric Cone	Centigrade	Fahrenheit
022	600°	1112°	022	585°	1085°
021	650	1202	021	595	1103
020	670	1238	020	625	1157
019	690	1274	019	630	1166
018	710	1310	018	670	1238
017	730	1346	017	720	1328
016	750	1382	016	735	1355
015	790	1454	015	770	1418
014	815	1499	014	795	1463
013	835	1535	013	825	1517
012	855	1517	012	840	1544
011	880	1616	011	875	1607

Seger Pyrometric Cone	Centigrade	Fahrenheit	Orton Standard Pyrometric Cone	Centigrade	Fahrenheit
010	900	1652	010	890	1634
09	920	1688	09	930	1706
08	940	1724	08	945	1733
07	960	1760	07	975	1787
06	980	1796	06	1005	1841
05	1000	1832	05	1030	1886
04	1020	1868	04	1050	1922
03	1040	1904	03	1080	1976
02	1060	1940	02	1095	2003
01	1080	1976	01	1110	2030
1	1100	2012	1	1125	2057
2	1120	2048	2	1135	2075
3	1140	2084	3	1145	2093
4	1160	2120	4	1165	2129
5	1180	2156	5	1180	2156
6	1200	2192	6	1190	2174
7	1230	2246	7	1210	2210
8	1250	2282	8	1225	2237
9	1280	2336	9	1245	2273
10	1300	2372	10	1260	2300
11	1320	2408	11	1285	2345
12	1350	2462	12	1310	2390
13	1380	2516	13	1350	2462
14	1410	2570	14	1390	2534
15	1430	2606	15	1410	2570
16	1460	2660	16	1450	2642
17	1480	2696	17	1465	2669

	SiO_2	P_2O_5 (phosphoric acid)	Al_2O_3	Fe_2O_3
isu-wood ash	34.60	3.93	4.38	0.49
pine ash	24.39	2.78	9.71	3.41
rice-hull ash	96.00	0.02	1.00	0.04
bamboo ash				
rice-straw ash (100.25)	40.00	2.51	1.13	0.26
common ash (*dobai*) (99.42)	30.99	1.91	8.91	3.04
nara (oak) wood ash				
kusu (camphor) wood ash				
bone ash (99.56)	2.71	40.88	Tr	0.32
Fukushima feldspar (99.72)	65.26		19.10	0.09
Shiraishi feldspar				
Hatoyama feldspar	regional feldspars used by rural potters			
kasasa feldspar				
Amakusa stone (100.16)	77.21		15.13	0.36
kimachi stone (100.04)	61.28		15.86	5.88
akako (Mashiko clay) (100.09)	63.97	0.22	13.48	6.16
Kamogawa stone (100.13)	47.88		14.21	14.80
Somoda clay	similar to Mashiko clay			
#2 *yusha*	a boardlike stone with a 21% iron content			
#2 *shaju*	a stone containing 5.9% iron			
Okawachi stone	a natural iron stone			
odo (ochre clay) (96.39)	58.61		18.50	10.44
gairome (fireclay) (99.31)	46.54		37.68	1.03
Shigaraki clay (100.05)	57.55		27.13	1.98
Bizen clay	62.80		22.10	3.20
limestone	a natural calcium carbonate			
glass powder (99.94)	68.70		2.35	0.05
magnesite (99.43)	7.54		0.88	0.20
kaolin (Korean) (100.01)	45.24		38.96	0.76
shiratama (powdered lead glass or frit)	composition = 50% basic lead carbonate; 39% quartz (SiO_2); 11% calcined borax			

GLAZE MATERIALS

CaO	MgO	K$_2$O	Na$_2$O	MnO	TiO$_2$	L.O.I.
47.71	5.99	2.51	0.06	0.33		
39.73	4.45	8.98	3.77	2.74		
0.48	0.22	0.90	0.26	0.19	0.16	0.96
3.07	1.38	3.57	0.77	0.30		47.26
22.42	3.30	3.91	2.33	1.26		21.44
52.44	1.33					1.88
0.26	0.23	9.82	4.60			0.36
0.17	0.18	3.12	Tr			3.99
5.36	1.88	1.36	3.68	0.23	0.63	3.94
3.48	1.81	1.69	2.31	0.19	0.67	6.11
7.08	4.12	1.34	3.92	0.52	2.33	4.02
0.20	0.95					7.69
0.44	0.30					13.32
0.48	0.22		2.38	1.50	0.41	8.40
0.67	0.86	2.15	1.90			6.57
8.46	1.71	1.22	16.69			0.76
1.48	42.13					47.20
0.96	0.26					13.83

JAPANESE GLAZE COMPOSITIONS

LEAD GLAZES

RAKU UNDERGLAZE COLORS

OVER the years the term Raku has come to mean low-fire ware. The following compositions for underglaze Raku colors were presented by Tomimoto as those developed by Kenzan. Kenzan VI is the potter with whom Bernard Leach first studied.

Blue

shiratama (powdered lead glass)	10
tonotsuchi (white lead)	15
blue cobalt (cobalt stain made by firing cobalt and silica together)	10

White

shiratama (powdered lead glass)	20
tonotsuchi (white lead)	80
keiseki (powdered silica)	20
shiratsuchi (special white clay)	100

Black

shiratama (powdered lead glass)	4
tonotsuchi (white lead)	4
manganese	10

Red

tonotsuchi (white lead)	2
shiratama (powdered lead glass)	2
benigara (red iron oxide)	1
odo (yellow ochre)	10

(Note: Red is a difficult color. Firing must not exceed 600–800°C.)

Green

shiratama (powdered lead glass)	35
tonotsuchi (white lead)	70
rokusho (copper powder)	70

(Note: If pure copper oxide is used instead of *rokusho*, only one-half of the amount should be used.)

Yellow

shiratama (powdered lead glass)	10
tonotsuchi (white lead)	5
benigara (red iron oxide)	1.5
sanka anchimoni (antimony oxide)	0.1 or 0.3

(Note: Prior to the last war *toshirome*—impure antimony oxide—was used instead of *sanka anchimoni*.)

The above underglaze colors are covered by a transparent Raku glaze. The following is Tomimoto's composition for this glaze.

Transparent Raku Glaze

shiratama (powdered lead glass)	10
tonotsuchi (white lead)	100
keiseki (powdered silica)	35

(Note: In ancient times *hino-oka* was used in place of *keiseki*. Hi-no-Oka was the name of the place between Kyoto and Otsu from which the silica sand was secured. *Hino-oka* is no longer used.)

OTHER LEAD GLAZES

LEAD glazes used in the Fujina area. These glazes fire at about 1260°C. and are made in transparent, yellow, and green. The transparent glaze composition is: feldspar, 10 parts; lime, 5 parts; white lead, 2 or 3 parts.

The yellow glaze is composed of the following materials: white lead, 10 parts; *kimachi* stone, 10 parts; lime, 2 parts; feldspar, 4 parts.

The green glaze is made by adding five percent copper oxide to the yellow glaze.

SOME FELDSPATHIC, ASH, AND LIME GLAZES

Tomimoto gave the following suggestions for *kaki* and *temmoku* glaze compositions.

kaki: Iron oxide plus lime, water-sifted. The iron oxide is obtained from yellow clay produced as a result of the disintegration of natural rock. When the clay is suspended in water, the yellowish iron oxide will sink. Use that which has settled in a stream below rapids or a step in the stream bed. To this, add varying increments of lime glaze.

kaki and *temmoku*: Mashiko stone, Seto *mizuchi* stone, and *kimachi* stone, plus ash. When ash is added to *kaki* glaze it will turn black, and when it flows, "rabbit-fur" streaks will result. 10–20% additions of ash will be sufficient, depending on the firing temperature. For "oil spots," add 10–20% Kamogawa stone to the black glaze and stir only slightly.

Fire the above glazes in a reduction fire. The rate of cooling will influence the resulting effect. Cool slowly for oil spots. Spots are usually better inside of bowls.

Among the feldspathic glazes of Korean origin that have become adapted to local conditions are the following:

Koishibara and Onda transparent: *akadani* stone, 4 parts; rice-straw ash, 2 parts; common ash, 4 parts. Since the materials are in water solution, the unit of measure is parts by volume.

Ryūmonji transparent: *tokusa*, 10 parts; *iwa*, 10 parts; kitchen wood ash, 10 parts.

Ryūmonji black: red sandy iron oxide, 10 parts; kitchen wood ash, 3 parts.

Ryūmonji *ame* (amber): red sandy iron oxide, 10 parts; kitchen wood ash, 16 parts.

Agano transparent: Hotoyama feldspar, 5 parts; oak or camphorwood ash, 5 parts.

Tarōemon Nakazato recommends the use of rice-straw ash to replace silica in glazes and the use of what he calls plate iron (which contains iron hydroxide and ferric oxide) from between strata in a coal mine.

The Shino glaze composition is: Fukushima feldspar, 60 parts; limestone, 10 parts; silica, 30 parts. It is fired in an oxidizing fire at Seger cone 8–9 (1290°C.)

For old *ao* Oribe the glaze composition is as follows: Fukushima feldspar, 20 parts; rice-straw ash, 80 parts; copper carbonate, 12 to 13 parts. For transparent, colorless glaze, the copper is omitted.

The Tamba bottles shown in *Fig. 132* are first glazed with common commercial limestone glaze containing iron oxide, which produces the brown. They are then dipped in black glaze composed of *kimachi* stone (60 percent), wood ash (40 percent), and a 5-percent addition of iron oxide. The dipped Mashiko mug (*Fig. 131*) uses Mashiko stone as the base glaze, with rice-straw ash or rice-hull ash glaze over the top.

TYPICAL JAPANESE GLAZES

The following glaze compositions are presented through the courtesy of Masatarō Ōnishi of the Kyoto Municipal Industrial Research Institute. A number of these glazes are illustrated in the accompanying glaze color chart.

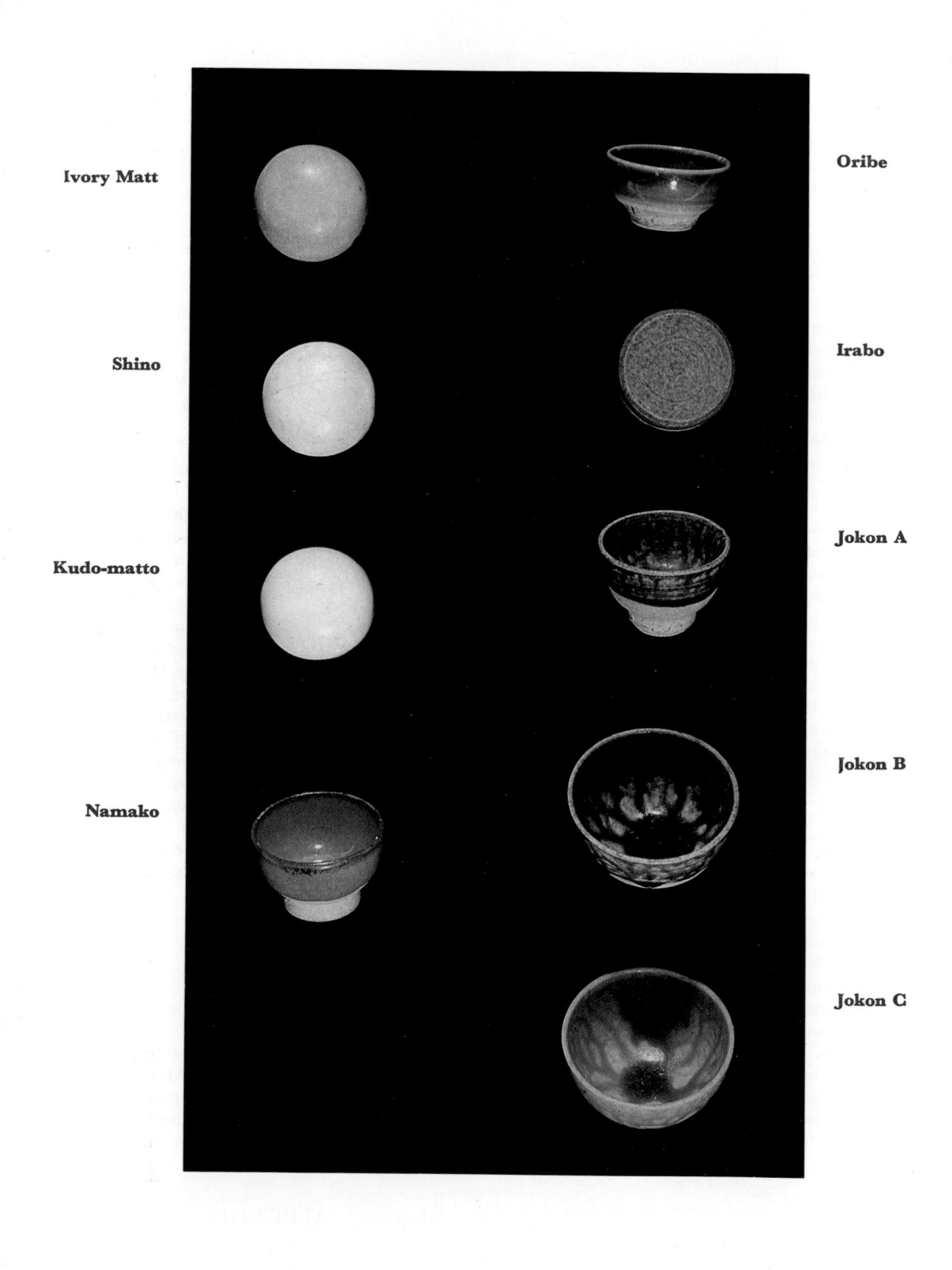

Ivory Matt

Shino

Kudo-matto

Namako

Oribe

Irabo

Jokon A

Jokon B

Jokon C

Shinsha No. 2

Shinsha No. 3

Shinsha No. 4

Ame

Temmoku

Seiji No. 1c

Seiji No. 2a

Seiji No. 2b

Kinyo

Shinsha No. 1

Seiji (Celadon) Glaze No. 1: Seger Cone 11 (1320°C.)
(For use on porcelain with reduction fire.)

	A	B	C
Fukushima spar	32.0	32.17	58.59
Amakusa stone	28.5	28.59	9.71
limestone	16.0	15.76	10.25
silica	23.5	23.48	21.97
iron silicate (Fe_2SiO)	4.0	4.0	4.0

Seiji (Celadon) Glaze No. 2

	A	B
limestone glaze No. 1	100.00	100.00
iron silicate	3.0	3.5
chrome oxide	0.05	0.0

Kinyo Glaze: Seger Cone 11 (1320°C.)
(For use on porcelain with reduction fire.)

Fukushima spar	30.0
synthetic common ash	30.0
synthetic rice-straw ash	40.0
barium carbonate	10.0
nickel oxide	4.0
copper carbonate	1.0

Shinsha (Copper-red) Glaze No. 1: Seger Cone 11 (1320°C.)
(For use on porcelain with reduction fire.)

Fukushima spar	30.0
synthetic common ash	30.0
synthetic rice-straw ash	40.0
powdered glass	4.0
copper carbonate	2.0
tin oxide	3.0

Shinsha (Copper-red) Glaze No. 2: Seger Cone 11 (1320°C.)

Fukushima spar	30.0
synthetic common ash	20.0
synthetic straw ash	50.0
barium carbonate	10.0
copper carbonate ($CuCO_3$)	2.0
tin oxide	4.0

Shinsha (Copper-red) Glaze No. 3: Seger Cone 11 (1320°C.)

Fukushima spar	30.0
synthetic common ash	30.0
synthetic straw ash	40.0
barium carbonate	10.0
copper carbonate	2.0
tin oxide	4.0

Shinsha (Copper-red) Glaze No. 4: Seger Cone 11 (1320°C.)
(For use on porcelain with reduction fire.)

Amakusa stone	55.0
Fukushima spar	10.0
barium carbonate	35.0
copper oxide	3.0
tin oxide	3.0

Ame (Light-brown) Glaze: Seger Cone 9 (1280°C.)
(White stoneware body; oxidation fire.)

limestone glaze No. 1	70.0
common ash	25.0
red lead	5.0
red iron oxide	8.0

Temmoku Glaze: Seger Cone 9–10 (1280–1300°C.)

Fukushima spar	42.0
limestone	13.0
gairome clay	8.0
barium carbonate	2.0
silica	20.7
manganese oxide	2.0
cobalt oxide	2.0 to 5.0
chrome oxide	1.0
red iron oxide	4.0

Oribe Glaze: Seger Cone 9 (1280°C.)
(White: half stoneware, half porcelain body; oxidation fire.)

limestone glaze No. 1	100.0
copper oxide	7.0 to 8.0

Irabo Glaze: Seger Cone 9 (1280°C.)
(White stoneware body; oxidation fire.)

common ash	35.0
ochre clay	40.0
limestone	25.0
porcelain body	10.0

Jokon Glaze: Seger Cone 8 (1250°C.)
(White stoneware body; oxidation fire.)

	A	B	C
barium carbonate	45.0	45.0	45.0
common ash	25.0	25.0	25.0
rice-straw ash	30.0	30.0	30.0
copper oxide	3.0	3.0	1.0
cobalt oxide	0.0	0.8	0.0
manganese oxide	0.0	0.0	5.0

Ivory Matt Glaze: Seger Cone 9–10 (1280–1300°C.) (White stoneware body; reduction fire.)

	A	B
prophyllite	30.0	26.0
limestone	25.0	25.0
Fukushima spar	34.0	34.0
silica	11.0	15.0
titanium oxide	2.0	1.0
manganese carbonate	0.0	1.0

Shino Glaze: Seger Cone 8 (1250°C.)
(White stoneware body; oxidation fire.)

Fukushima spar	60.0
limestone	10.0
silica	30.0

Kudo-matto (Magnesia Matt) Glaze: Seger Cone 8–9 (1250–1280°C.) (Porcelain body; oxidation or reduction fire.)

Fukushima spar	25.0
limestone	11.0
magnesite	15.0
kaolin	14.0
silica	25.0

Namako Glaze: Seger Cone 9 (1280°C.)
(White stoneware body; oxidation fire.)

Fukushima spar	50.0
limestone	25.0
gairome clay	13.0
silica	15.0
titanium oxide	9.0
manganese oxide	9.0

Common Limestone Glaze No. 1: Seger Cone 9–10 (1280–1300°C.) (Used on porcelain and for blue-and-white; reduction fire beneficial.)

SiO_2	66.50
Al_2O_3	11.53
Fe_2O_3	0.05
CaO	8.83
MgO	0.48
K_2O	2.19
Na_2O	2.36
L.O.I.	8.41
	99.90

Synthetic Limestone Glaze No. 1

Fukushima spar	34.03
limestone	15.42
kaolin	12.87
magnesite	0.95
silica	36.73

The following compositions for synthetic common ash and synthetic straw ash are also presented by Masatarō Ōnishi:

Synthetic Common Ash

Fukushima spar	12.0
limestone	62.0
Korean kaolin	10.0
silica	3.0
magnesite	5.0
bone ash	7.0

Synthetic Straw Ash

Fukushima spar	22.2
limestone	5.8
silica	72.0

OVERGLAZE ENAMELS

CLAY BODIES

Sakujirō Terao, of the Kagoshima Prefectural Research Institute, is commissioner of cultural tradition for the prefecture. The type of body he has developed for white Satsuma has the following composition: *kaseda* sand, 8 parts; *ibusuki* white clay, 10 parts.

Some porcelain compositions that work well are the following: (1) Amakusa stone, 80 parts by weight; *gairome-tsuchi*, 10 to 20 parts by weight. (2) Amakusa stone, 100 parts by weight; limestone, 25 parts by weight. (3) Amakusa stone, 10 cups fluid; *isu*-wood ash, 6 cups fluid.

A popular commercial porcelain body used by Kyoto potters is made by the Nihon Torio Co., which fires to cone 10 or 11. It has the following analysis: silica, 73.74%; alumina, 17.66%; iron oxide, 0.60%; limestone, 0.33%; magnesia, 0.38%; potassium, 2.78%; soda, 0.60%; and ignition loss, 4.04%. This clay fires a good white and provides an excellent body for decoration in blue and overglaze enamel colors.

GLAZES

White Satsuma: three variations

	A	B	C
Fukushima feldspar	42	60	60
kyonomine stone (silica (stone)	22	10	6
nara (oak) wood ash	36	30	34

The ware is fired to Seger cone 9–11 and decorated at about 800°C.

Tomimoto's lime glaze for a porcelain body. He found that the addition of ash stopped the enamel from peeling. Cone 9–10 (about 1300°C.).

feldspar	15
Amakusa stone (kaolin)	60
quartz	5
limestone	20

to this, add 20% common ash

ENAMELS

There are a limited number of individual workers in enamel on porcelain. The products of the Kakiemon, Nabeshima, and Kutani kilns have continued to the present date, but their work is done by skilled artisans trained in the traditional style of 300 years ago.

Tomimoto lists the colors and techniques he has used in his own work:

Aka (vermilion red—Arita red is lighter)

benigara (red iron oxide)	12
tonotsuchi (white lead)	5
shiratama (powdered lead glass)	50

(Note: Firing temperature for red is 800°C.; other colors somewhat lower. All enamel colors must be fired in an oxidizing flame.)

Kutani *aka* (dark vermilion)

benigara	4
tonotsuchi	6
shiratama	15
keiseki (quartz)	3

(Note: This is the best red to use with gold and silver.)

Tamagusuri (transparent colors)
Midori (leaf green)

rokusho (copper oxide)	1.5
tonotsuchi	11.0
shiratama	16.0
keiseki	2.0

Toruko Ao Midori (Turkish blue-green)

blue powdered glass	10
tonotsuchi	3
keiseki	2

(Note: For this composition use powdered bluish glass or soda glass and add some cobalt. If the above needs to melt at a lower temperature, add lead until it runs, then stiffen with quartz.)

Ao (blue)
cobalt oxide	1
tonotsuchi	100
shiratama	3
keiseki	2

Murasaki (purple, old style)
lowest-class Chinese cobalt	0.13
tonotsuchi	10.00
shiratama	15.00

Kuro (black)
manganese	6
Chinese natural cobalt	4
quartz	2

(Note: This color is to be used for line drawing or painted decoration under transparent color. More quartz will increase the refractoriness of the black, but it spoils the color. The black is best under green. It turns brown under yellow. To paint well with this black, it must be mixed with tea. For black enamel, cover the black color with transparent green enamel.)

Uwae no Shiro (white enamel)
tonotsuchi	3
shiratama	10
quartz	4
shiratsuchi (kaolin)	3

Kurai-ki (dark reddish yellow, Kutani school)
benigara	0.8
tonotsuchi	12.0
shiratama	20.0

Akarui-ki (light or canary yellow, Arita school)
sanka anchimoni (antimony oxide)	0.4
tonotsuchi	1.4
shiratama	2.3
quartz	0.8

(Note: Prior to the war, *toshirome* or impure antimony oxide was used.)

Transparent Colorless Enamel
tonotsuchi	50
shiratama	45
quartz	10

(Note: This transparent enamel is for lightening colors—e.g., 10 parts purple to 5 parts transparent for light purple.)

In Japan, particularly before the war, the potters could not get iron oxide; so the practice was for the potter to make his own. Tomimoto's methods for making copper powder, red iron oxide, and manganese are explained in the following sections.

Rokusho (copper powder)
Place copper filings or sheet copper in salt water for about a week, stirring three or four times each day. The copper will turn green. After the green color appears, wash with water several times or a black dirty-green color will result when it is used. Since all of the salt must be removed, pour tea into the copper once or twice. The tannin in the tea reacts with the salt and cleans the copper. Wash with water again.

If possible, get copper scale from manufacturers of cooking pots. It is not necessary to remove salt from this scale. In the salt process, after the powder is dry, remove the top and bottom layers for purity of color. The top layer contains tannin and the bottom layer copper metal. Discard these layers.

Benigara (red iron oxide)
Secure iron sulphide and bake at 350° for two hours. During baking it will have a strong odor. As soon as there is no longer any odor, remove from the oven and sift through a 250-mesh screen. If it is baked too long, a dark red will result. After screening thoroughly, stir the powder into water. Let it sit overnight and pour off the liquid. Set aside what has settled for more grinding.

Repeat washing four of five times. The oxide must be very fine-grained. For good red, it should be ground for one month with a mortar and pestle.

Mangan (manganese)

Try different manganese oxides to make black or purple. Kutani purple is famous because of a manganese mine in the area, from which the desired manganese rock could be selected.

Screen all coloring oxides very fine. This is especially true for red. When applying an enamel thickly, use some fine and some coarse oxide to avoid peeling after firing. In working with porcelain enamel, quartz and lead oxide balance each other. If the enamel is too fluid, add quartz; if too refractory, add lead. If the green color is too finely ground, it will peel after firing. Prepare large quantities of overglaze enamels at a time and store in jars.

AMERICAN EQUIVALENTS OF TYPICAL JAPANESE GLAZE AND PORCELAIN BODY COMPOSITIONS

SOME SUGGESTIONS FOR THE POTTER

Ceramic Materials

No ceramic material is an exact substitute for another except where chemically pure oxides of elements are concerned. Changing a glaze or body composition from its materials batch to its empirical formula and recalculating it on the basis of molecular equivalents of its oxide components will theoretically duplicate a ceramic mixture. However, the fired results, while similar, will often vary from the original. For the potter this provides an interesting challenge and a

stimulus to experimentation: here is a problem to be solved.

It is suggested that an important value of this book is to point a direction for potters everywhere. It should provide a stimulus to explore their surroundings for native regional materials from which they can develop a completely unique, individual type of pottery. If those potters for whom such an approach is possible and practical were to follow it, there would be a revolution in ceramic exhibitions and a development of public interest that would surpass our imagination.

There are many potters for whom such an approach is not at present a practical solution to their potting problems. For them the following suggestions are presented.

Albany slip clay and Michigan slip clay are similar to Mashiko clay, Somoda clay, and *kimachi* stone. In combination with wood ash and feldspar they provide brown and black glazes similar to those used at Ryūmonji, Onda, Koishibara, Tamba, Mashiko, Ushinoto, etc.

Barnard clay is similar to many of the rocks and clays containing iron and manganese used by Japanese potters. It may be used effectively for underglaze iron decoration and should be tried as a possible substitute for #2 *yusha*, Okawachi stone, Kamo River stone and #2 *shaju*.

The majority of the darker iron glazes used by Japanese potters make use of ash having a fairly high iron content, i.e., pine, cedar, redwood, etc.

Eureka spar, while not an exact substitute for Fukushima feldspar, is very close to it in composition, except for a higher silica content. When substituting Eureka for Fukushima spar, reduce the silica (flint) used in the glaze by 10% to 12%.

Investigate local shales, rocks, soils, and clays for use with various types of ash, calcium, and feldspar as possible

materials for the dark iron glazes.

A lime glaze to be applied over cobalt decoration should contain ash containing a low percentage of iron. The ash of fern, bean stalk, camellia, oak, and bamboo is all hard ash and has a low iron content.

Cottonseed ash, when used in a lime glaze, will result in a pale green color on porcelain fired in a reducing fire. The pale green color is excellent as a ground upon which to apply overglaze enamel decoration.

For iron spots (*goma*) in a pottery body, use crushed decomposed granite. Volcanic ash is also quite effective.

Chinese red enamel

The *tenkai* red enamel of the Chinese was very finely ground. A father ground red enamel for his son to use, and he in turn ground enamel to be used by his son. Thus fineness of grain was assured. For dark red the enamel must be thickly applied. Tomimoto recommended 10 parts *benigara* and 10 parts lead oxide applied thickly. When fired, this combination results in the *tenkai* red of the Chinese.

Firing

The temperature at which red Raku is fired will affect the color. The fire must be an oxidizing fire or the color will change to a burnt sienna.

Iron-bearing clays and glazes will, in a reducing fire, produce green to blue-green; in an oxidizing fire, red or brown; and in a middle fire, gray. In theory, a middle fire is halfway between oxidation and reduction fire in the *nobori-gama*. In other kilns it may be achieved by alternating periods of oxidation and reduction.

An oxidizing fire provides a smoke-free (carbon-free) atmosphere. It results from a good blue flame at the burners and open dampers.

A reduction fire provides a smoky atmosphere with carbon and unburned fumes and gas present in the ware chamber. It results from a yellow flame, and the dampers partly or completely closed. In an electric kiln, oil, oily rags, sawdust, small pieces of wood, or mothballs dropped into the kiln while firing will provide a reducing atmosphere.

Some Black, Brown, and Amber Iron Glazes (Orton Standard Cone 9–10; reduction fire)

Tamba Black Glaze
Black when thick, brown when thin, on redstone* body.

Michigan slip clay	60
common wood ash**	40
iron oxide (red)	5

 *A red-brown stoneware from Quyle Kilns, Murphys, California.
 **Common wood ash consists of a mixture of pine, oak, redwood, walnut and prune wood ash—predominantly pine wood ash.

Black *Temmoku* Glaze
Black *temmoku* when thick, golden brown when thin, on redstone body.

Michigan slip clay	100
common wood ash	10 to 20
Barnard clay	10 to 20

#1 *Soba* Glaze
Yellowish green mottled with brown, on redstone body.

ochre (yellow)	10
common ash	6
redwood ash	7

#1 *Irabo* Glaze
Yellow-brown matt on redstone body; chestnut and golden-brown mottled matt on porcelain.

Barnard clay	6
whiting	2
common ash	2

M *Kaki* Glaze

A very good *kaki* on porcelain.

nepheline syenite	38.70
colemanite	20.00
zinc oxide	8.10
barium carbonate	9.85
kaolin	25.80
flint	33.00
red iron oxide	2 to 6% addition

I.G.I.

Black to red-brown, depending on thickness, on stoneware or porcelain.

kaolin	15
whiting	30
flint	73
Kingman feldspar	60
red iron oxide	22

Temmoku Glaze, Type A

This glaze gives best result on redstone clay. Black with streaks of brown when thickly applied, fired to cone 10 or above, and cooled slowly. Forms characteristic roll above bare foot. Flat, slightly greenish-brown on porcelain.

Albany slip	100
common ash	20
Barnard clay (stirred into glaze)	20

Temmoku Glaze, Type B

Best on redstone clay. Very strong red-brown with indications of crystalline structure.

Albany slip	100
common ash	20
red iron oxide	20

Celadon-Iron Glazes (Cone 9–10; reduction fire)

G #1 Celadon Glaze

Excellent gray-green waxy celadon. Non-fluid; good on redstone or porcelain body.

glaze spar #56 (Kona F4)	44
whiting	18
kaolin	10
flint	28
Barnard clay	12

M #1 Celadon Glaze

Light jade-green on porcelain.

nepheline syenite	77.4
whiting	40.0
zinc oxide	16.2
barium carbonate	19.7
China clay	51.6
flint	66.0
redstone clay	10% by addition or an addition of 2% red iron oxide

#1 Celadon Glaze

Good waxy gray celadon on porcelain; greenish-gray on redstone body.

Kingman feldspar	78
whiting	6
flint	14
red iron oxide	2

#3 Celadon Glaze

Dark-green waxy celadon on both redstone and porcelain bodies.

glaze spar #56	38.8
whiting	7.9
barium carbonate	14.3
kaolin	11.2
flint	27.7
red iron oxide	3% addition

A #1 Celadon Glaze

A waxy pale-green celadon on both redstone and porcelain bodies. Mutton-fat texture.

Buckingham feldspar	27
whiting	20
kaolin	20
flint	33
red iron oxide	4% addition

Transparent (Colorless) Glazes (Cone 9–10; oxidation or reduction fire)

#6–1 Glaze

glaze spar #56	44
whiting	18
kaolin	10
flint	28

#6–2 Glaze

Keystone spar	52.0
colemanite	15.0
dolomite	9.5
talc	18.0
kaolin	5.5

M. A. Glaze

Kingman spar	47.5
colemanite	20.0
whiting	8.5
barium carbonate	2.0
zinc oxide	8.5
kaolin	14.5
flint	18.5

#2 Transparent (Mist) Glaze

Particularly good over Barnard clay decoration on stoneware body.

nepheline syenite	25
Kingman spar	25
colemanite	10
dolomite	7
talc	13
kaolin	5
flint	15

Opaque (Non-fluid) Glaze (Cone 9–10; oxidation or reduction fire)

Good for decoration scratched through to the body or decoration by sgraffito through Albany or Michigan slip, with this glaze over sgraffito decoration.

Keystone feldspar	14.5
whiting	19.0
nepheline syenite	14.5
kaolin	7.0
flint	28.3
zircopax	10.0
zirconium spinel	6.7

Color in Glazes

When the following metallic oxides are added, they will provide color in glazes.

Oxide	Percentage	Oxidation Fire	Reduction Fire
cobalt	1 to 4	blue to red-violet, depending on basic composition of the glaze	darker blues to black
copper	1/10 to 4	green to turquoise blue, depending on basic composition of the glaze	red to purple to brown
manganese	1 to 4	brown to purple-brown	gray to white to colorless
iron	1 to 15	brown, red-brown, red, yellow	celadon green, black, gray
nickel	1 to 4	gray-green to greenish tan	black
chromium	1/10 to 4	green, yellow, gray-green, pink, tan, maroon, etc., depending on composition of the glaze. Calcium and tin promote pinks, reds, and maroons.	black
uranium	6 to 12	yellow to orange	black or brown
tin	4 to 12	white, and to help with chrome pink and maroon, also in small quantities for copper reds	unaffected
rutile	4 to 12	cream, tan, and mattness	blue to purple

Kyoto Research Institute Glazes

The following are glazes developed by Masatarō Ōnishi at the Kyoto Research Institute. They have been recalculated on the basis of materials available on the American market.

Common Limestone Glaze: Cone 9–10
Under reduction fire, this glaze is transparent where thin on redstone or porcelain. When thickly applied, it becomes milky (semi-transparent) and has a waxlike texture. Non-fluid. When thick, will also pick up iron spots from redstone clay. Approximately the same reaction in oxidizing fire.

Eureka spar	49.38
whiting	14.67
kaolin	12.09
flint	23.60
magnesite	0.26

Seiji A (Celadon) Glaze: Cone 9–10
Reduction fire. Excellent dark-green celadon with waxy gloss texture, viscous on both redstone and porcelain bodies. Should be applied thickly for best results.

Eureka spar	48.35
whiting	14.50
magnesite	0.15
soda ash	0.50
kaolin	8.50
flint	28.00
red iron oxide	4% addition

#2 Shinsha (Copper-red) Glaze: Cone 9–10
Reduction fire. Matt, non-fluid copper-red on porcelain and redstone bodies. This glaze was hand-ground and may become less matt and more fluid when milled.

Eureka spar	68.35
potassium nitrate	2.99
soda ash	1.20
dolomite	5.30
bone ash	10.28
barium carbonate	9.99
flint	21.30
copper carbonate	2.00
tin oxide	4.00

#3 Shinsha (Copper-red) Glaze: Cone 9–10
Reduction fire. Similar to #2 shinsha. Requires about cone 11 for best results. Has semi-gloss and is non-fluid.

Eureka spar	48.64
potassium nitrate	1.50
soda ash	1.33
dolomite	3.68
bone ash	9.20
barium carbonate	6.53
flint	29.12
copper carbonate	2% addition
tin oxide	4% addition

Kinyo Glaze: Cone 9–10
Reduction fire on porcelain. Equivalent to the #3 shinsha composition with 4% nickel oxide instead of the tin oxide and 1% copper carbonate.

#4 Shinsha (Copper-red) Glaze: Cone 9–10
Reduction fire. An excellent peach-bloom type of reduced copper glaze on both redstone and porcelain bodies.

Eureka spar	14.4
kaolin	20.5
barium carbonate	32.0
whiting	0.5
flint	32.6
copper carbonate	3% addition
tin oxide	3% addition

Ame Glaze: Cone 9–10
Oxidation fire. Dark amber glaze on porcelain, red-brown on redstone clay.

#1 limestone	70
common ash (pine, oak, and redwood, predominantly pine)	25
red lead	5
red iron oxide	8% addition

Temmoku Glaze: Cone 9–10
Reduction or oxidation fire. Black *temmoku* glaze with silvery sheen. Forms characteristic fatty roll when fired on bowl with unglazed lower portion. Must be thickly applied. Best on redstone body.

Eureka spar	40
whiting	13
redstone clay	8
barium carbonate	2
silica	18
manganese dioxide	2
cobalt oxide	4
chromium oxide	1
red iron oxide	4

Shino White Glaze: Cone 9–10
Reduction fire: very viscous white, mutton-fat texture, slightly transparent when applied thickly; crazed and transparent where thin. Oxidation fire: very viscous white glaze on both porcelain and redstone bodies; has crater surface on redstone clay.

Eureka spar	82.89
whiting	8.99
flint	8.12

Kudo-matto Glaze: Cone 9–10
Reduction or oxidation fire. A white matt glaze on both redstone and porcelain; silky texture; completely non-fluid.

Eureka spar	40.06
magnesium carbonate	15.76
kaolin	14.50
flint	17.98
whiting	11.68

Namako Glaze: Cone 9–10
Reduction fire: a flowing ("rabbit-fur" streaks) blue-violet to brown glaze; more blue-violet where thin. Oxidation fire: purple-brown streaked glaze; flows readily on redstone clay; brown matt where thin; shows tendency to crystal formation.

Eureka spar	68.30
soda ash	0.12
whiting	22.25
magnesite	0.25
redstone clay	7.76
Al_2O_3	1.42
titanium dioxide	9.00
manganese dioxide	9.00

Oribe Glaze: Cone 9–10
Oxidation fire. On porcelain body, strong green to blue-green, transparent where thin. Almost opaque, metallic blue-green surface where thickly applied.

#1 limestone glaze	100
copper oxide	7 to 8

Irabo Glaze: Cone 9–10
Oxidation fire. On porcelain body, yellow-green to brown mottled matt surface.

common ash	35
yellow ochre	40
whiting	25
porcelain body	10

(Nihon Torio Co. porcelain)

Jokon Glaze A: Cone 9–10
Reduction fire: interesting streaked brown to green-brown on lighter background on both redstone and porcelain bodies. Oxidation fire: blue-green, semi-matt streaked and mottled surface.

barium carbonate	45
common ash	25
wheat-straw ash	30
copper oxide	3

Ivory Matt Glaze A: Cone 9–10
Reduction fire: glaze becomes transparent, seeded, and a pale grayed amber color; more interesting on redstone than on porcelain body. Oxidation fire: glaze becomes a creamy, transparent, seeded semi-matt on porcelain.

Eureka spar	47.89
magnesium carbonate	0.18
pyrophyllite	27.06
whiting	23.03
titanium dioxide	1.83

For a variation of this glaze, 1% manganese dioxide is added to the above.

Some Porcelain Body Compositions

It should be noted that the addition of 3 to 5 percent of bentonite to any porcelain body will aid with plasticity.

KFI: Cone 9

Keystone feldspar	25
Kentucky ball clay	25
flint	50

#2: Cone 9

Kingman feldspar	20
nepheline syenite	5
Kentucky ball clay	25
flint	50

#3: Cone 7

Keystone feldspar	22.5
nepheline syenite	8.5
kaolin	42.5
flint	22.5
bentonite	4.0

#4: Cone 10–11

Keystone feldspar	25
kaolin	47
flint	25
bentonite	3 to 5

The Nihon Torio Company porcelain body composition given above is undoubtedly based on a very high percentage of Amakusa stone, a kaolinic rock, which, when combined with 20 percent *gairome* (fireclay), provides an excellent porcelain body.

There are many combinations of materials that could approximate the percentage composition given, but the following is a suggested possible range of materials that will result in a Japanese-type porcelain between Orton Standard Cone 9 and 13.

Kingman feldspar	4 to 25%
ball clay and	
kaolin	44 to 30%
flint	52 to 45%
bentonite	3 to 5% addition

MAP OF JAPANESE

1. Hirosaki	22. Inuyama	42. Otokoyama	
2. Kuji	23. Tokoname	43. Kairakuen	
3. Naraoka	24. Kasugayama	44. Osaka	
4. Shinjō	25. Wakasugi	(Takahara,	
5. Hirashimizu	26. Ono	Nanba,	
6. Tsutsumi	27. Kutani	Kikkō)	
7. Tatenoshita	28. Hisaka	45. Mita	
8. Ōhori Sōma	29. Oda	46. Tamba (Tachikui)	
9. Aizu	30. Rakurakuen	47. Higashiyama	
10. Maganoshima	31. Shimoda	48. Izushi	
11. Mashiko	32. Takahara	49. Inkyūzan	
12. Kasama	33. Shigaraki	50. Ushinoto	
13. Tokyo	34. Banko	51. Sodeshi	
14. Shidoro	35. Kobanko	52. Mori	
15. Etchū Seto	36. Iga	53. Shizutani	
16. Kosugi	37. Antō Akogi	54. Bizen	
17. Shibukusa	38. Isawa-banko	55. Mushiake	
18. Minoko	39. Kyoto (Kiyomizu,	56. Kōrakuen	
19. Tajimi	Raku)	57. Fujina	
20. Seto	40. Asahi	58. Izushi	
21. Nagoya	41. Akahada	59. Ōda	

KILNS AND KILN SITES

GLOSSARY - INDEX

Numbers in *Italics* refer to illustration pages

in superimposed glaze painting, 213

copper cutting wire, 104, *70*

copper-red underglaze decoration, 185, 188, 189, *32*

cords used for rope-impressing, 169, *77*

cracking
 as decoration, 133
 of luted clay slabs, 122
 of thrown ball-mill-ground porcelain, 219
 of thrown porcelain, 63

crackle (controlled glaze crazing)
 on Awata and white Satsuma ware, 220
 celadon, spiral, 61, *23*

crazed glaze or crazing (result of glaze thermal expansion and contraction being out of adjustment with that of clay body to which applied, producing fine-mesh cracking during or after firing)
 of black Raku teabowls, 194
 of lime glaze, 96

cutting cords, 125, 135, *70, 117*
 cotton, 64
 rice-straw, 64
 wire, 64, 124, 135, 136

cutting-cord decoration, 135, 136

dami-fude (large brush, usually used in painting washes of color), 92, 177, 216, *78, 161, 163, 208*

dango (knuckle-shaped rib used inside pot for shaping on potter's wheel), 62, 125, *69*

dental tool, 187

D'Entrecolles, Père (François Xavier d'Entrecolles [1663–1741], French missionary who wrote on Chinese ceramic processes), 197

design, Japanese ceramic, Westernization of, 54

dipping
 of engobe, 174
 glaze, 200, 213, *207, 208*
 slip, 178, *164*

distortion, conscious, 130–133, *137*

dogū, Jōmon, *47*

donko glaze (superimposed glaze mottling) process, *205, 206*

downdraft kiln (European-type kiln in which burners are located at sides and outlet to smokestack is through floor), 61, 94, *83*

drain (or casting) mold (plaster mold used for casting ware), 63, 89, 122, 123, *111*

drape molds (mold forming interior contour of ware, over which slabs are pressed or paddled), 89, 121, *74*

drying bowls, clay, 98

earthenware
 clay bodies, natural, 96
 overglaze enameled, 53, 189, 219, 220, *30, 31*

Edo period (1615–1867; also called Tokugawa period), 96, 179
 casting in biscuit molds, 89

egote (throwing stick used on inside to shape tall pieces on wheel), 62, 63, 125, *69, 114–116, 154*

Eisai, priest, 228

elbow-forming process, 101, 102, *105*

electric kiln, 95, 223, *85*

electric wheel, 61, 124

enameled porcelain (porcelain decorated with overglaze enamel), *see* overglaze enamel

England, 55, 56

English slipware, influence of, 195, *21*

engobe, (slip coating entire surface of piece; employed to change the color or to conceal undesirable texture of clay body), 174, 177, 178, 185, 196, 199, 215, *156, 164*

Enshū Iga ware, 182

e Oribe (Oribe ware with painted decoration under the glaze), 196

e Shino ("picture" Shino), 196, *23*

esthetic, Japanese ceramic, 95

esthetic, tea-ceremony, 189, 228, 229
 crazing of Raku teabowls, 194

etching process, cobalt-blue underglaze, 187, 188

excising, 171, *153*

impressed decoration, 91, 166–169, 171, 172, *77, 148–151*
incising, 170, 171, 187, 195, *153, 155*
industrialization of Japanese ceramics, 54, 55, 89
inlay
 clay, 172, 173, *155, 156*
 cobalt-blue underglaze, 187
 Koryo dynasty, 173, 174, *76*
 and *mishima*, 167, 172, *155*
 rope-pattern, 169, *151*
 superimposed glaze, 216, *29*
institutes, ceramic training and research, 54, 199
"intangible cultural properties," living, 179, 180
iro-gawari (Ryūmonji transparent glaze), 99
iron
 iron-bearing clays, 134, 166, 172–174, 181, 183, 195, 197, 220, *23, 147*
 iron-bearing glazes and glaze materials, 98, 99, 166, 183, 194–198, 213, 221, *22, 147*
 iron-bearing overglaze enamels, 217, 218
 iron-bearing slip, 177, 196
 decoration, 174, 176, *159*
 Oribe ware, 196, *24*
 under salt glaze, 200
 Shino ware, 196
 underglaze, 185, 188, *159, 161, 201*
 spots
 as decoration, 166, *147*
 elimination of, 217
 strap iron used for trimming tools, 89, 90, *75, 153*
ishihaze ("stone explosion"; caused by rock pieces in the clay exploding and causing miniature mountain peaks to appear on the ware surface), 165, *146*
Ishikawa Prefecture, 218
ishi-tsugi (third chamber of *nobori-gama*; chamber following the porcelain chambers), 94
isu (*Distylium racemosum*) ash
 bark and leaf, 217
 wood, 218
Itō, Suiko, 216, *29*

Itō, Tōzan, 220, *31*
iwa, see *gun*
Iwabuchi, Shigeya, *147, 157*
Izumi-yama stone, 186, 199

Japanese Chronicle, 41, *45*
Japanese Craft Association, 57
Japanese ink (*sumi*), 214, 221
jigger wheel and jiggering, 89, 126, *68, 118*
Jōmon (literally, "rope pattern"; a prehistoric pottery having diagnostic rope or mat markings; also the period and culture associated with this pottery)
 period, 41, 102, *46, 48*
 pottery, 91, 168, 169, *46, 47, 150*

Kaga Province, 218
Kagoshima, 53, 103, 197, 219, 220, *31*
kaki ("persimmon") glaze, 198, *22*
kaki ("persimmon") overglaze enamel, 217, *36*
Kakiemon I (the first Japanese potter to develop a Japanese overglaze enamel on porcelain), 44, 217
Kakiemon XII, 217
Kakiemon XIII, 217
Kakiemon ware, 189, 217, 218, *36*
kama ("kiln"), 92
Kamakura period (1185–1333), 179
Kamogawa (Kamo River) stone, 193, 194
Kanazawa, 44
Kaneshige family of potters, 179
Kaneshige, Tōyō, 57, 132, 165, 179, 180, *17*
kanna ("planes"), 89, 90, 124, 127, *75, 119, 153*
 "jumping," 178, *164*
Karatsu
 area, 43, 44
 kiln, *80*
 ware, 165, 177, 188, 195, *201*
kasasa feldspar, 197
kasuri-mon (chatter-mark decoration) process, 178, *164*
Katō, Hajime, 90, *71, 112, 152, 153*
Katō, Mineo, 168, 169, *150*
Katō, Tamikichi, 53

molds, 64, 65, 89
 biscuit, 64, *71*
 drain (or casting), 63, 89, 122, 123
 drape, 89, 121, *74*
 jigger wheel, 126, *118*
 press, 63, 89, 121, 122, 131, 135, 136,
 168, *74*, *143*, *145*
Momoyama period, (1573–1615), 179, *23*
Morino, Kakō, 199, *204*
mottling, superimposed glaze, *205*, *206*

Nabeshima
 clan, 217, 218
 ware, 44, 189, 217, 218
Naeoshirogawa, 197, *204*
Nagasaki, 217
nagashi-gusuri ("glaze that is made to
 flow"; superimposed glaze dripping),
 215
Nagoya, 60
Nakano, Suemasa, 165
Nakazato family potters, 177
Nakazato, Tadao, 104, *108*
Nakazato, Tarōemon, 177, 195, 229, *163*
Nara period (710–794), 42, 190, 228
naze-kawa (chamois-skin swab), 63, 130,
 70, *109*, *113*, *116*
nejimomi ("screw-wedge" process used in
 preparing clay for potting), 98, *88*
neriage (type of ware originating in Sung
 dynasty China in which the form is
 developed by pressing clays of different
 colors in pattern into a mold, the
 pattern being the same inside as out-
 side), 136, 165, *142–146*
new *neriage* (type of inlay in which dif-
 ferent-colored clay is impressed into
 the surface of a partly thrown form,
 after which throwing is completed),
 165, *146*
nezumi Shino ("gray" Shino) ware, 196,
 24
nichrome wire, 135, 136, 223, *85*, *141*
nickel and iron clay-coloring pigment,
 173
Nihongi, see *Japanese Chronicle*
Ninnaji, Prince, 53
Ninsei (the Japanese potter who invented
 the technique of overglaze enamel on

earthenware), 53, 96, 189, 219, *30*
Nitten Academy, 57
nobori-gama ("climbing kiln"; a kiln with
 stepped chambers), 43, 93, 94, 97, 134,
 182, 200, *81*, *82*
Nonomura, Seiemon, *see* Ninsei
noren potters, 54, 56
Noritake factory (Nagoya), 126
nunome ("cloth-texture"), 131, *138*

ochre
 raw, 188
 slip, 192, *110*, *202*
offertory vessels, 101
Ogasawara clan, 177
Ogata, Kenzan, *see* Kenzan I
"oil-spot" *temmoku*, 190, 198, *22*
Okakura, Kakuzō, 227, 229
Okawachi mountains, 218
Okinawa, 90, *25*, *77*
Onda, 92, 103, 170, 176–178, 196, 215,
 86, *164*
Oribe ware, 168, 195, 196, *24*, *74*
Ōta, Kumao, 96–98, 175, 215
overglaze enamel (very low-fire glazes
 that fuse to the surface of a higher-
 fired glaze), 44, 53, 95, 217–225, *30*,
 31, *34–40*, *212*
Ōwari, 190, 195
oxidation firing (condition when the fire
 in a kiln has sufficient oxygen to pro-
 vide complete combustion; an absence
 of carbon or carbonaceous gases), 134,
 173, 180, 181, 188, 189, 195, 198, 200,
 214, *23*, *32*
paddles and paddling, 64, *46*, *77*, *108*
 of bottle forms, 130, 168, *137*
 in carved-out porcelain process, 123
 coiled forms, 91, 129, 168, 169
 in drape-mold forming, 121
 to make slabs, 121
 in *neriage* process, 136
painting, *78*, *138*
 cobalt-blue underglaze, 186, *160*
 gold, 223
 iron decoration, 196, *161*
 overglaze enamels, 221, 222, *40*, *212*
 with reed, 177, *163*
 slip, 176, 177

GLOSSARY-INDEX 263

rice-straw
 ash, 98, 189, 197
 cutting cord, 64, *70*
 hakeme brushes, 176, *78*
"rifle" kiln, *see* split-bamboo kiln
Risampei, 44, 186, 199
rokuro (original Oriental potter's wheel), 59
roller stamp (carved wood or clay roller used to impress continuous pattern into ware surface), 91, 167, *77, 150*
rope-impressing, 41, 91, 168, 169, *46, 77, 150, 151*
"rough touch," 176, see *hakeme*
rubber syringe, 176, 215, *26*
Ryūmonji, 92, 99, 177, 196, 197, *25, 78, 87, 114, 163, 205, 206*

sabi-tsuchi ("iron-rust clay"), 196
saggers (fireclay boxes in which pieces are fired in order to protect them from smoke, flames, and fumes within the kiln)
Saichō, monk, 228
Sakaida, Kakiemon, *see* Kakiemon I
Sakuma Tōtarō, 101, 167, 168, *78, 115, 150, 208*
saliva, 222
salt glazing (process of throwing common salt on kiln fire; the sodium combines with the clay to form a gloss and the chlorine is given off as gas), 180, 199, 200, *25, 204*
salt water, 182, *18*
Samejima, Satarō, 197, *204*
Sanagi village, 168
sand added to porcelain, 123
sanding, 134, 168
sandpaper, 124, 134
sashimono ("cabinet work"; building with clay slabs), 104
Satsuma ware (enameled cream-colored earthenware made in the Kagoshima area; also a type of folk pottery that originated in Korea and that has been made in this area for 360 years, sometimes called black Satsuma), 189
 black, 197, *204*
 white, 53, 219, 220, *31*

scrapers, steel, 124
 toothed, 91, 171, *76, 154*
scraping, 169, 172, 173, 187
sculpture, ceramic
 Bizen, Momoyama period, 179
 modern, 57, 122, *111*
seal
 Koishibara and Onda, 170
 Raku, 191
seaweed *hidasuki* 182, *18*
seiji ("green celadon"), 197, *see* celadon
Sen-no-Rikyū, 191
seri-daki ("racing fire"; a strongly reducing fire used for first two kiln chambers), 94
Seto, 43, 53–55, 61, 91, 168, 190, 191, 195, *51, 76, 154*
Seto Karatsu glaze, 195
settling tanks, clay, 97, 98, *87*
sewing needle carving tool, 75
sgraffito (decoration scratched through coating of slip to reveal body color underneath), 177, 178, 196, *163*
#2 *shaju*, 197
shell pattern resulting from cutting cord, 64, 135, *70*
shibui ("tastefully astringent"), 228
Shidoro ware, 228
Shiga Prefecture, *67*
Shigaraki, *67*
 clay, 96, 214, 219, 220
 Sue ware tradition, 53
Shikoku, 103, 188, *68, 82, 107*
Shimaoka, Tatsuzō, 89, 130, 168, 169, *77, 137, 147, 151, 155*
Shimane Prefecture, *21*
Shinano ware, *162*
Shinkai, Kanzan, 169, *148*
Shino ware (type of ware made near Seto, characterized by a viscous white glaze applied over painted iron oxide or over sgraffito through an iron slip), 168, 195, 196, *23, 24, 119*
Shinshō Craft Association, 57
shio-gusuri ("salt glaze"), *see* salt glazing
Shiragi period, *see* Silla dynasty
shiratama (a Japanese frit), 194
shiro (white) Raku, 191
shizumi-botan ("sinking peony"; incised